Audrey
The 50s

DEY ST.
AN IMPRINT OF WILLIAM MORROW *PUBLISHERS*

drey

The 50s

David Wills

Designed by Stephen Schmidt

Contents

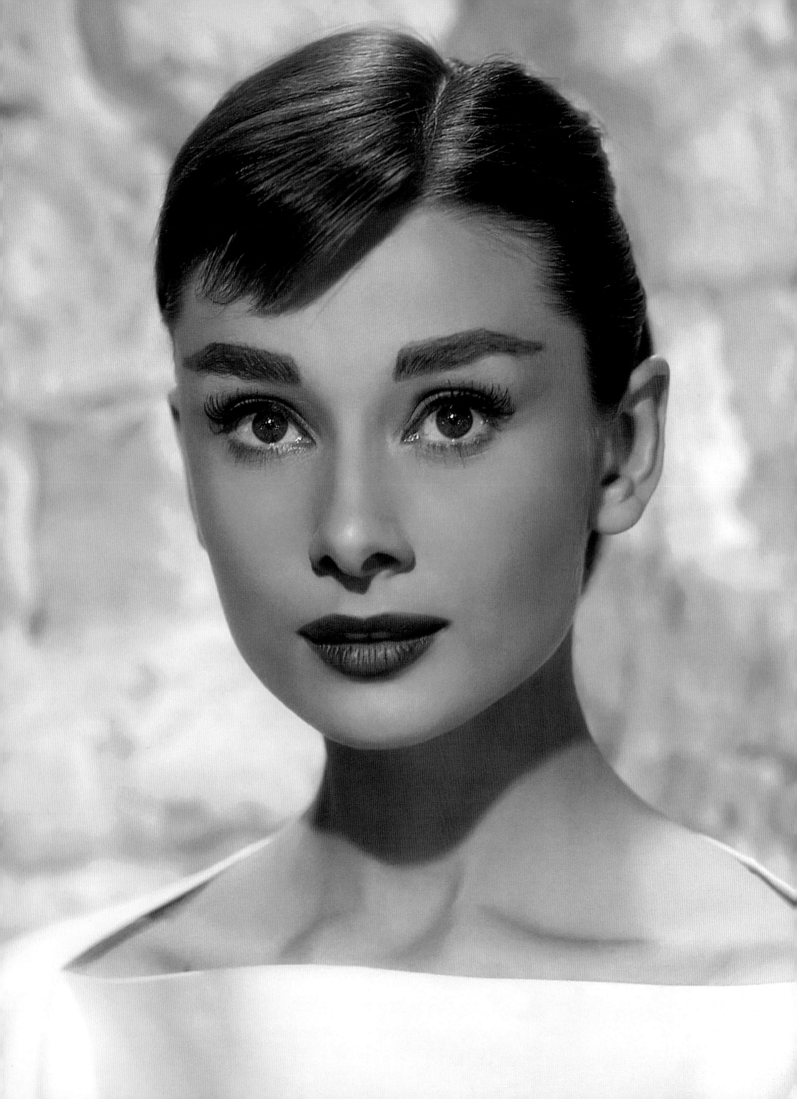

INTRODUCTION

"At midnight I'll turn into a pumpkin and drive away in my glass slipper."
—Audrey Hepburn as Princess Ann in *Roman Holiday*

Audrey Hepburn absolutely enchanted 1950s Hollywood. In an era dominated by the atomic prurience of the bombshells and on the heels of the forties glamazons, she revolutionized movie glamour with an understated allure that had never been seen on-screen before.

Not an actress of the chameleon variety, Audrey relied on innate gifts, undiluted by specific training. She maneuvered sleekly within a narrow range, her fashion-model perfection never completely submerged. Her unique appearance—the short hair, the slender frame and petite bosom, the long neck, the prominent brow, the strong jawline, and the irregular smile— set her apart; the cadence of her voice, with its velvet tones and tip-of-the-tongue enunciation, made for an unmistakable accompaniment that continues to melt hearts.

There is a modernity about Audrey Hepburn that reaches beyond the time in which her films were made. Her performances, as fresh and delightful as they were when originally released, resonate with contemporary audiences. In the 1950s Audrey filled a place on the popular screen that no one knew was vacant, and when she retired she proved to be irreplaceable. There is no actress alive who can turn a minute on-screen into a tutorial on poise, spontaneity, comic timing, professionalism, chemistry, and, of course, casual elegance.

Today she is everywhere—from the red carpet emulation by generations of new actresses, to the constant reference in contemporary style and fashion. As her films are universally available, she flickers across our consciousness more ubiquitously with each successive year—and devoted fans, both the loyal and an ever-increasing legion of the new, find themselves seeking out Audrey in classics like *Roman Holiday*, *Sabrina*, and *Funny Face*.

Her brilliant career was almost accidental, though inevitable. Audrey began her journey as a captivating young performer whose startling looks and luxe sensibility told a postwar Cinderella tale.

Cinderella: Part I

Audrey had appeared in bit parts in several small films by 1950, impressing her colleagues more than movie fans. It was while residing at a hotel in the South of France that the novelist Mlle. Colette took notice of a young actress at work in the lobby, filming a scene. Mlle. Colette was collaborating with Anita Loos, who was adapting the writer's 1946 novella for the Broadway stage. The production had been stalled in part for lack of a suitable ingénue to play its title character.

Seizing upon her first impression of Audrey, Mlle. Colette dashed off a telegram to inform Miss Loos that the search was over. Meanwhile at tea in her suite, Colette brashly declared to Audrey, "You are my Gigi."

Gigi was published in neutral Switzerland during the war, becoming a best seller in France after the liberation. Anita Loos characterized it as "a Cinderella story told in terms of sex." The turn-of-the-century piece concerns a young Parisian girl being tutored and tailored for life as a practitioner of the family business: the women are high-class courtesans. Gigi, a quintessential *jeune fille*, is kittenish, bright, naively flirtatious, thoroughly beguiling, and only sixteen. Despite Mlle. Colette's enthusiasm, Audrey wondered if, at age twenty-two, she could pass for a teen, and if she had the talent and experience to incarnate the coquette in a big Broadway theater. But with her inborn capacity to look and sound *parisienne*, her gamine persona, and sprightly charisma, Audrey survived a rough rehearsal period.

On November 24, 1951, at the Fulton Theatre, Broadway had a new star overnight, in Cinderella fashion. On opening night the marquee had read *"Gigi* with Audrey Hepburn"; a week later it read "Audrey Hepburn in *Gigi.*" The box office sold out.

Fame had been flirting with Audrey; now it was enamored. She won a Theatre World Award in 1952, was photographed for *Life* and *Look*, and made two showy feature appearances in live television dramas. The charming girl, ready or not, was becoming a lovely young woman onstage at every performance. Each night, she grew more at ease and confident, as her childhood melancholy, and youth defined by the sorrows of war, slipped further into memory.

Survival

Ella van Heemstra, a Dutch-born baroness, had two sons with her first husband, Esquire Hendrik Gustaaf Adolf Quarles van Ufford, whom she divorced in 1925. A second marriage, to Joseph Victor Anthony Ruston, took the family of four to London in 1928, and to Brussels in 1929, where Edda Audrey Kathleen Ruston was born on the fourth day of May. (Ruston soon amended his surname to Hepburn-Ruston; Audrey preferred Hepburn when her career required de-hyphenization.)

Ella raised her children amid Depression-era privations. She moved her family to Arnhem in the Netherlands in 1936, to stay with relatives. Soon after, Audrey was sent to boarding school in England, away from the chaos advancing on the Continent. Audrey's rootless early years had a not unusual side effect—she became fluent in five languages: Dutch/Flemish, French, English, Spanish, and Italian.

A reserved, somewhat aloof presence in Audrey's life, Ella tried to hold on to what remained of her status as a baroness. As a result, "I became a rather moody child," Audrey revealed, "quiet and reticent, and I liked to be by myself a great deal." She didn't care for dolls, preferring the company of dogs, cats, rabbits, and birds, though she did have a habit of peering into babies' prams, sometimes even picking them up to hold.

The Great Depression gave way to the war. One of Audrey's brothers was forced into a labor camp, relatives lost their lives, and the family moved about for safety and shelter, coming to a tense rest near Amsterdam. The "Winter of Hunger" followed the Nazi occupation of Holland in 1944. The Rustons got by, barely, on endives, tulip bulbs, and water, a diet that rendered an already slender girl alarmingly thin and anemic.

The Hepburn-Rustons, after the United Nations liberators came through Holland, returned to London. Audrey, always passionate about dancing, trained at Marie Rambert's School of Ballet. It was evident,

however, as noted by Mme. Rambert, that "she had lovely long limbs and beautiful eyes, but her tragedy was being too tall." So, Audrey spent years studying ballet but never became a true dancer. Ironically, she never studied acting but was to become spectacularly successful as an actress.

(Self) Discovery

With the latest issue of the trade weekly *The Stage* in hand, Audrey, now in her late teens, auditioned as a dancer in theaters, nightclubs, and music halls. The quiet introvert blossomed into a vibrant beauty by the war's end, and found work as a model for a few commercial photographers who were quite taken by her striking bone structure, fine complexion, and lack of model self-regard.

Audrey danced, demonstrating more personality than polish, in the chorus of *High Button Shoes* in the West End, and in a few revues was singled out to introduce the comedy sketches. Without any focused intent, Audrey stole the show. As one fellow dancer pointed out, "They're always looking at bloody Audrey. We don't stand a chance when she's onstage." The other chorus girls resented her audience appeal, yet had nothing but affection for her behind the scenes.

Audrey concurrently played, in very small movies, very small roles: a stewardess, a receptionist, a cigarette girl. Her first director spoke of their initial meeting: "I saw a dream coming into the room," and he immediately offered her the job. Audrey challenged his impulse by simply stating, "I am not an actress. You will regret it." He didn't.

Bit part by bit part, Audrey inched her way into her unchosen profession, securing an agent, then a contract at Associated British Pictures Corporation at seventy-five pounds a week, a lot of money for the Ruston household. In the autumn of 1950, Ealing Studios borrowed Audrey from ABPC for *The Lavender Hill Mob*. Opposite Alec Guinness, she played Chiquita, a former liaison to whom he passes a small sum as a parting gift, with the response "Oh, but how sweet of you," and an adoring squeeze. Guinness was

impressed with her knack for making the most of a mere moment on-screen.

Secret People (1952) featured Audrey in her largest role to date, portraying a refugee/ballerina in London after the war. Her ballet training served her well, but the acting came easier than the grueling rehearsals and filming of the big dance sequence. Audrey was given the starlet promotional blitz, although she refused the padding and push-up bra to simulate a Diana Dors-ian chest.

It was at a cocktail party to publicize the film that Audrey met and quickly fell in love with James Hanson, Baron Hanson, who proposed in 1952 with Baroness Ella's definite approval. Sensing, however, that their professional lives were keeping them apart, Audrey called off the wedding. She had already had a wedding dress made in Rome by the Fontana sisters, whom she asked to give it away to "the most beautiful, poor Italian girl" they could find.

Audrey's next movie role was pivotal, but not because it was a lead. In *Monte Carlo Baby* (1952), or, as it was titled in Great Britain, *Baby Beats the Band*, Audrey played Melissa Farrell, a young movie star with a baby in tow. Shooting a scene in the lobby of the hotel on the French Riviera—and without the full star attention to hair, makeup, and lighting—was the moment Audrey Hepburn caught the eye of her *Gigi* champion Mlle. Colette.

Hollywood Calling

Before Audrey left London for her Broadway debut in *Gigi*, she was spotted by director William Wyler, who was in the city to test ingénues for the lead role in a film he was preparing to shoot on location in Rome—*Roman Holiday*. Wyler arranged with *Secret People*'s director, Thorold Dickinson, to film Audrey at Pinewood Studios; the cameras would be kept rolling without her knowledge, to capture her potential in a more relaxed mode.

Wyler was pleased with the test, convinced that Audrey, with her mixed-European heritage and vaguely Euro accent, could portray his "real, live, *bona fide* princess" (Jean Simmons had been at the top of

Wyler's shortlist). The executives at Paramount Studios in Hollywood were so enthusiastic that they urged the London office to take up Audrey's option immediately, via telegram, "The test is one of the best ever made in Hollywood, New York, or London."

Audrey's like-no-other face and figure were a bonus. She could appear convincingly royal with her long-necked, ballerina posture; she could be lovably vulnerable with her large wide-set eyes; she could stand her ground with her square, strong jawline; she could wear with ease any costume thanks to her superslender model's frame. She was *Roman Holiday*'s perfect Cinderella in reverse.

Princess Ann, as the movie opens, is up to her tiara in duty, protocol, and pageantry, and flees the palace walls for some fresh air and plain-clothed freedom in nearby Rome. She is gently waylaid by an American reporter who recognizes the princess and senses a sensational news story, not expecting that a love story is about to be written instead. Movie star Gregory Peck had agreed to play the reporter, satisfying the Paramount heads. With an unknown opposite him, the film's bottom line looked more promising—two leads, one and a quarter salaries.

The Broadway producers of *Gigi* agreed to Audrey's early exit, with the stipulation that she star in the West End production in London upon the film's completion. They were literally banking on Audrey's return to the show as a genuine movie star, and therefore a box-office bonanza.

Peck, as reporter Joe Bradley, fell just a bit for his costar, calling her "Wonderful. An amazing girl, really. She can do anything, without effort." Audrey acknowledged that "maybe there was a little chemistry between us that made our scenes work. I was in Rome being treated like a princess, and it was not difficult for me to believe I *was* the princess . . . and it was not difficult for me to believe I was in love with Gregory Peck." There were hints in the press that the two had entered into an affair. But it was just another fairy tale, even though ads for *Roman Holiday* later announced,

"The man of every girl's dreams, Gregory Peck, meets the screen's most audacious new star, Audrey Hepburn."

Witnessing a sensation in the making as filming progressed, Peck pointed out to director Wyler that his own name over the title with Audrey's in smaller type below it preceded by "Introducing"—as contracted—now seemed inappropriate. Peck's agents urged him to let it be, but he argued that he "would begin to look like an aging star desperately trying to hang on to status," and that Audrey's performance was headed for acclaim in the awards season.

Audrey transformed on-screen for the role and female audiences took note. A significant device in that transformation was the shearing of Audrey/Ann's shoulder-length hair to a semi-short cut achieved on camera: real six- to eight-inch tresses fell to the floor of the Roman hair salon. The shortish cut was a modern revelation, appearing especially fetching when blown out as she rode through the streets of *la bella Roma* on the back of Joe Bradley's Vespa. Female audiences took note.

Roman Holiday premiered August 27, 1953, at Radio City Music Hall—a massive movie palace hosting an intimate romantic comedy in black and white, without a proven female costar—but the reviews were ecstatic. *Life* magazine pronounced Audrey "the most gifted star hired by Hollywood in years." *Time* photographed her for its September 7 cover and wrote, "Paramount's new star glows and sparkles with the fire of a finely cut diamond."

The Cinderella story continued when the nominations for the 1953 Academy Awards were announced: Audrey was included in the list of five for Best Actress. The motion picture story by Dalton Trumbo, credited to Ian McLellan Hunter due to the strictures of blacklisting, won its category. Already favored, as she had been cited by the New York Film Critics Association, Audrey won the night on March 24, 1954 (at the "annex" ceremony in New York), wearing a gown from *Roman Holiday* she had asked Hubert de Givenchy to alter. She unveiled to the general public for the first time the true pixie cut, and with her eyebrows

at their most Grouchoesque and her wide, wide smile, Audrey made a stunning, even shocking, impression, her Oscar looking like a gold-plated doll in her hands.

Prince Charming

Jean Giraudoux reimagined, in 1939, a French fable for the stage, and with a new translation/adaptation, the Playwrights' Company was backing a Broadway presentation for the spring of 1954, with Alfred Lunt directing. *Ondine* recounts the tale of an earthbound water nymph who falls in love with the knight Hans. In accordance with the magical powers that be, he must not be unfaithful to her or he will die. This was not standard fare for the Great White Way, but Lunt wrote to his colleague, the playwright Robert E. Sherwood, in November 1953: "I think Hepburn is absolutely ideal for the part of Ondine. She has had ballet training and . . . the whole play seems to have a ballet quality." It appears that Audrey's participation was the dealmaker.

Audrey had met Melchior Gastón Ferrer, twelve years her senior, through Gregory Peck. Audrey and Mel were mutual admirers. She particularly enjoyed his performance opposite Leslie Caron in *Lili*, which she saw three times. Mel sent her the *Ondine* script, and she was quite taken. She informed the producers that she would agree to star if Ferrer was cast as the knight—her professional Prince Charming—with co-billing.

Upon announcement of the opening, Audrey shared with a journalist, "It's a wonderful part, the kind I feel would be good for me. . . . A serious dramatic part, and an unusual one." Plus, a mythic creature in an enchanted setting was a perfect fit for the ethereal, boyishly slender Audrey. Some reviewers buzzed that she should play Peter Pan. Costume designer Richard Whorf, with Audrey as inspiration and mannequin, devised an embellished leotard, trimmed with a garland of leaves and the lightest fishing net, suggestive of water and rain, forest and flight. Audrey's large eyes were kohl-rimmed with a swath of smoky eyebrows above.

Marian Seldes, Princess Bertha in *Ondine*, had

been alerted by her agent to the part, "the heavy in a play with Hepburn," and thought he was speaking of Katharine Hepburn. "But when I worked with Audrey . . . she behaved in such a way that my admiration for her was on a par with what I felt for my early idols. I loved watching her rehearse and act. How beautiful [she made] other people feel! That was her magic on and off the screen."

Opening night, on February 18, 1954, at the 46th Street Theatre, was a blur of nerves and applause. "I don't remember getting onstage or saying my bits or even the final curtain call," Audrey recalled. She scored another triumph. Brooks Atkinson, in the *New York Times*, described her as "tremulously lovely . . . All grace and enchantment."

Again, rumors of a love match between Audrey and her leading man were heard around town—and this time they were true. Audrey's mother, Ella, insisted to those who asked that her daughter and Mel Ferrer were not romantically involved, but the play's production seemed to have sealed the attraction.

Ondine closed its limited run on July 3, with 157 performances. Audrey's doctor prescribed immediate and prolonged rest—she was fifteen pounds underweight, with symptoms of asthma. She took her very first significant break from work, sojourning with Ferrer as an acknowledged partner. They were married September 24, 1954, in Bürgenstock, Switzerland. Audrey wore a Pierre Balmain ivory organdy dress, her short hair encircled with a coronet of white roses. Audrey and Mel settled in together and established married life before his work or promotional demands of the already-filmed *Sabrina* would keep them apart.

Cinderella: Part II

With Audrey already in mind, Billy Wilder purchased the rights to a Broadway play, *Sabrina Fair: A Woman of the World*, by Samuel A. Taylor, in 1953, and set it up at Paramount where she was already under contract. The piece suited her like one of Sabrina's white gloves; even more so as Ernest Lehman, in his rewrites, tailored

it for the voice, the figure, and the charm that were Audrey's alone.

To welcome Audrey back to Hollywood, talent agency MCA threw a gala in her honor. Jennings Lang, an MCA vice president at the time, sketched the scene: "You had to be a star simply to be a waiter at this party. If you weren't on the guest list, you had to crawl out of town."

One star was not a fan; Humphrey Bogart was of the opinion that Audrey had risen to the Hollywood heights prematurely. He was also well aware that he was not Wilder's first choice—Cary Grant had declined the role–to play Linus Larrabee, the all-business one-third of the love story at the heart of the film. Bogart grumbled and bullied his way through the film's shoot, alienating crew and cast, including Audrey. Bogart later apologized to Wilder but never managed the same for Hepburn before his death in 1957.

Sabrina was intended to hit Audrey's sweet spot perfectly. It would showcase her in a romantic fable with a focal formal ball; an upstairs/downstairs story with a love triangle; a tale complete with a fairy godfather and an almost-missed happy ending; and a fashion show with a transformation from the plain to the patrician. The film even begins with Audrey's own velvety voice-over—"Once upon a time . . . there lived a small girl on a large estate . . ."

Edith Head, who had designed Audrey's princess-on-the-run make-under for *Roman Holiday*, was again engaged to costume the cast, and relished the opportunity. "Every designer wishes for the perfect picture in which he or she can really show off design magic. My one chance was in *Sabrina*. . . . It was the perfect set-up. Three wonderful stars, and my leading lady looking like a Paris mannequin." What Edith didn't know was that Wilder had given Audrey the go-ahead to shop in Paris for genuine couture to capture Sabrina's metamorphosis from gangly girl—designed by Edith—to chic woman. That job fell into the lap of a Paris couturier.

While on holiday in Paris, Audrey dropped in at the atelier of Hubert de Givenchy, for whom she had modeled several seasons before. M. Givenchy had no recollection of this, so when Miss Hepburn was announced, he assumed the great Katharine was at his door. His guest surprised him as she entered the salon "like a fragile animal [with] such beautiful eyes, so slender—and she wore no makeup. [She was] dressed in plain trousers, ballerina shoes, a short T-shirt, and a beribboned straw [gondolier's] hat."

M. Givenchy, quite charmed, opened his sample room doors to Audrey. From the spring/summer '53 collection, she zeroed in on "that jazzy suit" in gray wool ottoman that would wow David Larrabee and the audience upon Sabrina's return from Paris. Givenchy recalled, "The change from the little girl who arrived that morning was unbelievable. The way she moved in that suit, she was so happy. The suit just adapted itself to her. Something magic happened. . . . You could feel her excitement, her joy."

Audrey next chose a ball gown, "way off the shoulders and yards of skirt," for the annual Larrabee fête. The dress had two skirts—one very narrow and well above the ankle, over which billowed from the back a full train, all white with black embroidery and jet beading. Dreda Mele, then directrice of the Givenchy salon, recalled, "The snowdrift white dance dress. She was something unreal—a fairy tale!"

Audrey/Sabrina chose white for her big night with David; she selected black for an important evening with Linus. The quintessential Audrey cocktail dress, crinoline-skirted with a small bow at each shoulder, featured, as M. Givenchy made clear, "a *décolleté bateau*, afterward called the *décolleté* Sabrina." Audrey loved this high, horizontal neckline, as it obscured her "skinny collarbone but emphasized her very good shoulders." The dress was topped by a hat resembling a medieval crown—a risky choice, but one befitting the fairy tale.

Accompanying all this couture was the signature Audrey footwear: the kitten-heel pump that she insisted made her height a nonissue with all her screen partners. Her makeup was refined from pretty girl to sophisticated woman, her dense brows stopping short of a near miss over her nose before and shaped to a fine point after.

Such a recalibration was attributed to the influence of her fairy godfather, the baron from the cooking school who took Sabrina under his kindly wing. He first eliminated the excess pony in her ponytail; he then banished her bangs. Under Sabrina's little hat is the pixie haircut, at the time unfamiliar, very short and styled into points across her brow. In a flash, close-cropped hair for women no longer seemed mannish, exotic, or quixotic—just chic.

Filmed at Paramount Studios in Hollywood and on location at Glen Cove, Long Island, *Sabrina* had a tight shooting schedule of seven weeks—October through November 1953—and was budgeted at about $2,500,000. Wilder had to work efficiently; Audrey was committed to start rehearsals on a Broadway play by the end of the year. *Sabrina* was released in October 1954, to mostly favorable reviews; Audrey received near unanimous praise for her natural grace and charm, her acquired elegance and sophistication, her black-and-white radiance. She had yet to be seen in a major picture filmed in color.

Audrey was named "World Film Favorite" by the Hollywood Foreign Press Association, photographed and lauded in fashion magazines, her gamine style the look of the moment and classic all at once. Her pixie cut was re-created on women all over the world. Her reputation within the industry was impeccable. Crowning all of this was the nomination for the 1954 Academy Award for Best Actress. She could not be present at the ceremony held in early spring 1955.

Audrey was gratified by the Academy's recognition, but was distressed when only Edith Head's name appeared as nominee for Best Costume Design (black-and-white feature), and truly mortified when Edith rushed to the stage to accept the Oscar and then failed to mention Hubert de Givenchy as a major contributor. Audrey telegrammed Hubert at once, personally apologizing for the omission. He played down the slight; having garnered much publicity for his business, and welcoming new clients to his salon seeking "the Hepburn look." A lifelong friendship was thus sealed, and the two worked together on six more films.

M. Givenchy's designs served as the basis for her personal wardrobe from then on.

Costume Drama

"I wanted Audrey from the start," producer Dino De Laurentiis said of his epic production of Leo Tolstoy's classic *War and Peace*. "Her girlish charm and wide-eyed naiveté would do much to enhance the character of Natasha [Rostova]. I also thought Mel would be wonderful [as Prince Andrei]. He had a brooding quality. . . [an] added dimension of soulfulness."

And so the negotiations went back and forth in late 1954. Audrey, for $350,000 plus substantial amenities, signed on to *War and Peace*. The role of Pierre Bezukhov, the true hero of the piece in his opposition to the imminent armed conflict as Russia and Austria mobilized against the advancing armies of Napoleon in 1812, was more difficult to cast. After several names were tossed about the part went to Henry Fonda, another name on Audrey's list of costars old enough to be her father.

At the time, there were two competing teams hoping to realize *War and Peace* for the screen, one with De Laurentiis and Carlo Ponti producing, the other with Mike Todd producing and Fred Zinnemann directing. Ponti/De Laurentiis won the skirmish by partnering with Paramount, where Audrey was under contract. The studio, betting on a *Gone With the Wind*–size hit, put up half of the six-million-dollar budget. The production would spread over the entire forty-eight acres and all nine stages at Cinecittà in Rome, and shoot on location outside the city as well as in Yugoslavia, with President Tito's approval. King Vidor would direct and cowrite, with five other screenwriters.

The grand epic was Audrey's first color picture, and with cinematographer approval in her contract, she chose Jack Cardiff, someone she trusted to protect her and show her to best advantage. She felt the same affinity for Alberto De Rossi as makeup supervisor and for his wife, Grazia, as her hairstylist. Audrey prevailed upon her friend Hubert de Givenchy to attend her fittings

with costume designer Maria De Matteis. M. Givenchy consulted on color and cut, fabric and embellishment, increasing Audrey's self-assurance and comfort.

Audrey fully immersed herself in the demands of the role. She was taught the elaborate court dances typical of nineteenth-century Moscow. She learned to ride in aristocratic style on a Russian pony, in spite of a childhood riding accident that had left her with a fear of horses. She endured heavy, layered costuming in the dead heat of summer and gypsum-coated cornflakes propelled by wind machines to simulate Russian winter.

The comedic and romantic films *Roman Holiday* and *Sabrina* were shot chronologically, a great help to a young actress still learning her craft. But the monumental logistics of *War and Peace*—15,000 extras alone in one battle sequence—precluded such concessions. Audrey had to be young and flirtatious one day, much older and in mourning the next. "Acting doesn't come easily to me," she admitted. "I put a tremendous effort into every morsel that comes out. I don't yet have enough experience or store of knowledge to fall back on." King Vidor, although thoroughly charmed by his leading lady, was consumed with the rigors of epic filmmaking and could not provide the attention and guidance she needed. Henry Fonda remained remote, and Ferrer unavailable after leaving for Paris when his scenes were complete to start work on another movie.

In a year (1956) of spectacles and epics—*The Ten Commandments, Giant, Around the World in 80 Days*—*War and Peace* opened to mostly unfavorable critical response. At a running time of nearly three and a half hours, showings per day were limited and the public stayed away. Exhausted and wary, Audrey decided, and her husband agreed, that her next project should be light, fun, a breath of untroubled air. As an extra treat, the following film would be partially shot in the city of her dreams—Paris.

Cinderella Once More

In a single movie Audrey Hepburn wished to act, to dance, and to sing. And for this triple-threat performance, she wished to partner with Fred Astaire.

Incredibly, her every wish was granted as writer Leonard Gershe, producer Roger Edens, and director Stanley Donen were assembling a musical project out of puzzle pieces culled from classic Broadway and Hollywood tropes—Gershwin tunes, a used title, a borrowed story, some new material, and two stars, one an old master, the other a star still rising. Gershe considered Audrey "the hottest thing in the business," and told her that Astaire was very interested if she was—in turn informing Fred that Hepburn was available if he was the leading man. The old strategy worked, but complicated and prolonged negotiations followed. Audrey's studio, Paramount, took up the property package, with expertise provided by MGM's much-admired Freed Unit (Donen, Edens, Gershe, and others).

Funny Face was imagined as a breezy spoof of the high-end rag trade in Manhattan and Paris, at its center a fashion photographer and his new discovery. With Audrey as the willowy model-to-be, a bit of Hollywood history was made. Previously, a curvy, voluptuous, overtly sexy star would have portrayed the high fashion mannequin, but as Gershe pointed out, referencing the 1944 musical *Cover Girl*, "Carmel Snow or Diana Vreeland would never have put Rita Hayworth on a cover of *Vogue* or *Harper's Bazaar*."

Stanley viewed *Funny Face* as a unique picture, needing an expert to handle its technical demands and exploit its glossy pictorial possibilities. He invited professional photographer Richard Avedon on board as "visual consultant." His collective contributions were so singular, inventive, and modern that they anticipated music video creativity twenty-five years later. (Astaire's character, Dick Avery, is a little inside tribute to Richard Avedon.)

An Avedon montage opens the movie: "Think Pink" is a ploy to perk up the impending issue of *Quality* magazine, whose editor, Maggie Prescott, is portrayed by the high-style steamroller known as Kay Thompson. She swoops (à la Vreeland) through a litany of tongue-in-chic mandates for the woman looking to pink up her life—even though Prescott herself "wouldn't be caught

dead" in the color. Top print models of the fifties—Suzy Parker, Dovima, Sunny Harnett—vignette their way through all things pink, courtesy of Avedon, Technicolor, and VistaVision.

Endless April showers, in the spring of 1956, plagued the company for days, turning the white wedding into a bridal bog. Fred and Audrey had been looking forward to their dance together, but what they got was brief and soggy, a "pas de mud," over the sod that had been laid just for this scene and soaked by the rain. Audrey is in full happily-ever-after mode, however, in Givenchy's drop-waist, full-skirted wedding dress. The tea-length dress, floating mid-calf, became a bridal sensation, simple and modern, accessorized with a veil attached to the back of the bateau neck, echoing the bell shape of the skirt. Little wrist gloves took the place of the conventional opera-length. It all added up to an unforgettable fifties fashion moment.

A big moment in the fashion show itself is Audrey's appearance in a spectacular evening gown with a very narrow satin skirt and a back-buttoned pink bolero, with three-quarter sleeves topping it off. A full train extends from the jacket's shoulders, creating its own elegant backdraft on the catwalk. The look is finished with severely slicked-back hair, accentuating Audrey's already prominent jawline. The angles are softened by the diadem circling her head, and the luster of Wally Westmore's runway makeup. Later, Audrey as Jo swaddles herself in a voluminous to-the-floor sky-blue cape. The garment is bizarre when its hood is up and tight, and all that remain are her face and gloved arms and hands. She looks swallowed up in this disconcerting bit of couture, but mostly Audrey is ravishing and thrilling, and as Jo, she embodies the Cinderella theme to the hilt.

Choreographer Eugene Loring said that working with Audrey was "the happiest experience" he had had with any star. "She would try anything." She was delighted to sing her own songs and to have a solo dance to the percussive piece "Basal Metabolism," a pseudo-Beat number in an underground Parisian boîte. Audrey and director Donen had a disagreement, however, when it came time to put the dance on film. With her black pants, turtleneck, and loafers, would Audrey wear the black socks she felt she needed to minimize what she considered her large feet (a residual ballet school complex)? Or, would Donen's insistence on white socks to point up movement in the very dark, cavernous setting make the cut? Donen, as director, won the debate, Audrey realizing later how right he was.

The all-black dance outfit was put together by Edith Head, for this picture, knowingly sharing the design duties with M. Givenchy. Edith also delivered Audrey's bookstore clerk costume—the droopy, big-buttoned, oversized jumper paired with black sweater and tights—and the travel sportswear consisting of a hooded khaki parka, turtle, and tight black pants, "the perfect American look," according to designer Isaac Mizrahi.

Critic Rex Reed, in a retro rave, singled out Funny Face as "the best fashion show ever recorded on film." The Academy was in agreement, with their 1957 nominations recognizing both Edith Head and Hubert de Givenchy in the costume design (color) category. The movie received three other nominations.

Ferrer, steering both their careers, encouraged Audrey to decline film and stage offers but agreed to a deal that would star both of them in a television production of Mayerling, a poorly received Producers' Showcase presentation on February 4, 1957. Audrey was still much publicized, and included on celebrated lists of ten: "best dressed," Cholly Knickerbocker's "most fascinating," and Anthony Beauchamp's "loveliest" women. Resting and restoring after filming back-to-back fables of love and fashion—Love in the Afternoon quickly followed Funny Face in 1956—Audrey read of these accolades "as if they were being bestowed on another woman." The charming girl, now a lovely woman, was maturing out of fairy tales—almost.

"Hello, Thin Girl"

Even though surrounded by "the loveliness of Paris," Audrey was anxious in August 1956, shortly after

Funny Face wrapped. She was nervous about meeting and then jumping right into work with Gary Cooper and Maurice Chevalier for *Love in the Afternoon*. Some big-star insecurity surfaced, in spite of her reputation as a dedicated professional. "I was more worried about how I looked when I started this movie than any other film of my career," Audrey recalled. "Maybe it was because I lost so much weight during *Funny Face*." Fatigue was a factor, but also, now in her late twenties, she would be playing a girl as much as eight years her junior.

Mel Ferrer thought he had a solution. He returned to their hotel suite one day carrying a very tiny Yorkshire terrier, reasoning that Audrey needed a focus outside of herself, a receptor of love and care. "Mr. Famous" did his job, and a calm settled over her fears.

Billy Wilder reunited with his *Sabrina* star to film an adaptation of a period novel by Claude Anet, *Ariane, jeune fille russe*. The setting was moved to contemporary Paris and a third character added, Claude Chavasse, Ariane's father and a private detective, to be played by Chevalier. Wilder, in partial homage to his mentor Ernst Lubitsch, the past master of scintillating thirties romantic comedy, continued his preference for black and white, in this instance putting it to a very practical end. According to Dick Guttman, assistant publicist for the film, Cooper's face was "always in shadow, as allowed by black-and-white photography." The Technicolor process would have required full lighting of all actors. Not only was Cooper shadowed, he was often shot in profile, and with a substantial degree of filtering to massage ten years off his appearance. Audrey was alone in thinking, "Coop's crags gave him character, while I just looked washed out and hollow-eyed."

Audrey's hair and makeup, meant to accentuate her youthfulness and glow over any "hollow-eyed" effects, succeeded only in part. Her envied eyebrows are in place, but the pixie cut has grown to shoulder length and folded under to present a sort of bouffant bob, parted in the middle. The matronly style actually aged Audrey a bit, tolerable for scenes with Cooper, not at

all for young cello student Ariane. The unattractive do thankfully disappears for two sequences, once on a picnic date, where Audrey enchants in bright sunlight, her hair in two girlish ponytails, bangs swept to the side.

The Givenchy wardrobe is captivating but requires a significant suspension of disbelief. Most of Ariane's clothes would be way out of reach for an ordinary French household. Thousands of dollars of custom couture, while a real feast for the eyes, threatens to overwhelm the fragile romantic comedy. An exception, rarely noticed, is the cotton, straight-skirted, sleeveless dress that Ariane wears when returning to Flannagan/ Cooper the borrowed evening hat from the night before. Ariane/Audrey also convinces when sporting a plain little jacket and matching skinny trousers, and again, at the picnic, in a white shirt, cardigan, and capri pants. Ariane's ultra-slim frame prompts Flannagan to greet her always as "Thin Girl." He never learns her name.

For most of the film, however, Audrey is a fashion show in a series of stellar ensembles. The Givenchy signatures are all in evidence: bateau necklines, the little cap sleeves, the full-skirted silhouette, the black-and-white geometry, the precise hats, the wrist gloves, and little or no jewelry. One costume underscores a very poignant moment for Ariane—the white opera dress, strapless, tulle-skirted, with a tailored bolero jacket in satin. At the opera with a friend, she catches sight of Flannagan with an adoring date. He does not see Ariane until she poses herself in his direct vision while the other woman is in the powder room. He fails to recognize her from his last trip to Paris. "You know who I am, Mr. Flannagan," Ariane says flatly. "I'm the girl in the afternoon."

As is his routine with his women, Flannagan offers to buy Ariane an extravagant gift, whatever she wants. She slips the carnation from his lapel, saying she desires nothing more. The carnation is just one of the intriguing props that Wilder employs to detail his storytelling. There are also Ariane's cello case, Flannagan's Louis Vuitton luggage outside his hotel door, the anklet at the picnic, and the misplaced kitten-heel shoe. Even the Gypsy string quartet functions as a music box, playing

"Fascination" endlessly as the sound track to Flannagan's love life.

A more sartorially subdued Ariane accompanies Flannagan to the train station to say good-bye. Wearing a slim wool coat, high-waisted and closed off-center with two very large buttons, her face surrounded by a tight scarf, she takes his carnation. Tears in her eyes, she fabricates one more story before Flannagan impulsively sweeps her up into the moving train. Maurice Chevalier speaks the final voice-over: "On Monday, August 24th of this year, the case of Frank Flannagan and Ariane Chavasse came before the superior judge in Cannes. They are now married, and serving a life sentence in New York, state of New York, USA."

Love in the Afternoon opened to very mixed reviews, much as the picture was an uneven mix of romance and melancholy. The subject matter, as well, generated a stir of controversy. Facing accusations of amorality, the film was censored in Spain, while in France the title reverted to *Ariane*, as *"Love in the Afternoon"* was considered too explicit. The voice-over at the end was a last-minute fix for the American market, lest anyone get the idea that Ariane and Flannagan did not consummate their relationship legally. The Catholic Legion of Decency denied the movie its full approval, finding that "it tends to ridicule the virtue of purity by reason of undue emphasis on illicit love." Despite the fuss, Audrey secured another Golden Globe nomination.

While the Ferrers spent an extended holiday in Bürgenstock, Switzerland, the director George Stevens, in one last effort to get a yes from Audrey for the lead role in *The Diary of Anne Frank*, sent Frank's father, Otto Frank, from Zurich to persuade her. Audrey still declined—the war narrative was too close, her memories still too raw; and she had strong reservations about exploiting the story for a salary. And, she was now too old to play Anne Frank.

Forest Fire

Rima, the Bird Girl of the Venezuelan jungle, was a role Mel Ferrer desired for his wife, more, it seems, than she wanted it for herself. The character was created by W. H. Hudson for his 1904 classic *Green Mansions*. Not only did Ferrer want Audrey to play the part he felt she was perfect for—once thought a fit for Dolores del Río, and later Pier Angeli—he sought to be her director. Approaching MGM, which owned the rights, he made a deal to direct if he could deliver Audrey as the star.

A supernatural being in her original incarnation, Rima evolved, in the Dorothy Kingsley adaptation rewritten by Ferrer, from spirit into real girl, but one in profound sync with her jungle home. She was the undesignated guardian of the forest and its secrets, able to communicate with wildlife. Ferrer saw in his wife manifestations of such an earthbound sprite, going back to Ondine, the nymph she played when they shared the Broadway stage in 1954. At age twenty-nine, Audrey could still, in Ferrer's eyes, waft through a forest like no one else.

The initial plan called for a location shoot in South America, but was quickly abandoned when it became apparent that the jungle was too dense, not allowing enough light to reach the forest floor. Instead, extensive background footage was shot in British Guiana and Venezuela. These reels would be not only used as blue screen (later green screen) backup, but manipulated to show in color a forest in danger, on fire, in a slow smoking burn spurred by native and outside forces at war among themselves and with nature.

On the MGM lot in Culver City, Ferrer and his production designer supervised, on soundstage 24, the installation of a "real" rain forest, complete with imported South American flora and fauna—great trees, looping vines, ferns, flamingos, herons, a macaw, and a jaguar. One important "wild" card remained. The Ferrers had rented a house in Beverly Hills for the duration. It was decided that the young deer selected for her movie debut as Rima's companion should take up residence with them, in order to create a bond between Audrey and the animal so that she would follow Audrey during their scenes together. Audrey became devoted to "Ip"— an approximation of the sounds she made—saying, "At

the end of the day we all ride home together. We have a two-seat sports car. Mel drives, Famous sits between us and Ip falls asleep on my lap. She has the run of the house and garden. I feed her with a bottle."

To play Abel, the Venezuelan refugee seeking asylum in the forest, Ferrer and Audrey together agreed that Anthony Perkins, whom they had made a special trip to see on Broadway in *Look Homeward, Angel*, had the talent and requisite romantic appeal. At last Audrey had a leading man near her age—Perkins was twenty-six—with the possibility of celluloid fireworks. Satisfied with the pairing, Ferrer determined that the world should see the sensual side of his wife's star quality. Audrey, for her part, said she felt "uninhibited" being made love to by another man while her husband not only watched but supervised. Not since William Holden had she been able to portray the fever of attraction leading to physical passion, rather than just romantic affection.

Green Mansions was to be shot in Metrocolor and CinemaScope, but it was discovered that Audrey's face "ballooned" in the latter process. An anamorphic widescreen lens was employed to bring down to scale her prominent cheekbones and jawline in close-up. *Mansions*, as a result, became one of the first features to be shown in Panavision.

The care of the very long Rima wig was overseen by Hollywood great Sydney Guilaroff, who gave Audrey's face a rag-doll frame, and a soft enhancement not seen since the early scenes of *Roman Holiday*. William Tuttle, an acknowledged master of film makeup by 1958, gave her a fresh, pure look with a sensuous glow. Costume designer Dorothy Jeakins downplayed her task as well, draping Audrey in an extremely simple, filmy shift, raw-edged at neck, shoulder, and hem, with gradations of hue to suggest protective coloring. As staged by Ferrer, Audrey/Rima posed in earthy camouflage, emerging from the tangle of the jungle. In a memo, alarmed MGM executives demanded clearer shots of their expensive star: "We aren't paying for the 'Invisible Girl'!"

At Radio City Music Hall, on March 19, 1959, *Green Mansions* opened to tepid reviews and no box-office heat at all. The Ferrer-Hepburn professional teaming seemed over; but Audrey was hoping, anxiously, that the release of *The Nun's Story* would restore her career to its previous heights.

The Tolling of the Bell

While Mel Ferrer was cultivating his rain forest in Los Angeles, Audrey was stretching her talents for Fred Zinnemann in his production of *The Nun's Story*, based on a best-selling novel and adapted for the screen by Robert Anderson. Audrey's agent, Kurt Frings, assured her that the prestigious part of the conflicted nun "would be the role of a lifetime." Ingrid Bergman had declined to star, feeling herself too old, but suggested Oscar-winner Audrey to Oscar-winner Zinnemann.

The role was Gabrielle van der Mal, a nurse and daughter of a noted Brussels surgeon, who, in 1930, with the shadow of fascism already looming, feels the call to serve and, as a novice, enters a convent of nursing sisters. Personal struggles with faith, discipline, and humility cloud both her spiritual and medical studies, as her now strict and structured life, timed to the abbey bell, calls her to rise, to worship, to chores, to class, to meals, to bed, to begin again.

Every Hollywood studio passed on Zinnemann's project, until a pact was struck at Warner Bros., where executives, well before *The Sound of Music* made nuns fashionable, sniffed magic and money at the box office. "It was Audrey's name alone which made the deal possible," Zinnemann later confirmed.

"I am like Sister Luke in so many ways," Audrey was known to say, referring to their Belgian births, the loss of their fathers, the long war experience, their brothers being apprehended and sent to labor camps. Audrey met the real-life inspiration for Kathryn Hulme's novel, Marie Louise Habets, while preparing for her role. The two remained dear and lifelong friends until Habets's passing in 1986. The feeling of kinship empowered Audrey to take on a part "so completely

different from my previous roles."

Another part of Audrey's groundwork was close observance of the real lives of the sisterhood. "I stashed my 'nuns' [Hepburn, Edith Evans, Peggy Ashcroft] away at different convents," Zinnemann said. "Making the daily rounds at 10 A.M., I'd arrive in the warmth of a taxi . . . and all of them would come out of the cloisters absolutely purple with cold but fascinated by what they were involved in and very excited by the way they were getting prepared for their characters." Audrey was also schooled in the specific handling and care of surgical instruments.

The nun's story, literally, continues as Gabrielle—now Sister Luke—expresses her desire for a position at the convent hospital in the Belgian Congo to study and treat tropical disease. The request is denied, further testing her faith and obedience. None too swiftly, the assignment is granted, and Sister Luke arrives, in the searing Central African heat, at the Catholic compound where she encounters the attractive curmudgeon Dr. Fortunati, played by Peter Finch, who first discounts her skills, then admires the asset to the community she becomes. A severe case of tuberculosis threatens Sister Luke's life, and she pulls through thanks to an experimental treatment administered by the doctor himself. Some fans of the film have suggested a romantic connection between the two, which Zinnemann carefully discusses: "Of course, no conscious physical love affair. . . was to be implied or hinted at; but Peter Finch had the appeal to make the audiences feel the powerful attraction that existed between them."

The outbreak of war in Europe requires Sister Luke's return to Belgium, to submit to duty and discipline, the tolling bells again regimenting her days. Her father's compassionate voice in her head prompts a crisis of conscience as she realizes her true calling is outside the convent walls, in aid to the war's sick and wounded. She takes leave of her nun's habit, her vows, the cloistered life, and the command of the bells.

Audrey Hepburn, the fashion maven, took a sartorial break to live the story of the nun. She wears the simplest of period dresses and then the required vestments, courtesy of costume designer Marjorie Best. Her makeup and hair were again entrusted to the De Rossis. Alberto gave Audrey a clean, modest aspect; he did the same for the other actresses playing nuns, who needed to be made up to appear, in the dim chill of the abbey, as though they were wearing no makeup at all. Grazia had a pivotal moment on camera, when, dressed as a nun, she shears Audrey's hair to an appropriate bob as Sister Luke prepares to take her final vows. Zinnemann credits Grazia's "professional touch [that] avoided clumsiness and fumbling which might have marred the scene." So, once again, the cut and style of Audrey's hair took center stage as it did in *Roman Holiday*, *Sabrina*, and *Funny Face*.

Zinnemann originally planned to use Audrey's hair as a marker of visual change when Gabrielle prepares to leave Sister Luke behind. He suggested that as the wimple is removed, there be streaks of gray in her brunette hair to indicate the passage of time and the maturing of a woman. Audrey rejected the idea.

For her sensitive, probing performance, Audrey won raves from the press and cheers from the audience when the film opened at Radio City on June 19, 1959. The movie expanded nationwide in July and went on to become, at the time, the most profitable in Warner Bros.' history, with gross earnings of $12,000,000 against a $3,000,000 budget.

The film garnered eight nominations total, including Best Picture and, for Audrey, Best Actress in a Leading Role, her third Oscar nomination. The New York Film Critics handed her their Best Actress Award for 1959. *Films in Review* proclaimed that Audrey had finally transcended the confines of the wise child, the gamine in the city, the sprite in the forest, to deliver "one of the great performances of the screen."

Model on a Roll

After inhabiting a nun's habit and then dusting off some western wear in John Huston's *The Unforgiven* (1960), Audrey stepped into Holly Golightly's size 8 kitten heels and solidified, right then and there, not only her acting

credentials but her status as probably *the* fashion idol of all time. Being singled out was something Audrey had gotten used to since her career began. She was uncommonly thin, flat-chested, doe-eyed, and square-faced. But as with all great screen legends, there were no rules to her photogenicity—everything just worked. There was even perfection in the imperfection of her smile. Audrey blurred the line between actress and model as never before—or since.

Photographer Anthony Beauchamp, in the late forties, was working for British *Vogue* and a few society magazines. While attending the show *Sauce Tartare*, he was drawn to chorus girl Audrey and ventured backstage to find her, the one with "the big eyes." Taken by "her fresh new look, a beauty that was ethereal," Beauchamp noted that her appeal "certainly had nothing to do with her dancing. She was on the wooden side in that area, but she was so striking to look at, you barely noticed." Beauchamp photographed Audrey as a new starlet on the scene, employed her as a fashion model, and chose hers as the face for Lacto-Calamine complexion lotion. She graced hundreds of in-store displays in pharmacies across the country.

As Audrey continued modeling, auditioning, performing, and attracting more attention, reviewer Milton Shulman noted how she rose above the stage/cabaret trappings. She was, he wrote, "as conspicuous as a fresh carnation on a shabby suit." But the theater would have to wait as Audrey began to win bit parts in British movies, advancing to featured roles and ultimately the lead in the small film that attracted the eye of Mlle. Colette.

Audrey's big splash in *Gigi* resulted in significant exposure in *Time* and *Life* magazines. For the latter, photographer George Douglas spent two weeks snapping pictures of Audrey in costume in her theater dressing room, in Central Park, at the top of Rockefeller Center. Douglas, based in England and Los Angeles, and a contributor to the British magazine *Picture Post*, "fell a little bit in love" with his subject.

The bouncy ingénue of *Gigi* led straight to the sheltered princess in *Roman Holiday* and, consequently,

to the focus of Bud Fraker's camera. Fraker had worked in the stills department at Columbia Studios in Hollywood for his brother William, then took over when he passed away. He made a lateral move to Paramount, where he became the studio's director of still photography. Audrey, the new "it" girl on the lot in 1952, was subsequently photographed by Fraker for *Sabrina*, *War and Peace*, *Funny Face*, and *Green Mansions*. He was one of the first to take a formal studio portrait of Audrey, and his images of her to this day remain, in many ways, her most iconic.

"At last [she] appeared—a new type of beauty: huge mouth, flat Mongolian features, heavily painted eyes, a coconut coiffure . . . wonderfully lithe figure, a long neck. . . . In a flash, I discovered [her] spritelike charm." This was Cecil Beaton's first impression of Audrey when he met her, on the arm of Mel Ferrer, on a summer evening in 1953.

Sir Cecil Walter Hardy Beaton was a notorious aesthete, dabbling and succeeding in a number of artistic efforts: photography, painting, illustrating, interior decor, scenic and costume design, and a best-dressed Hall of Famer. As the Noël Coward of the visual arts, he wrote exactingly and exotically, often for *Vogue*, on the subject of some his most famous sittings: "She wears no powder, so that her white skin has a bright sheen. Using a stick of greasepaint with a deft stroke, she draws heavy bars of black upon her naturally full brows . . . [she] liberally smudges both upper and lower eyelids with black. In clothing the ingénue . . . wears a 'junior miss' version of highwayman coats, clergyman cassocks, or students' pants, overalls, scarfs. Yet she is infinitely more *soignée* than most students, possessing, in fact, an almost Oriental sense of the exquisite." Beaton's camera work was rigorously artistic, not technical. He photographed Audrey on several occasions in 1954 and 1955. Most notably, she later assumed the role of his muse for the stunning portraits taken for *My Fair Lady* in 1965.

Beaton observed/worked from a certain distance; Richard Avedon often endeared himself to his subjects, as he did with Audrey, who recalled, "The first thing I

saw when I came to America was the Statue of Liberty. The second—Richard Avedon." At their initial session, during rehearsals for *Gigi*, Audrey first "learned to mask what she regarded as defects," as biographer Alexander Walker suggests. "Her jawline looked too determinedly set, her face too square when viewed full on. Thus the three-quarter profile, head ever so slightly angled so that her high cheekbones slimmed the lower part of her face, became a characteristic pose of Audrey's."

Avedon employed a selective blur, a white-out style, and athletic posing, all in evidence in his color work for *Funny Face* in 1956. He had previously photographed Audrey, with Ferrer, in 1954, for a *Bazaar* feature called "The Big Star," shot in both black and white and color. Audrey appeared on two *Bazaar* covers, April and October 1956, both by Avedon, as well as in much dazzling promotional photography.

A beguiling black-and-white fashion editorial was published in *Bazaar*'s April 1959 issue. Titled "Paris Pursuit," and featuring mischievous cameos by Zsa Zsa Gabor, Buster Keaton, and Art Buchwald, the piece imagines the story of Jemima Jones, a traveling actress, and her encounters with Texas millionaire Dallas O'Hara (Mel Ferrer). Audrey cavorts confidently in eighteen outfits from Christian Dior, Guy Laroche, and Pierre Cardin.

Vogue editor Diana Vreeland hired Avedon away from *Harper's Bazaar* in 1965 to realize her vision of the "youth quake" of the mid-sixties. He continued to photograph Audrey at intervals through the next three decades; it was always a feast of mutual admiration.

Richard Avedon and Irving Penn were said to be rivals when the two well-regarded photographers were both working at *Vogue* in the 1960s. Penn's first cover for the magazine was a still life of accessories for the October 1, 1943, issue; his painterly composition reflected his fine arts training. His portraiture was legendary—Pablo Picasso, Truman Capote, Marlene Dietrich, and Miles Davis sat for his camera. Audrey's first session with Penn was a black-and-white portrait for *Vogue* in 1951. Like his subject, Penn safeguarded his privacy, but his camera seemed to connect deeply with Audrey. "There is always an element of empathy toward . . . [whoever] is in the frame," he once commented. "We don't call them shoots here. We don't shoot people. It's really a love affair."

Working around the edges of the high profile and high fashion, Sid Avery specialized in documenting the private life of celebrities. Raised in Southern California, he was familiar with Hollywood photographers and the stars they shot for the studios and the magazines. Step by step he became a sought-after freelance photographer for *Life*, *Look*, *Collier's*, and the *Saturday Evening Post*. Avery photographed Audrey with Ferrer and Mr. Famous at home in Beverly Hills in 1957, and Audrey alone during a television appearance that same year.

Philippe Halsman fled Nazi Europe in 1940, with the aid of Albert Einstein. Over the next thirty years, he shot covers for every major American magazine, 101 of them for *Life*. He collaborated famously with Salvador Dalí for over three decades, beginning in 1941. Halsman's "celebrity jumps" became his signature dynamic; Audrey jumped for him in 1954, at once joyously and balletically.

Photographer Bob Willoughby had this recollection from his initial encounter with Audrey Hepburn: "I could never have guessed this when I first photographed her at Paramount Studios in 1953. The new girl in town. [Audrey] certainly was not the typical image of a young starlet, for that was what I had been sent to photograph. I watched her across the room as she was being photographed by Bud Fraker, and she did have something . . . but I couldn't quite put my finger on it until I was finally introduced to her. Then that radiant smile hit me right between the eyes, warming me inside like a shot of whisky. The amazing instant contact she made, a remarkable gift that everyone who met her felt. She exuded some magic warmth that was hers alone." Willoughby was born in Los Angeles, took to photography early on, studied at the University of Southern California film school, and apprenticed with master graphic designer Saul Bass. One of Willoughby's most unusual assignments came in 1957,

when he photographed Audrey at home and through a day out in Beverly Hills, with Ip, the *Green Mansions* deer, as her constant companion.

Legendary lensman Milton H. Greene took pictures of Audrey in her *Gigi* costume on Broadway, and in Malibu for *Look* magazine in 1953. Norman Parkinson photographed her at "La Vigna," her rented villa in Rome, against a wall of fuschia bougainvillea for *Glamour* magazine in August 1955. George Daniell shot on set for *War and Peace*; Sam Shaw did the same for *Love in the Afternoon*; and Leo Fuchs for *The Nun's Story* in Belgium and the Congo. During the filming of *Sabrina*, Mark Shaw took photos of Audrey on set at Paramount and at her apartment on Wilshire Boulevard; Dennis Stock documented the same picture on location on Long Island in 1953. Angus McBean, in 1950, created an exceptional series of surrealist depictions of Audrey; and the same year Edward Quinn escorted her to the beach in Monaco for outdoor shots. These are just some of the fortunate photographers who appreciated the singular opportunity to work with a one-and-only.

Of this lengthy list, Richard Avedon gets the last word: "I am, and forever will be, devastated by the gift of Audrey Hepburn before my camera. I cannot lift her to greater heights. She is already there. I can only record. I cannot interpret her. There is no going further than who she is. She has achieved in herself her ultimate portrait."

Resonance
To Ralph Lauren, Audrey once confided, "I never thought I was pretty." And yet, looking back, as *Roman Holiday* was in preproduction, when Paramount offered to pay for the capping of some crooked teeth, she refused. She also wouldn't allow the makeup assistant to tame her heavy brows. Audrey was a lovely contradiction, one on her own terms.

From the release of *Roman Holiday* through to the promotion and premiere of *Sabrina*, Audrey became the epicenter of a shift in perception, an optical and figurative adjustment. In 1954 *Vogue* posited her as "today's wonder-girl. . . . She has so captured the public imagination and the mood of the time that she has established a new standard of beauty, and every other face now approximates the 'Hepburn look.'" Audrey would be photographed as the perfect mannequin, hers the implied signature on the dotted line of the latest fashion editorial. Her friend and colleague Stanley Donen noted, "Audrey was always more about fashion than movies or acting." She would have felt shortchanged by such a summing-up but would have graciously understood the observation.

Audrey's refreshing image was the antithesis of the bosomy, curvy, blatantly sexy presence of a certain newly minted star (and her copyists). *Silver Screen* proposed that Audrey was "changing Hollywood's taste in girls," while *Photoplay* described her as "altogether un–Marilyn Monroe-ish. And yet . . . Audrey Hepburn is the most phenomenal thing that's happened to the film capital since Marilyn Monroe."

Hollywood now had two starry options, with diverging essences: the breathless sensuality of the powdery, pillowy Monroe, or the sleek, stylish, sexy angularity of Hepburn. Marilyn led with her lips; Audrey captivated with her eyes—and both remain to this day the cinema's most popular and beloved female icons.

Designers were thrilled; a true movie star could wear their clothes right off the catwalk, in the pages of *Harper's Bazaar*, on the city streets, shopping, dining, dancing, receiving an award, as no other screen actress had been able to do before. Ralph Lauren has stated that Audrey "did more for the designer than the designer did for her."

At that time, it was designer Givenchy that Audrey depended upon, a loving brother-sister relationship, with business on the side. In January 1957 Hubert presented Audrey with a gift of perfume, a delicate, sophisticated scent formulated just for her, which she instantly adored. When a proposal was made to offer the fragrance to the public, she protested, "Mais, c'est interdit!" She soon consented, becoming the face of the fragrance in print advertisements that whispered, "Once she was the

only woman in the world allowed to wear this perfume." Fragrance expert Marian Bendeth writes, "L'Interdit was the first real celebrity perfume. She had class. . . . You have it or you don't, and Audrey had it in spades." She proved that by never taking any percentage or payment for the association, even though the scent was a best seller for years.

Today, and ever since magazines included those mesmerizing fragrance ads and Audrey-centered fashion features, the couture community has held her up as a role model. Few actresses continue to provide fashion inspiration that is attainable and can be adapted to the girl on the street and in the workplace—certainly not Monroe, with her shellacked visage and glittery Travilla creations in pleated lamé. Sporty outfits are assembled à la *In Style* to recall the runaway princess, the ballet-slippered Sabrina, or the black-clad Beat dancer (a clip retooled to sell Gap pants in 2006). The skinny capris, the wrapped and tied men's shirt, the Belgian loafers, the boatneck tee, the little scarf, and the oval drop earrings form fashion collages, their current counterparts available in stores or online. Evening dresses quoting the cut, the length, the volume of Audrey's designer originals still fill pages in *Elle* or *Marie-Claire* with more affordable ready-to-wear recommendations. Isaac Mizrahi declared to *Interview* magazine that Audrey "immortalized those clothes."

Audrey's mid-fifties pixie haircut is a style that returns every few years, like clockwork, grabbing press as an actress or model gets sheared to resemble Audrey, intentionally or not. The dense eyebrow is also cyclical, the results not always pure Hepburn, but the reference holds. Her powderless finish and dark lined eyelids still inspire. The kitten heels—the simple pump with the 3.5 cm heel—also reappear regularly, perhaps in a season that is reacting to superhigh stilettos rising ever higher. Audrey reset footwear fashion, but for practical purposes: to feel smaller, to de-emphasize her size 8 foot, to remain comfortable while retaining a sense of formality and sophistication.

Years of ballet, she said, had "wreaked havoc on my feet—high heels were too painful."

On a more whimsical note, doll collectors and Audrey fans have been able to grace their shelves with the Hepburn version of Mattel's Barbie doll, attired in small-scale re-creations of Givenchy or Edith Head. Asia has its squat, huge-headed, and funny Pullip dolls, with Audrey options. From back as far as the mid-fifties, Audrey always seemed the best among the movie-star paper doll books. Audrey's example emanates even from a paper gown with tabs at the shoulder, secured over a simple line drawing in her likeness.

"Simplicity was her trademark," Audrey's friend Leslie Caron remembers. "She had the originality never to wear any jewelry, and this at the time of double rows of pearls, little earrings, lots of little everything. . . . And then suddenly she would appear at a premiere wearing earrings that reached down to her shoulders. Really daring!" Known for adorning herself in marvelous clothes, Audrey claimed, "The beautiful dresses always seemed like costumes to me. I knew I could carry them off, but they weren't my attire of choice. That would be old jeans or pants that I could garden in."

Audrey Hepburn's Cinderella tale tells a personal version of happily ever after—the charming girl transformed into the elegant woman who became a legend of grace and compassion. The person behind the icon was the mother of two sons, lived what she believed, and found a sense of serenity, traveling and serving tirelessly as Goodwill Ambassador of UNICEF in support of child health, welfare, and education. Later in life Audrey spoke of her Hollywood years: "I am proud to have been in a business that gives pleasure, creates beauty and awakens our conscience, arouses compassion, and perhaps most importantly, gives millions a respite from our so violent world." We would have expected no less.

David Wills
Los Angeles, 2016

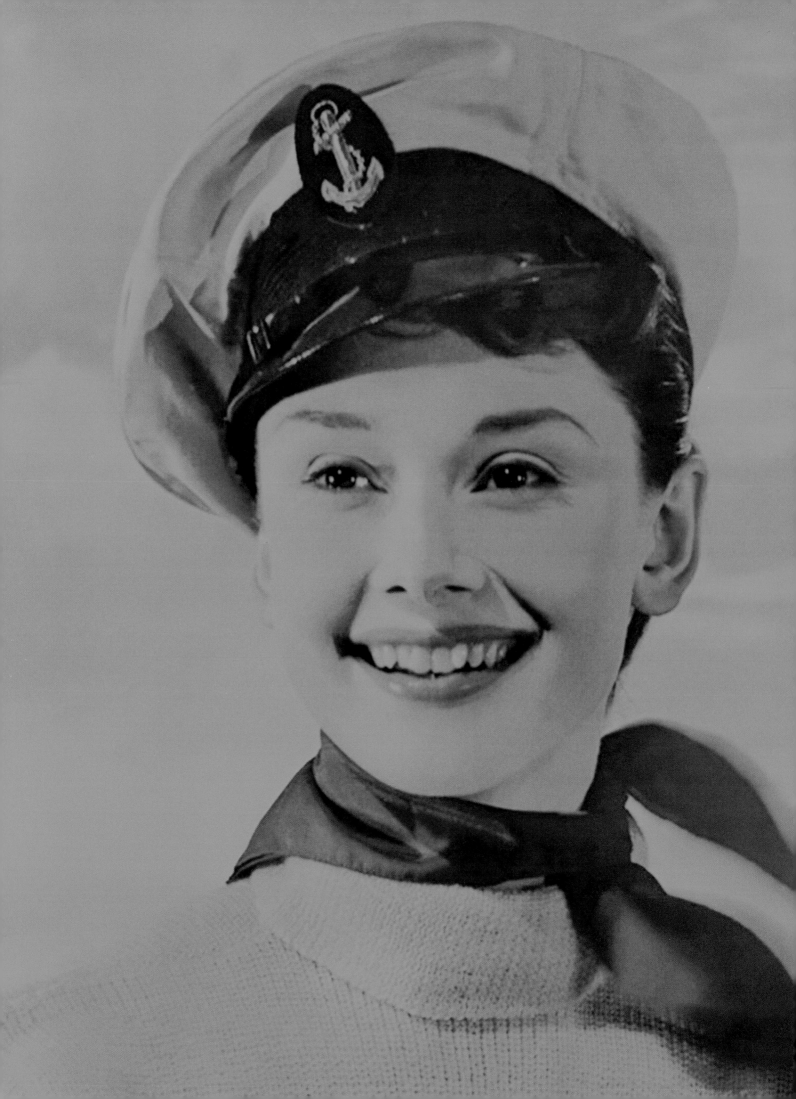

Audrey Ingénue

1950 – 1952

A young, beautiful, and glowing Audrey Hepburn on the brink of success, circa 1950. Original news caption: "While Britain shivers in wintry chill and busses skid on snow-covered streets this laughing-eyed Audrey Hepburn skips out of her studio and goes tobogganing at Elstree, Herts [Hertfordshire, England]."

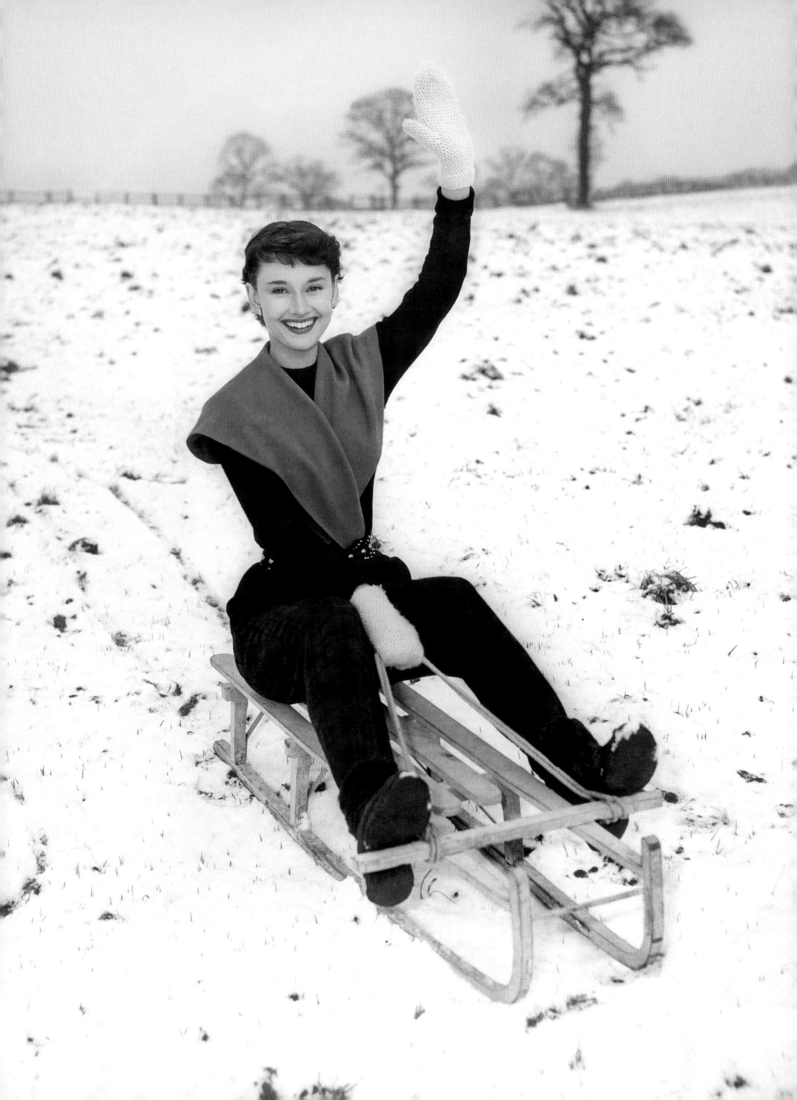

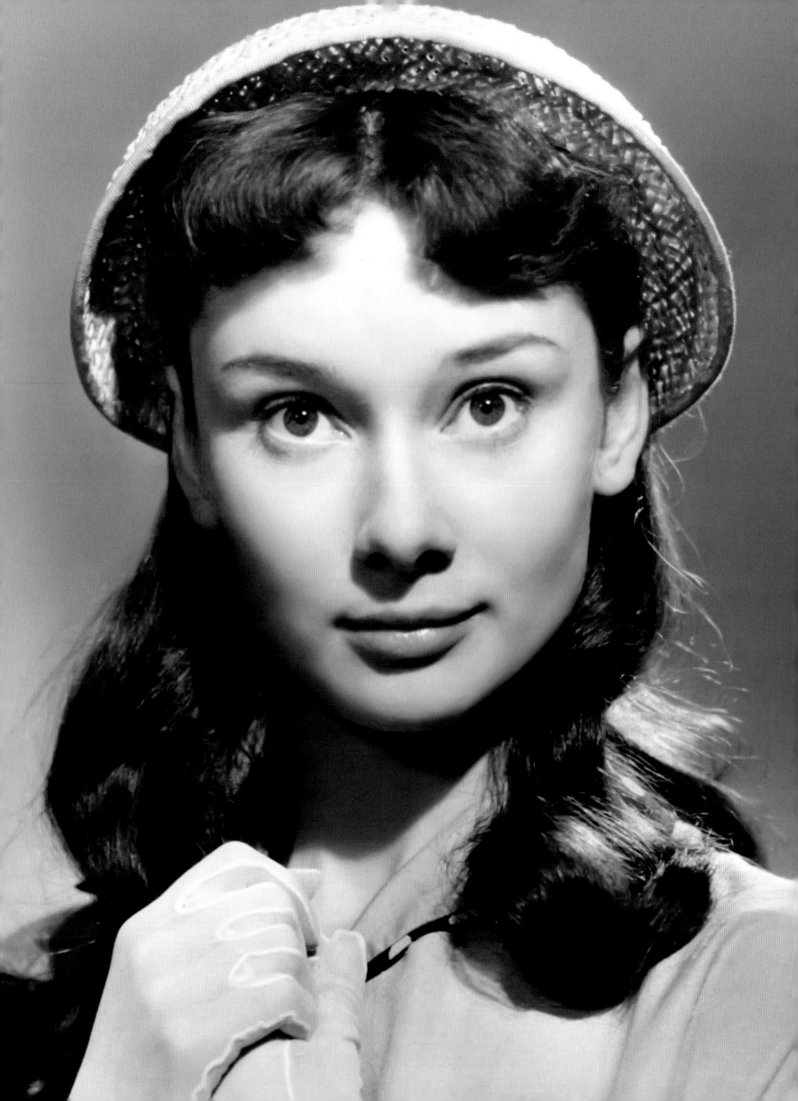

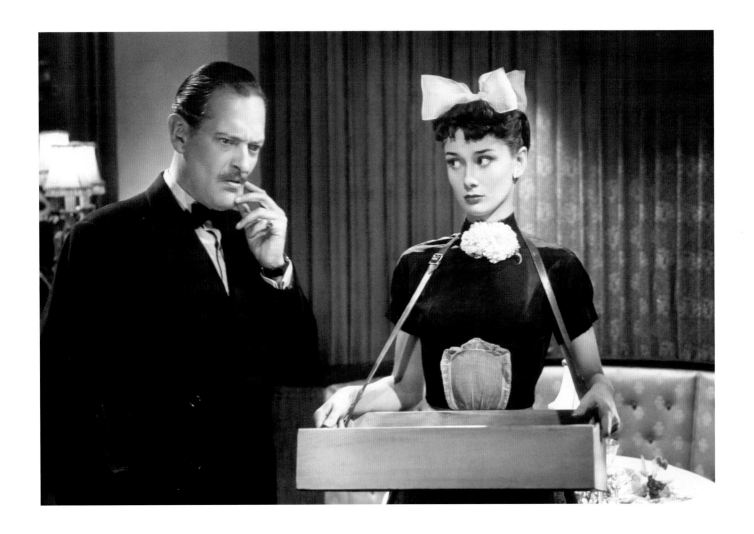

"I remember when Gilbert Miller [the producer of *Gigi* on Broadway] asked me to change my name so that I wouldn't be confused with Katharine Hepburn. My name! I had no trouble getting rid of Edda, but Hepburn was my blood. I had to say 'no.' In the end I was respected for knowing what I wanted and not wavering."

AUDREY HEPBURN

OPPOSITE In 1950 Audrey was registered as a freelance actress with the Associated British Picture Corporation. Her first film for them was *One Wild Oat* (1951), where she appeared in a bit part as a hotel receptionist. Other notable bit players in the film included James Fox and future 007 Roger Moore. **ABOVE** Another bit part, this time as Frieda, the sexy cigarette girl in the British comedy *Laughter In Paradise* (1951).

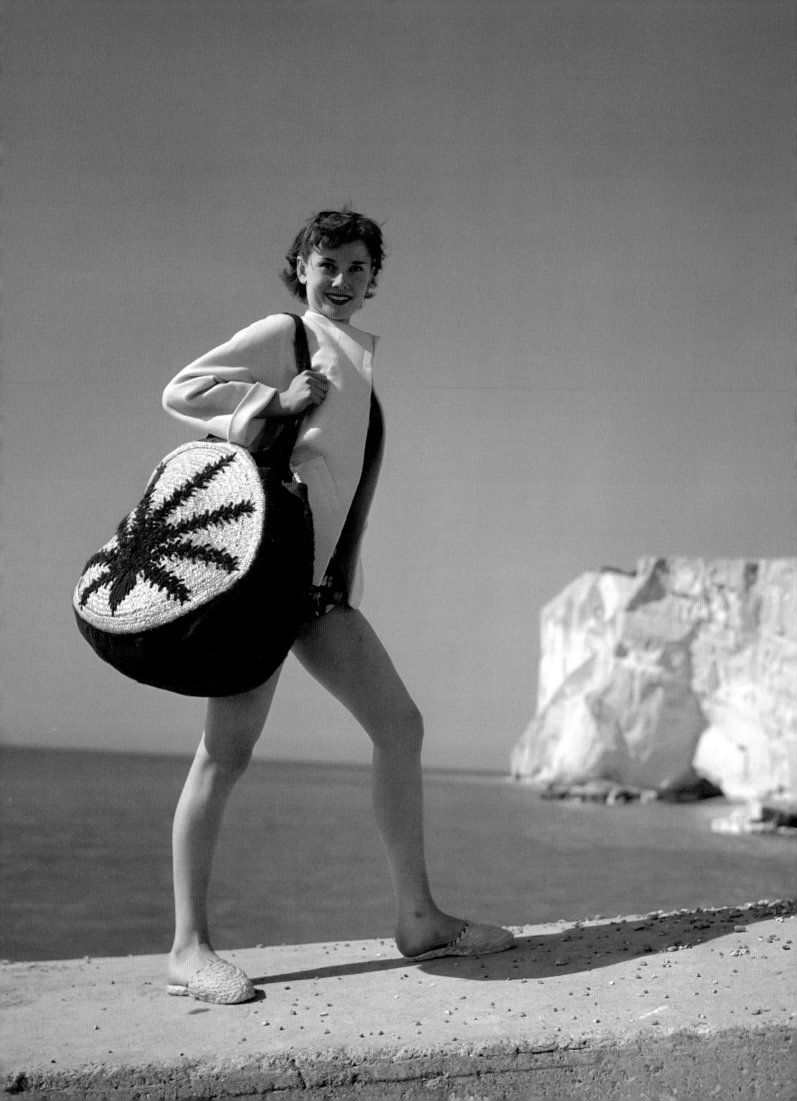

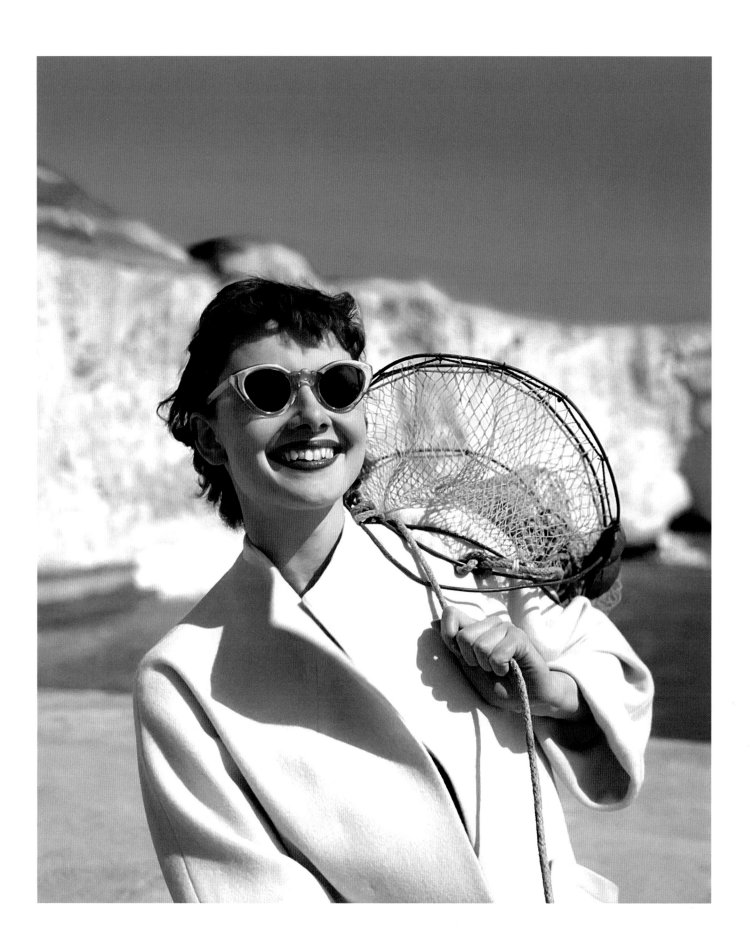

OPPOSITE AND ABOVE Audrey on the beach at Rottingdean, East Sussex, England, circa 1951.

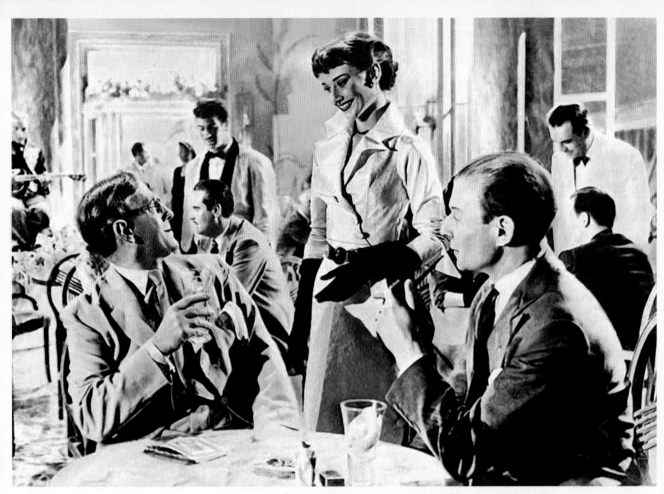

The J. Arthur Rank Organisation presents A MICHAEL BALCON PRODUCTION

THE LAVENDER HILL MOB

ALEC GUINNESS
STANLEY HOLLOWAY as
SIDNEY JAMES, ALFIE BASS

Directed by CHARLES CRICHTON. Original Screenplay by T. E. B. CLARKE Made at EALING STUDIOS

PRINTED IN ENGLAND

"She only had half a line to say, and I don't think she even said it in any particular or interesting way. But her faunlike beauty and presence were remarkable."

ALEC GUINNESS (Costar, *The Lavender Hill Mob*, 1951)

ABOVE Lobby card for *The Lavender Hill Mob* (1951), Audrey's first appearance in a major film. She had originally been considered for a larger role but was unavailable; however, Alec Guinness was so impressed with her that he arranged for her to appear in a bit part, as Chiquita. **OPPOSITE** Audrey with costar Nigel Patrick in the British comedy *Young Wives' Tale* (1951).

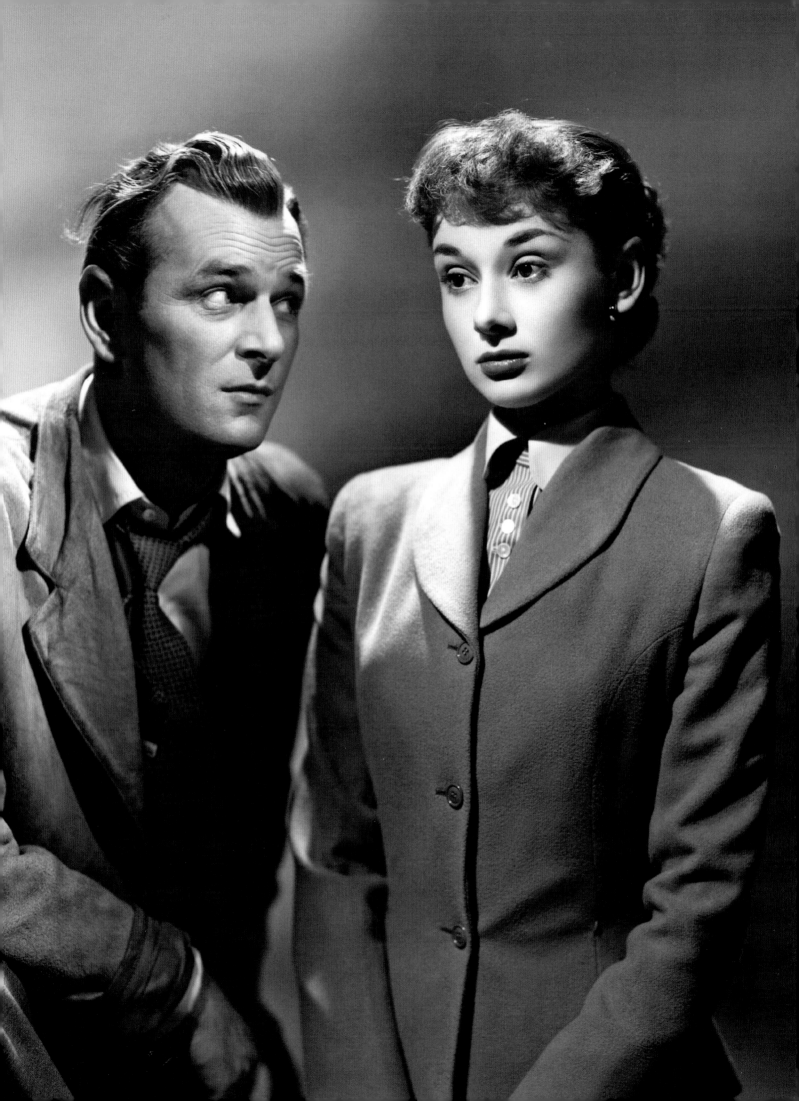

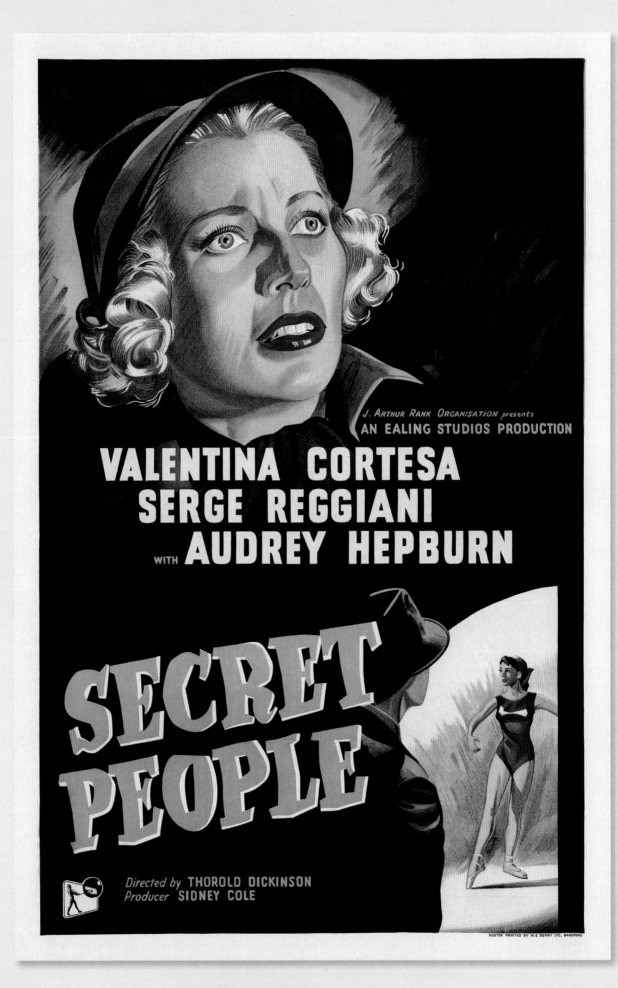

ABOVE Film poster for *Secret People* (1952).

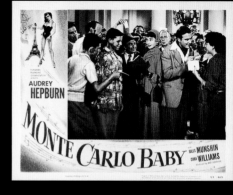

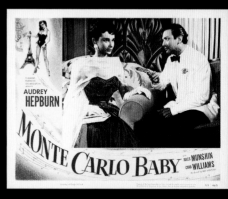

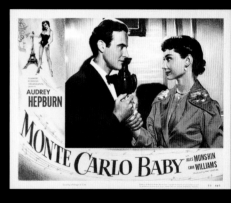

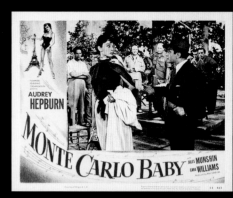

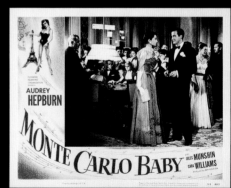

Film poster (Italy) and lobby cards for *Monte Carlo Baby* (1952). It was during the filming of this movie that Hepburn met French novelist Colette, who recommended her for a stage version of her novel *Gigi*.

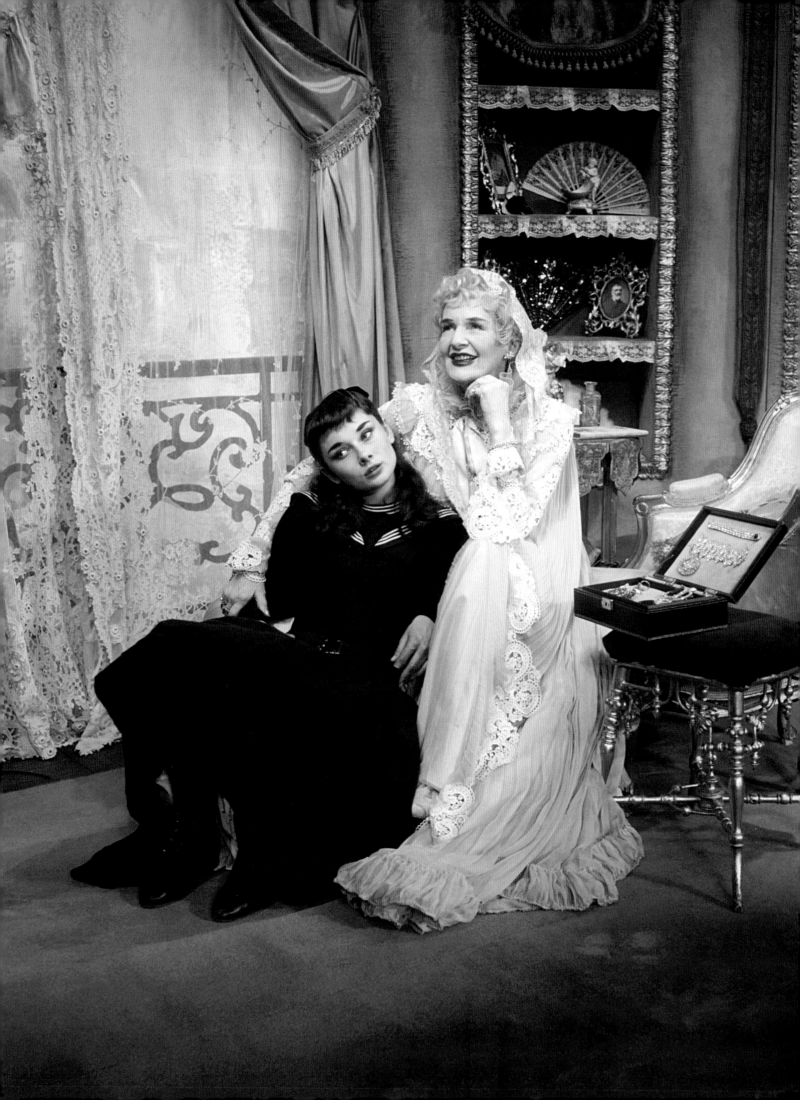

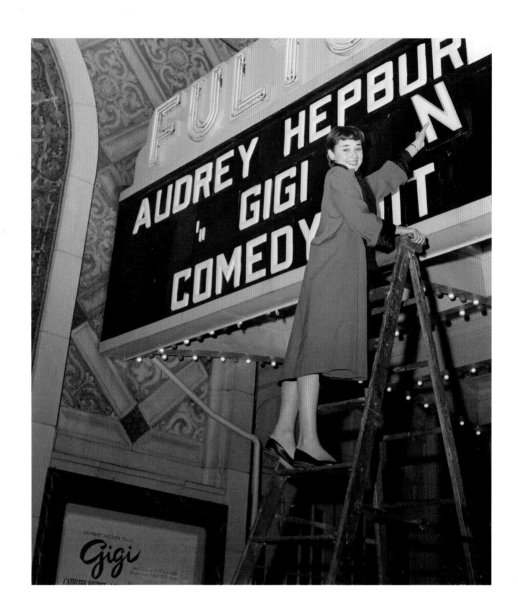

"During my first days of rehearsal, I couldn't be heard beyond the front row. I worked day and night. Every night I would go home and speak each word clearly and loudly. I could be heard at last."

AUDREY HEPBURN (On preparing for her role in *Gigi*)

OPPOSITE Audrey and costar Cathleen Nesbitt in *Gigi* on Broadway, 1951. The play was based on Colette's 1944 novel of the same name. **ABOVE** Original news caption: "New York, New York—With a triumphant opening night behind her, Audrey Hepburn places her name on the top of the theater's marquee. The Belgian-born actress, who was appearing on Broadway for the first time, scored in the title role of a new version of the perennial comedy *Gigi*. With her first show a hit, 22-year-old Audrey has been elevated to the rank of 'star.'"

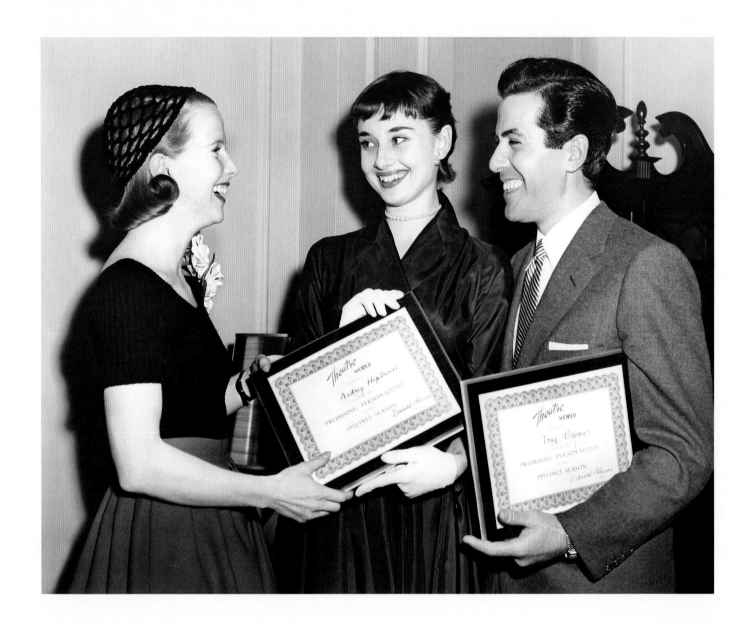

"Miss Hepburn is as fresh and frisky as a puppy out of a tub. She brings a candid innocence and a tomboy intelligence to a part that might have gone sticky, and her performance comes like a breath of fresh air in a stale season."

WALTER KERR (*Gigi* review, the *New York Herald Tribune*, November 25, 1951)

ABOVE Actress Julie Harris presents Audrey and Tony Bavaar with citations for "Most Promising Personalities of the Broadway Stage," May 20, 1952. **OPPOSITE** On a break from her success on Broadway in *Gigi*, Audrey and her fiancé James Hanson take in the sights at Rockefeller Center in New York, December 4, 1951.

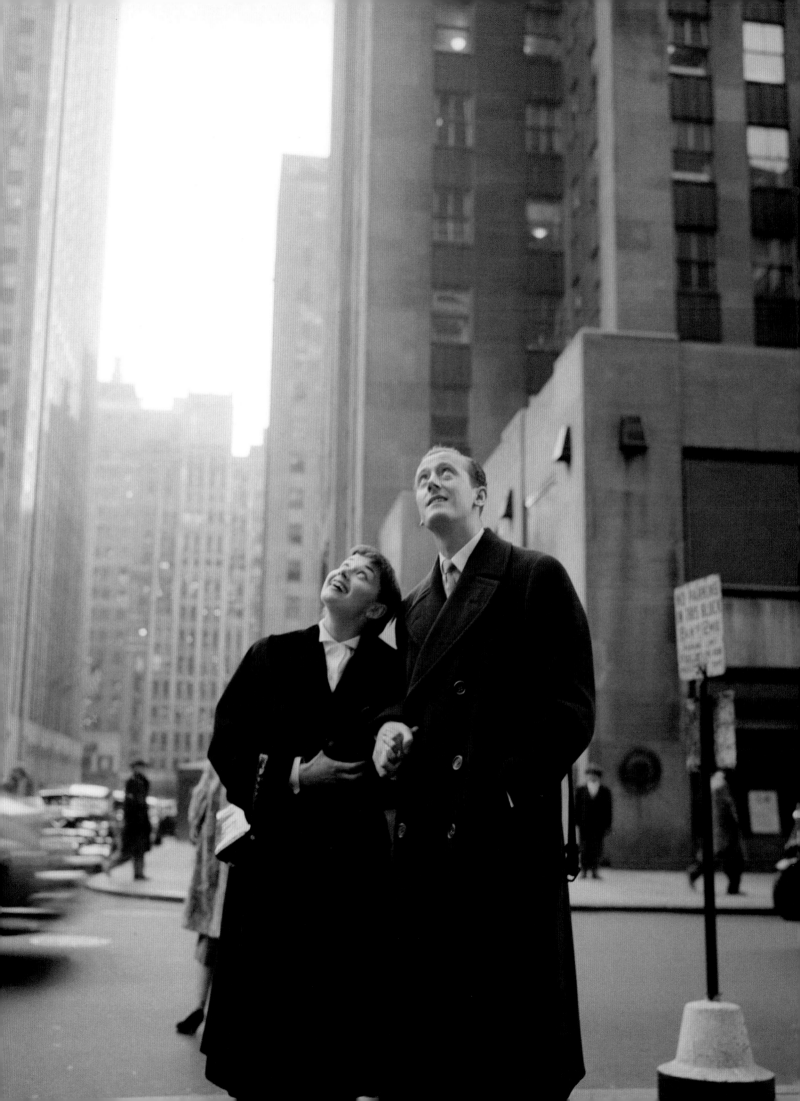

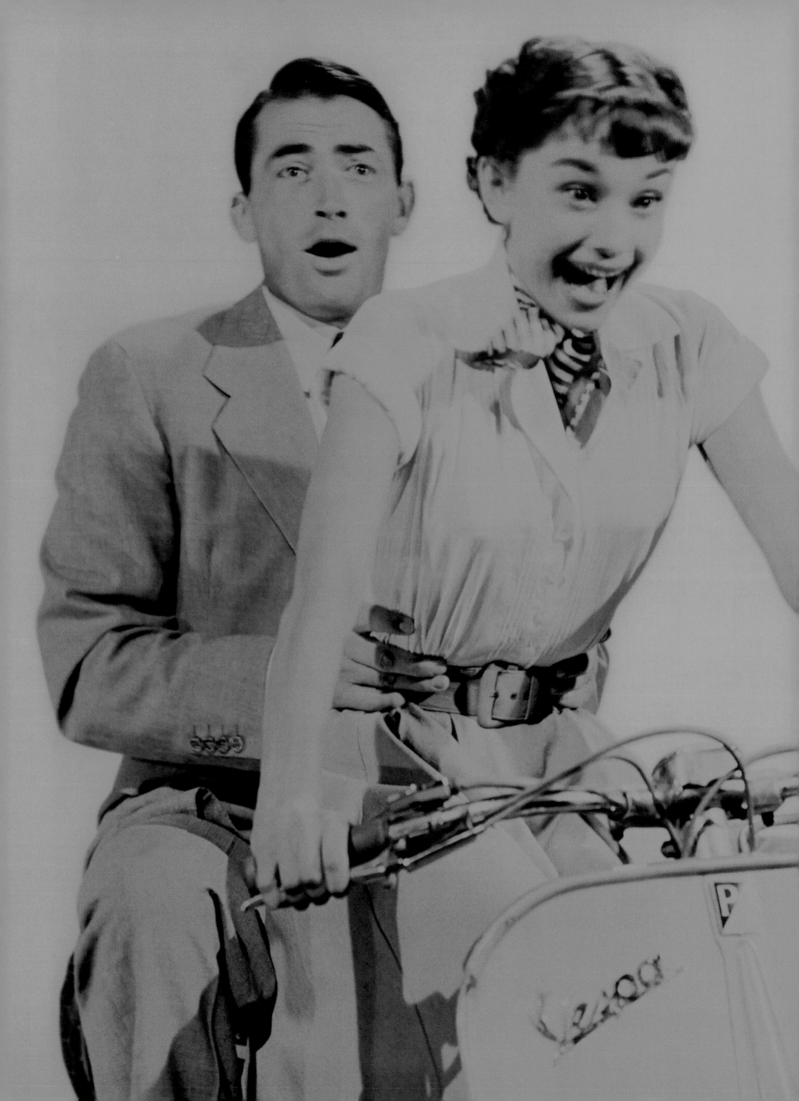

Roman
Holiday

1953

Eddie Albert as Irving Radovich, Gregory Peck as Joe Bradley, and Audrey Hepburn as Princess Ann in *Roman Holiday*. Directed by William Wyler, Paramount, 1953. (Photo courtesy Independent Visions/MPTV.)

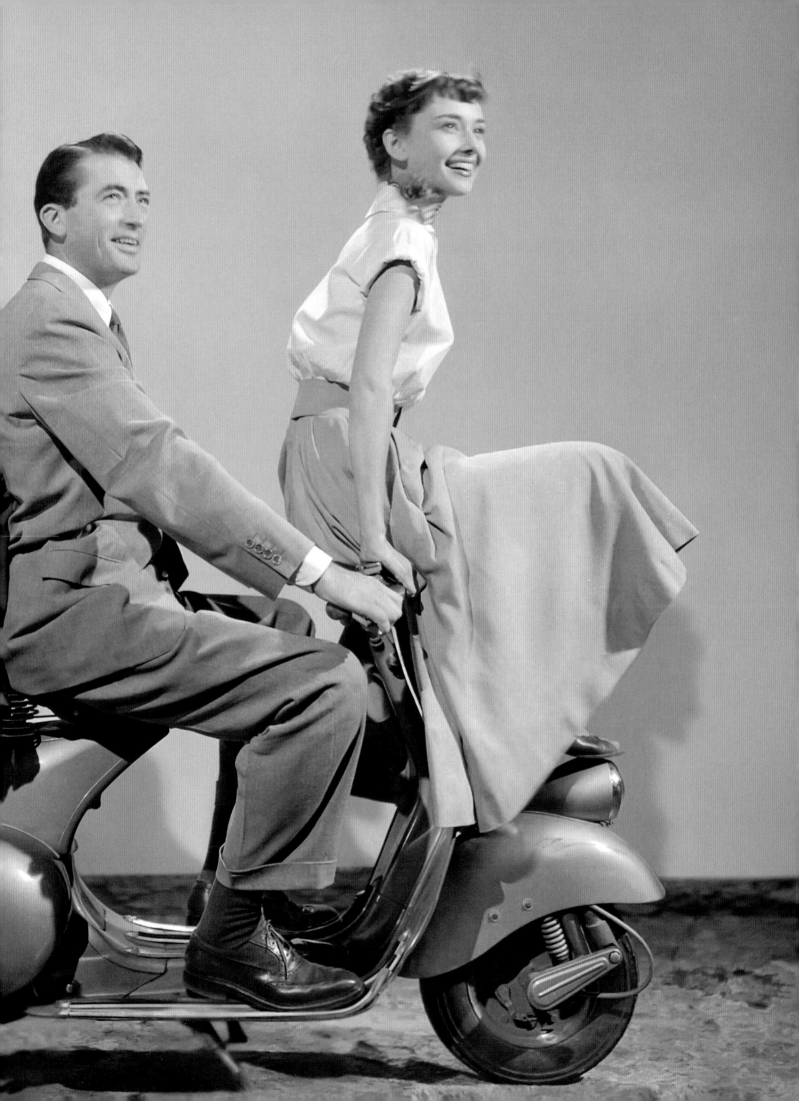

PARAMOUNT PRESENTS

gregory
PECK

audrey
HEPBURN

IN

WILLIAM WYLER'S

PRODUCTION OF

Roman
Holiday

WITH EDDIE ALBERT

SCREENPLAY BY
IAN McLELLAN HUNTER AND JOHN DIGHTON
STORY BY IAN McLELLAN HUNTER
PRODUCED AND DIRECTED BY WILLIAM WYLER

Paramount Pictures
A PARAMOUNT PICTURE

"Once you saw that sweet little girl in action, you knew that you were dealing with a volcano of talent. Anybody who worked with her saw that…. Everyone on the *Roman Holiday* set was in love with Audrey. We did that one picture together and I think it was the happiest experience I ever had on a movie set…. [There was] nothing mean or petty about her. I liked her a lot; in fact, I loved Audrey. It was easy to love her…. [Many thought of her] as regal—but I like to think of her as spunky."

GREGORY PECK (Costar, *Roman Holiday*, 1953)

OPPOSITE AND RIGHT Film poster and lobby cards for *Roman Holiday*.

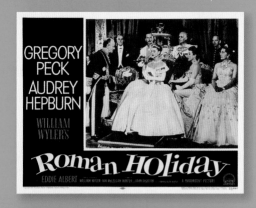
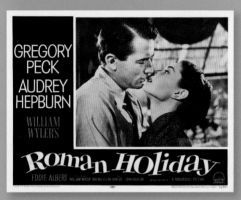
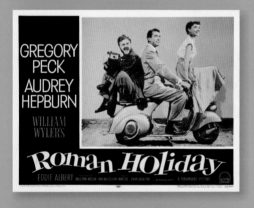
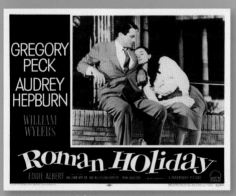
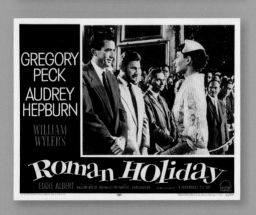

"She had everything I was looking for: charm, innocence, and talent. She also was very funny. She was absolutely enchanting and we said, 'That's the girl!'... She completely looked the part of a princess. A real, live, bona-fide princess. And when she opened her mouth, you were sure you'd found a princess. The one variable was: 'Could she act like a princess?'"

WILLIAM WYLER (Director, *Roman Holiday*)

Audrey with director William Wyler on the set of *Roman Holiday*, Cinecittà studios, Rome.

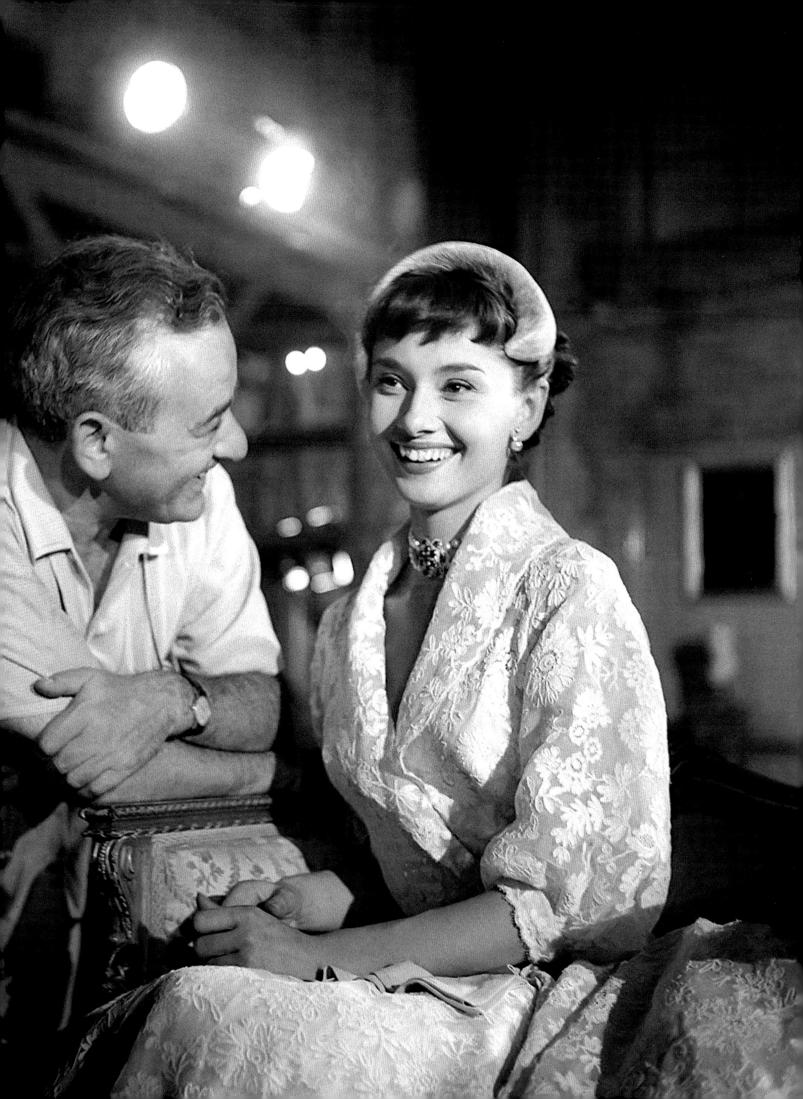

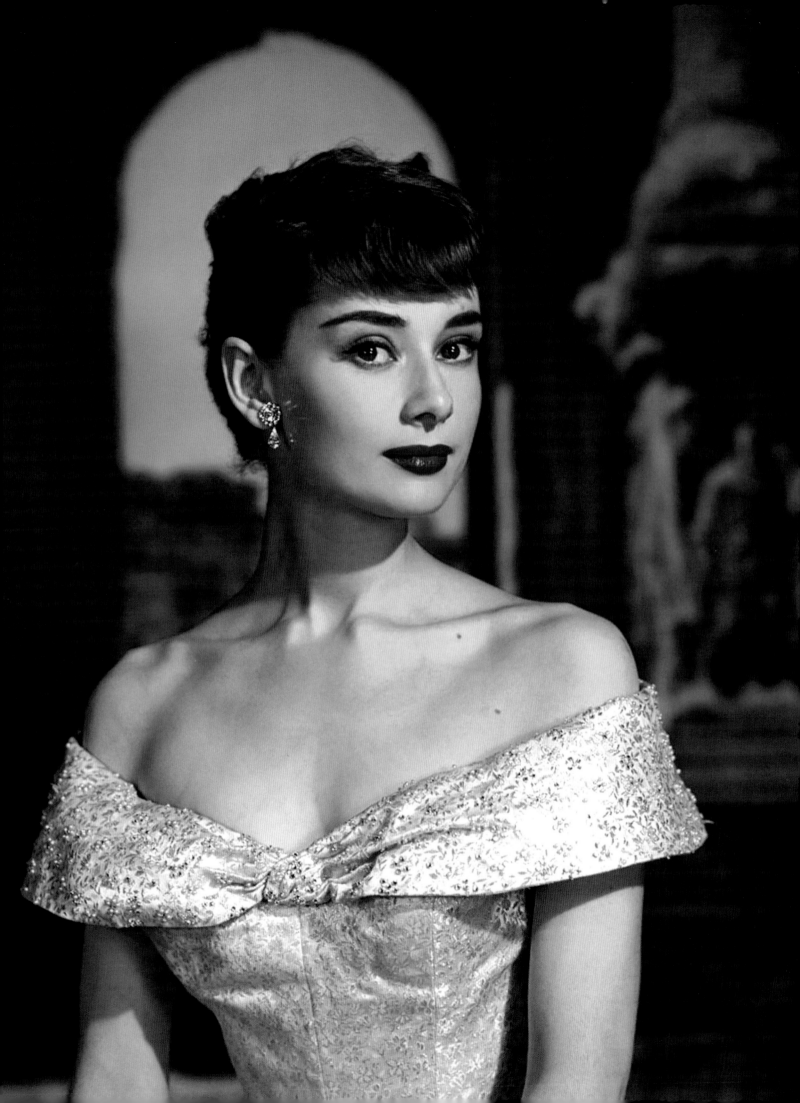

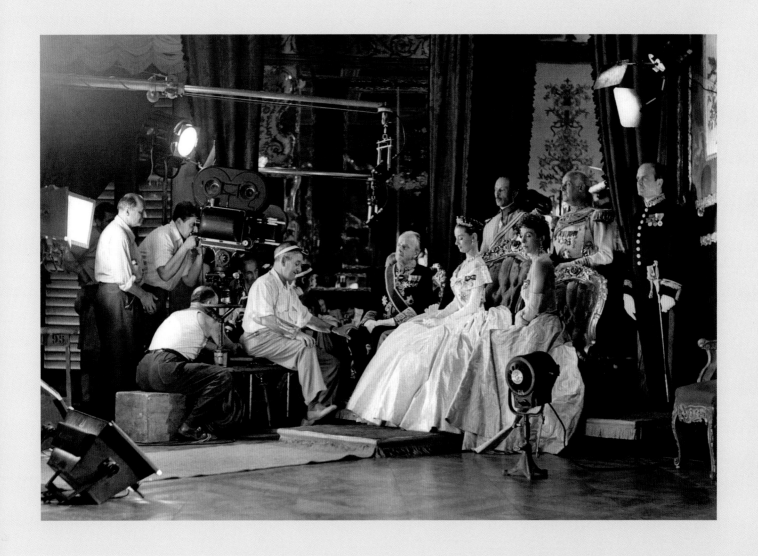

"Audrey plays Her Royal Highness Princess Ann, and the first time she appears on screen she is regally dressed in a brocade gown with the correct jewels, the correct orders, even the correct gloves. She is the epitome of royal protocol; everything about her is flawless. In true Hollywood form she hates her state of affairs and wants to be free of her crown and everything that goes along with it. She runs away from the palace and becomes something of a street urchin."

EDITH HEAD (Costume Designer, *Roman Holiday*)

OPPOSITE Audrey as Princess Ann. **ABOVE** Audrey with director William Wyler and costars Tullio Carminati and Margaret Rawlings on the set of *Roman Holiday*, Cinecittà studios, Rome.

"The costuming was very important in this film—it told the story. First she was a fairy-tale princess, then she became a sporty, wild, happy, very real person who had no regard for her appearance. The simpler the clothes, the better for Audrey. I tried to design things that would accentuate the novel qualities of her body. I called attention to her long neck so that people began to describe her as 'swanlike' and 'graceful.'… I emphasized her broad shoulders to draw the eye up toward her face…. And instead of trying to pad her hips, I put her in skin-tight pants. I didn't try to use camouflage on Audrey or to make her look like something she was not. Isn't it interesting that the Audrey Hepburn look, the reed-slim silhouette, is still the most sought-after look?"

EDITH HEAD (Costume designer, *Roman Holiday*)

OPPOSITE Costume sketch by Edith Head. **OVERLEAF** Original news caption: "Gregory Peck, second from left, talking to an unidentified man, then Mrs. Peck, Eddie Albert, Hollywood actor now vacationing in Rome, and Audrey Hepburn, leading lady of film *Roman Holiday* now being directed by William Wyler, for whom the birthday party was given in Rome, Italy, on July 1, 1952. Peck is not working yet on the picture but came along with his wife to cheer his director-to-be. (Photo by Mario Torrisi.)"

Audrey
Hepburn "Roman Holiday"
 1953

Edith Head

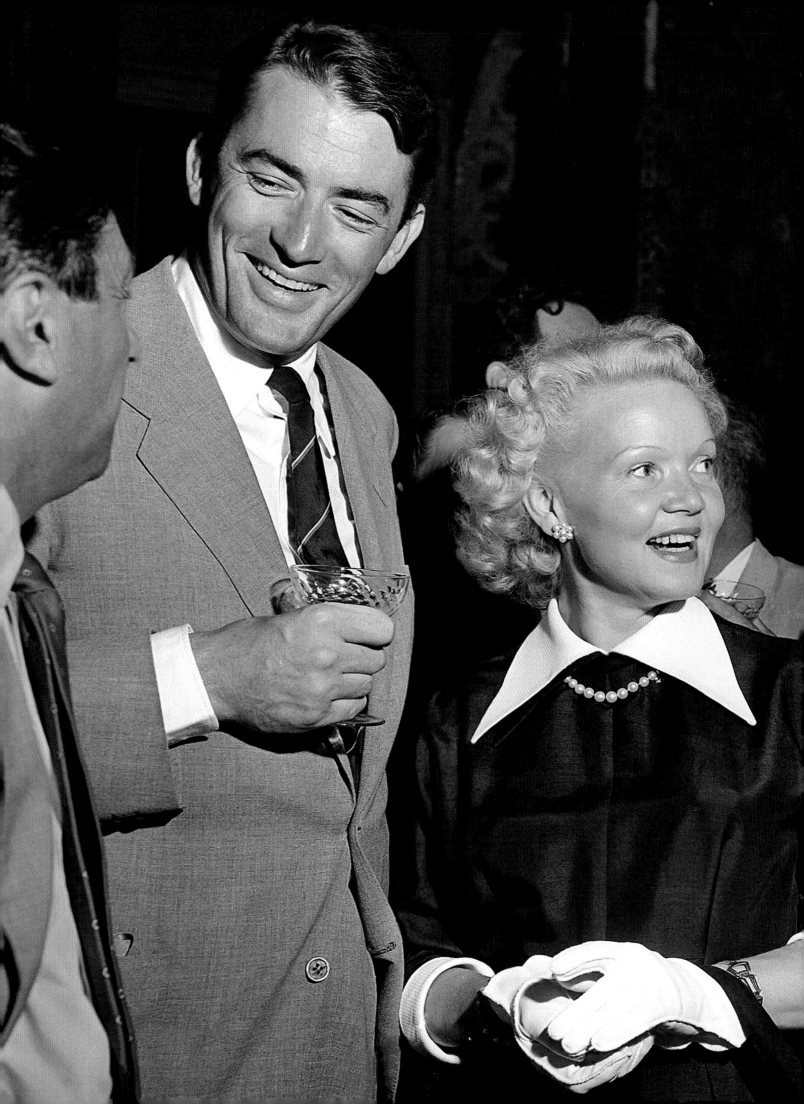

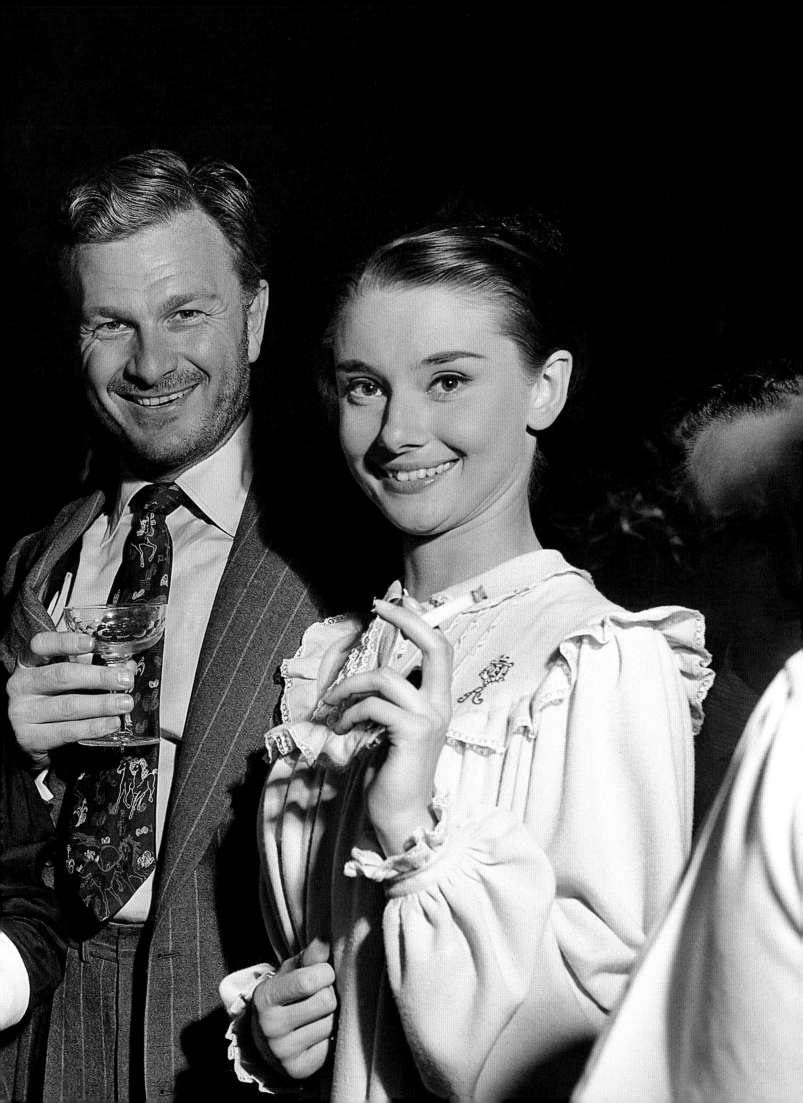

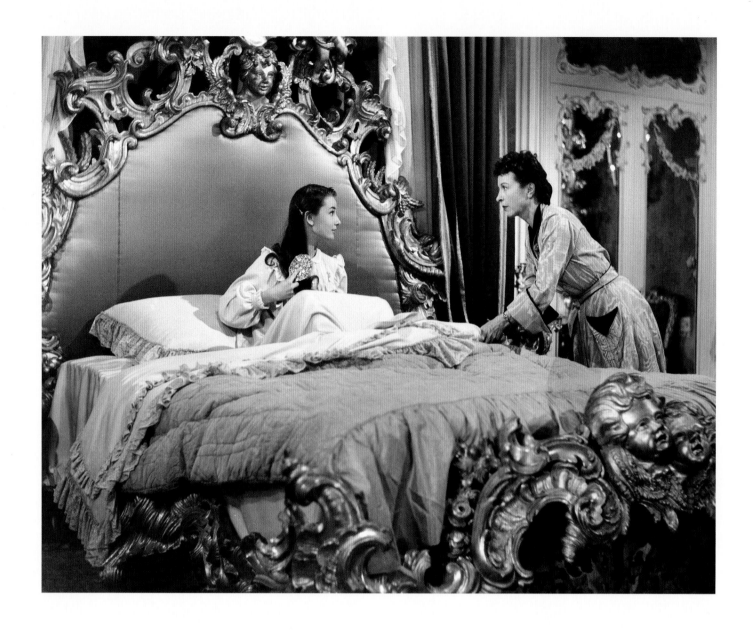

"I ate everything in sight.... You know, whole boxes of chocolates. I was ten pounds more than I had ever weighed in my life. It's funny to think I might not have gotten the part [in *Roman Holiday*] because I was too fat, because from then on everybody thought I was too thin."

AUDREY HEPBURN

ABOVE Audrey with costar Margaret Rawlings as Countess Vereberg, *Roman Holiday*. **OPPOSITE** Audrey as Princess Ann receives a transformative—and liberating—new hairdo from Paolo Carlini as barber Mario Delani.

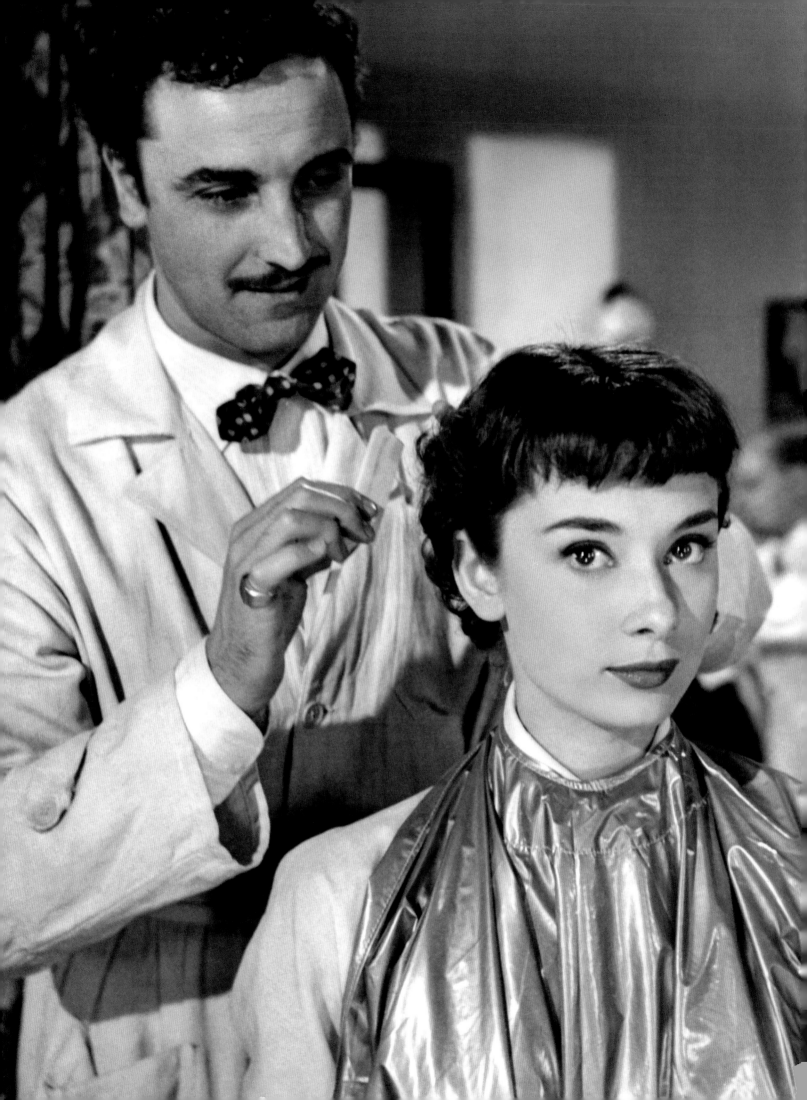

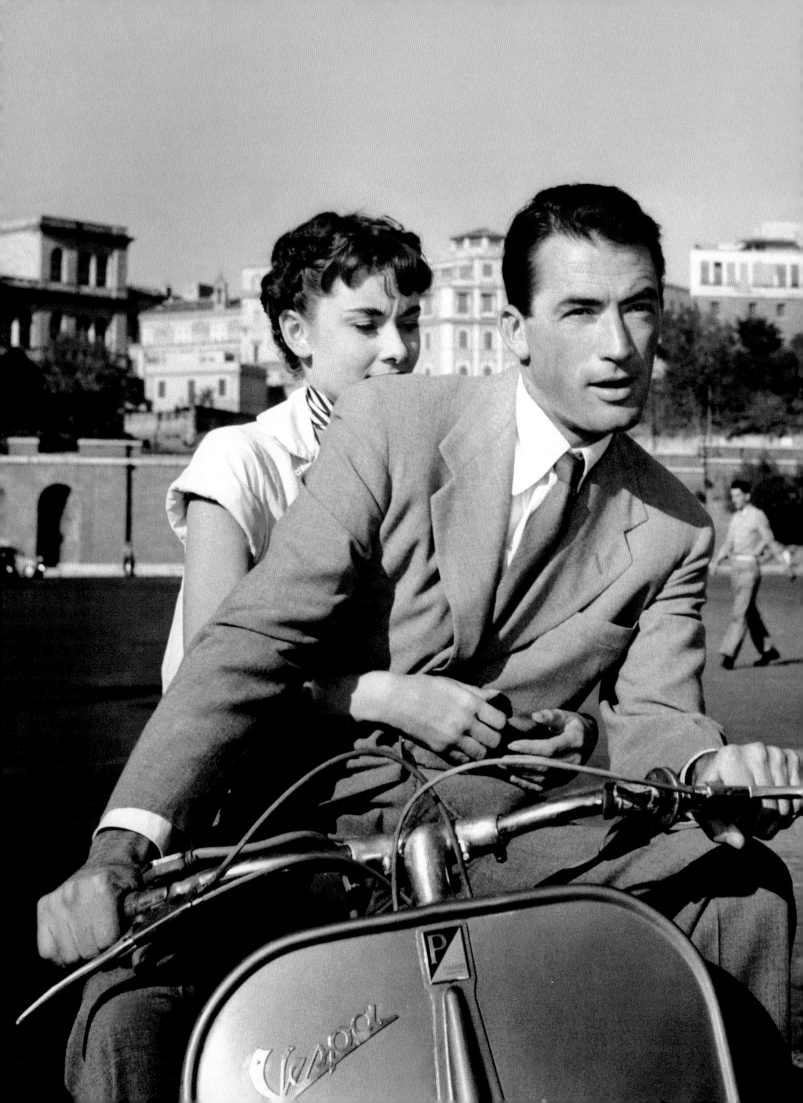

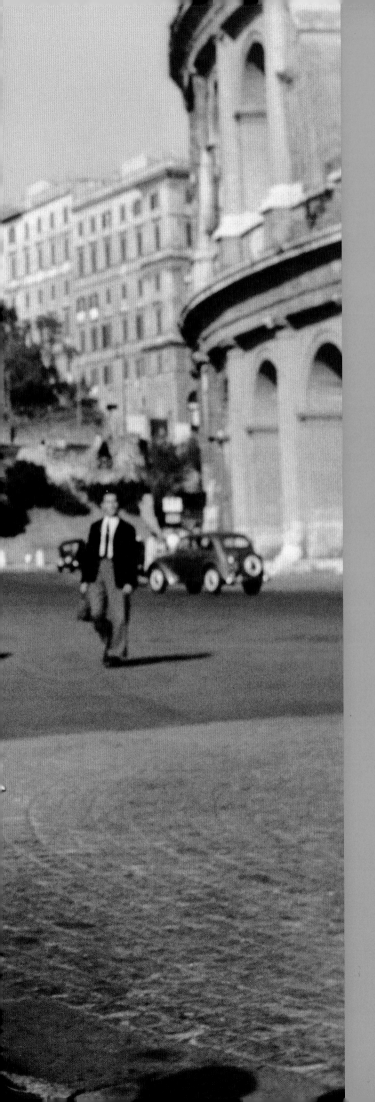

"She was as funny as she was beautiful. She was a magical combination of high chic and high spirits."

GREGORY PECK

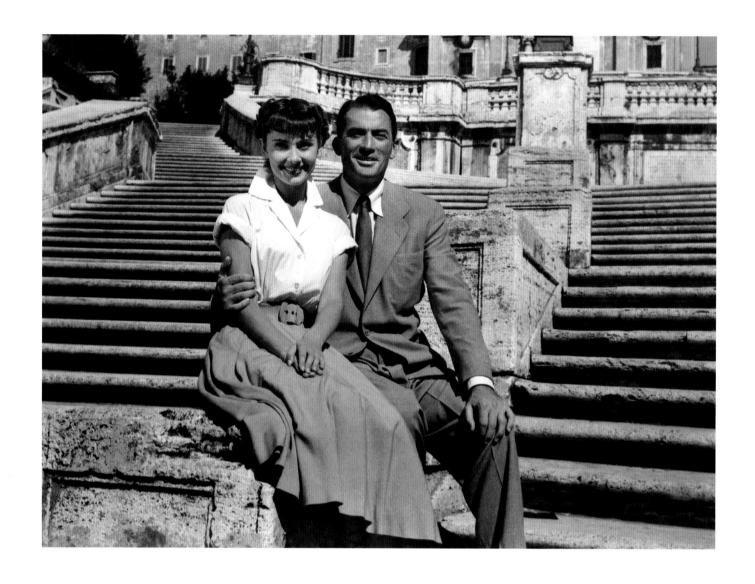

"Gregory always put me at ease before starting a scene. It was a happy company, without anybody going temperamental or putting up emotional barriers. I soon learned to relax, to look for guidance from Peck and Wyler. I trusted them, and they never let me down."

AUDREY HEPBURN

ABOVE AND OPPOSITE Audrey with costar Gregory Peck on the Spanish Steps in front of Trinità dei Monti church, Rome.

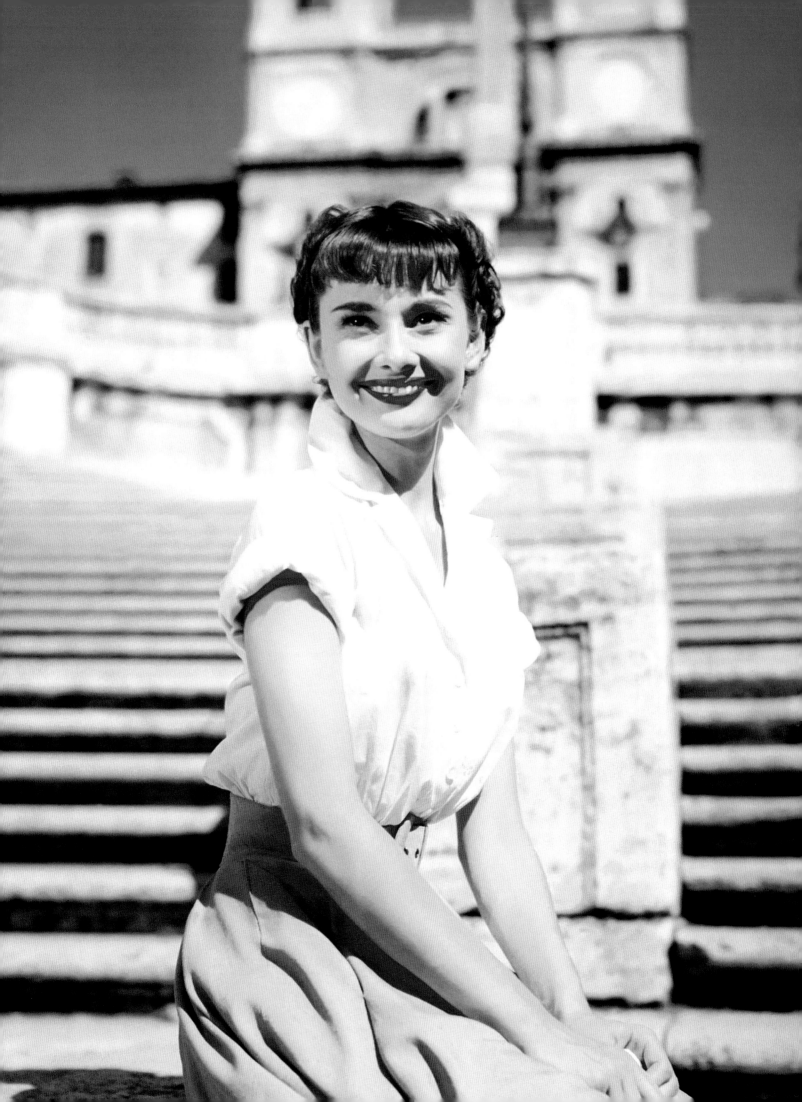

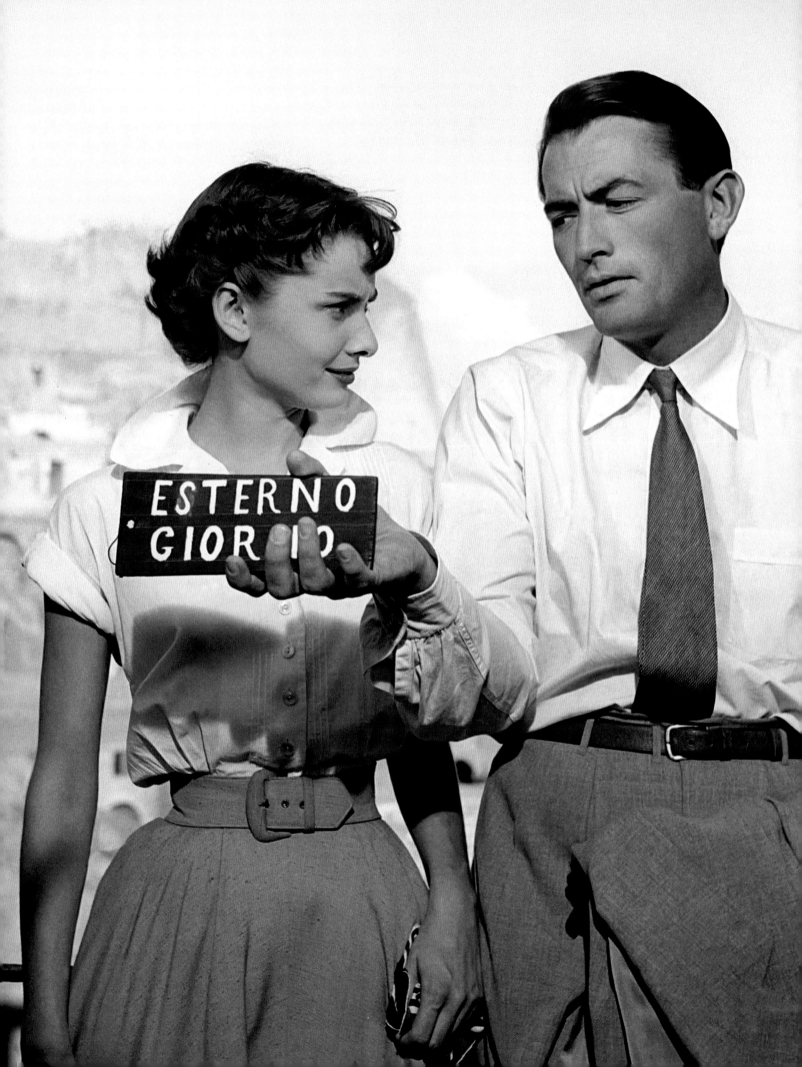

"The police couldn't stop them from whistling and heckling. A gallery of about 5,000 Italians, every one a critic and an actor. For Audrey and me, it was like acting in a huge amphitheatre before a packed house of rowdies. I asked her if she didn't find it very intimidating. Ah no, not at all. She believed her role. She took it as calmly and serenely as a real princess would have."

GREGORY PECK

Audrey with costar Gregory Peck, who is holding a sign indicating that the scene being photographed is exterior daytime, during a lighting test for *Roman Holiday*.

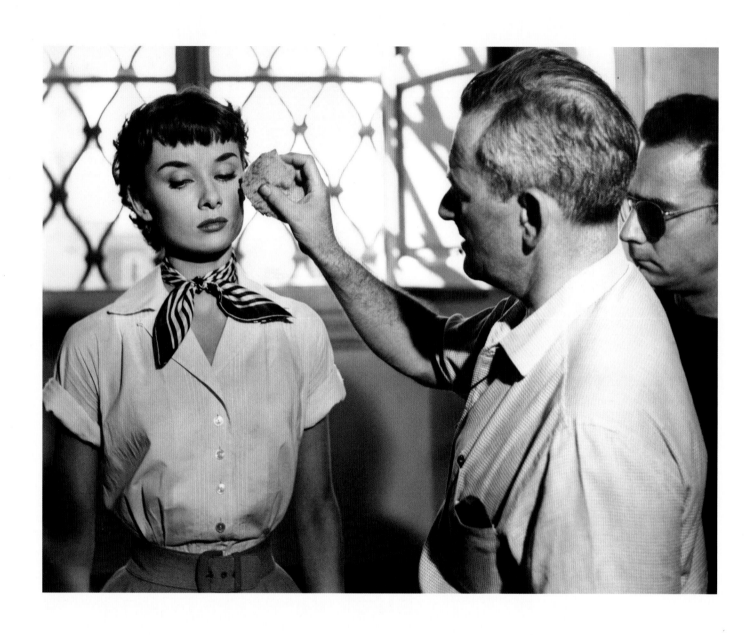

ABOVE Director William Wyler perfects Audrey's visage on the set of *Roman Holiday*.

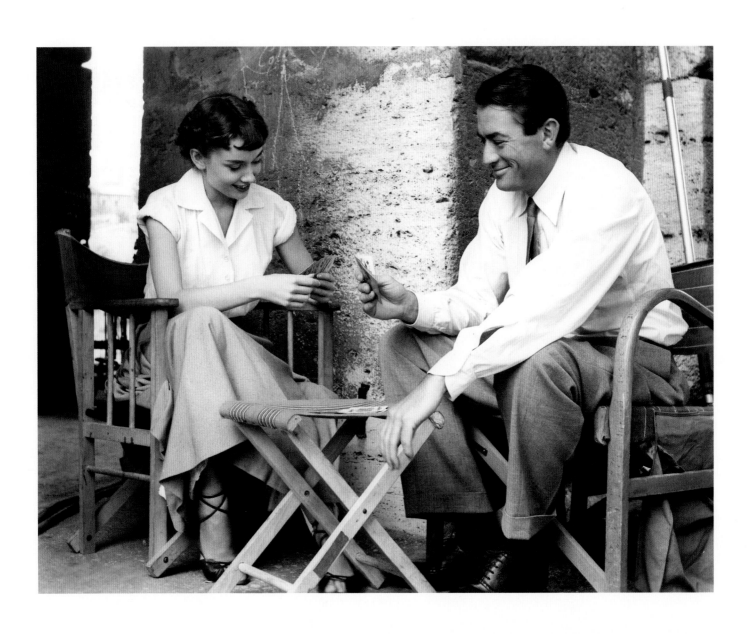

ABOVE Audrey and Gregory Peck on a break between takes, *Roman Holiday*. (Photo courtesy Independent Visions/MPTV.)

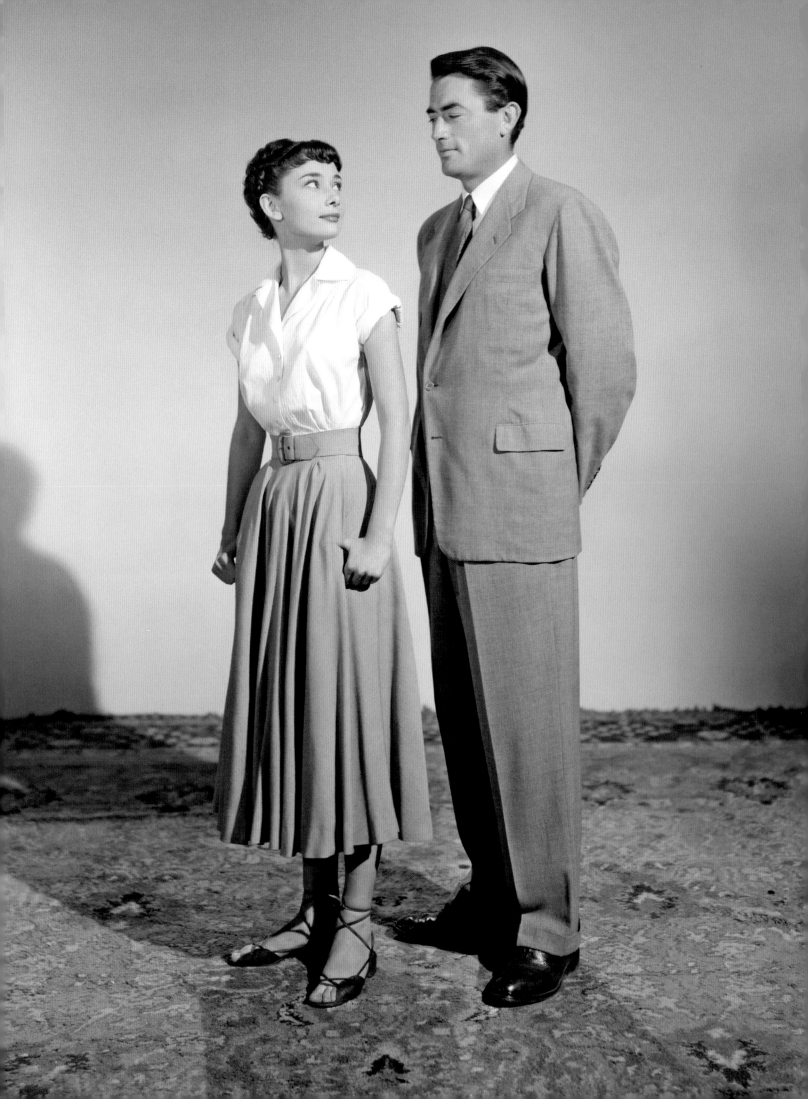

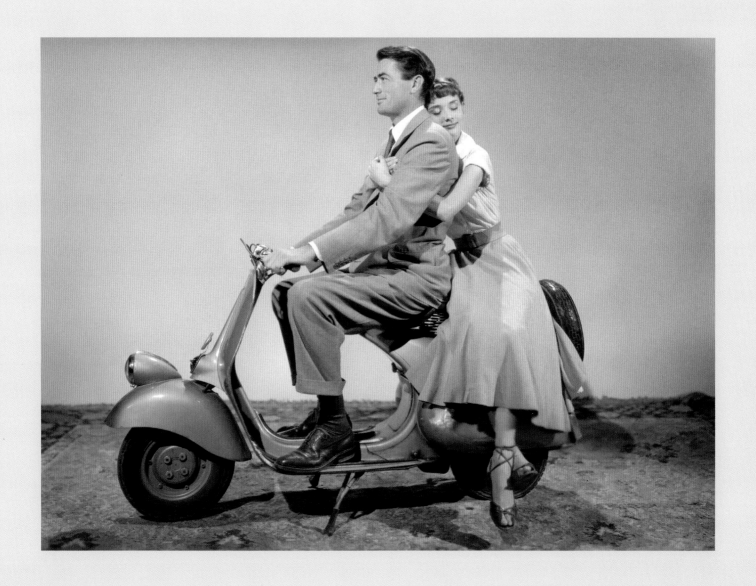

"Audrey Hepburn gives the popular old romantic nonsense a reality which it seldom had before. Impertinence, hauteur, sudden repentance, happiness, rebellion, and fatigue supplant each other with speed on her mobile, adolescent face."

TIME magazine, September 7, 1953.

OPPOSITE AND ABOVE Audrey and Gregory Peck in promotional photographs taken for potential use in poster art and lobby cards. (Photos courtesy Independent Visions/MPTV.)

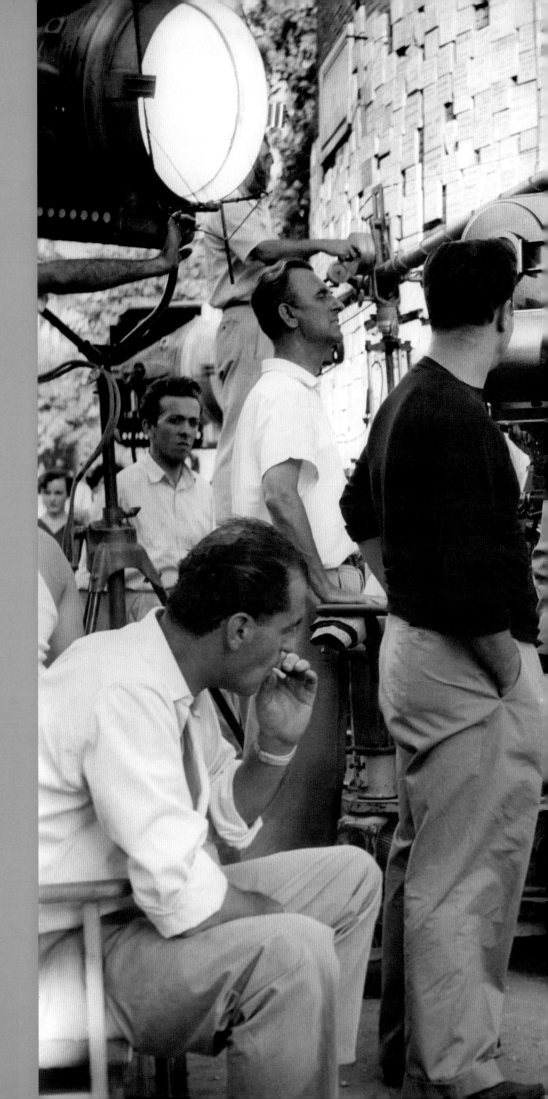

Audrey with director William Wyler,
costar Gregory Peck, and crew
members on location at "the Wall for
Wishes" on the Viale del Policlinico
in Rome, *Roman Holiday*. (Photo
courtesy Independent Visions/MPTV.)

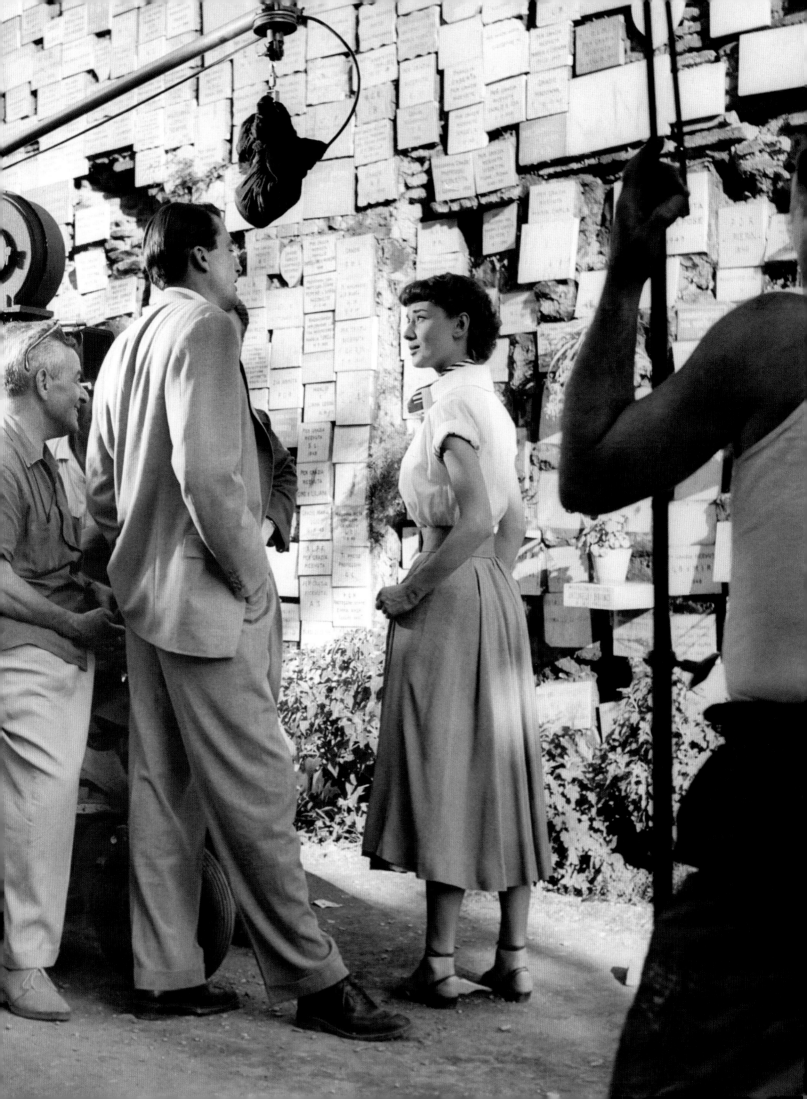

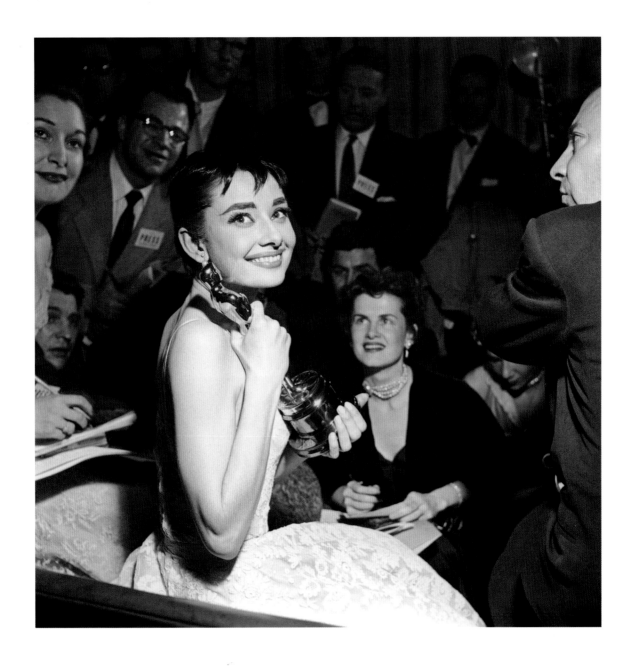

"It's too much. I want to say thank you to everybody who in these past months and years have helped, guided and given me so much.…I'm truly, truly grateful…and terribly happy!"

AUDREY HEPBURN (On accepting her Oscar for Best Actress for *Roman Holiday*)

ABOVE Audrey is surrounded by reporters as she holds the Oscar she won for her role in *Roman Holiday*, Los Angeles, March 25, 1954. **OPPOSITE** Audrey onstage accepting her Oscar at the 26th Academy Awards ceremony. (Photo courtesy Independent Visions/MPTV.)

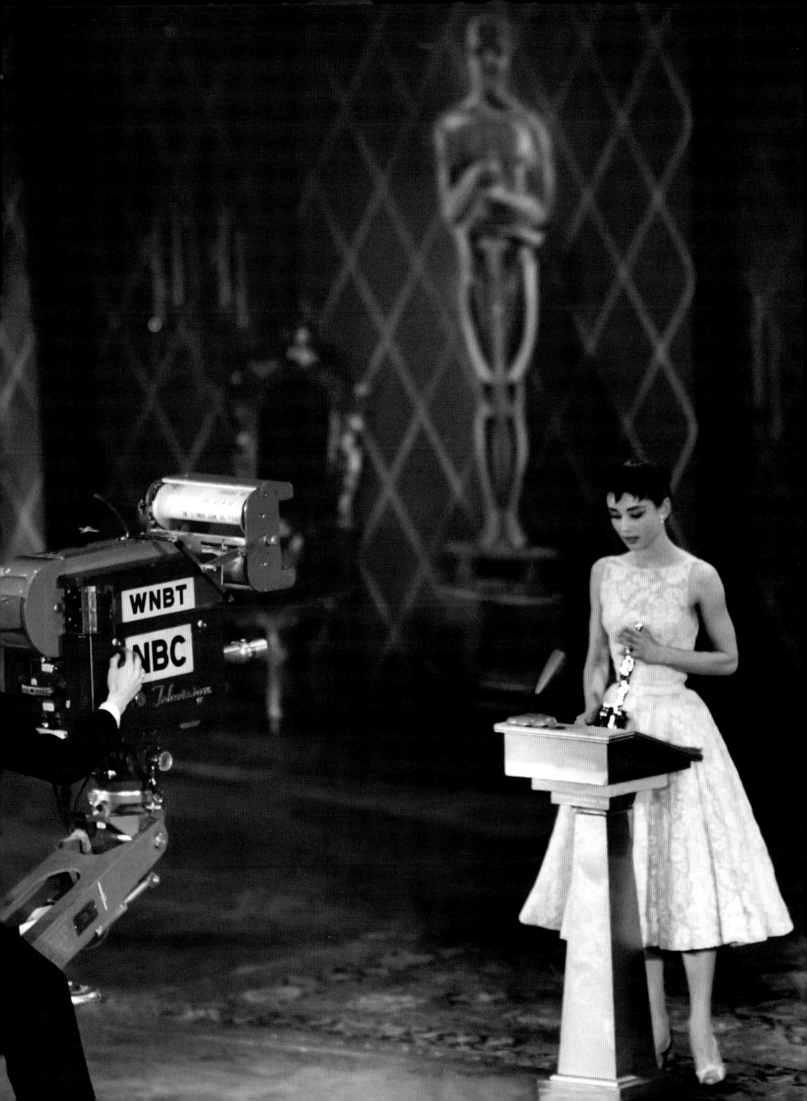

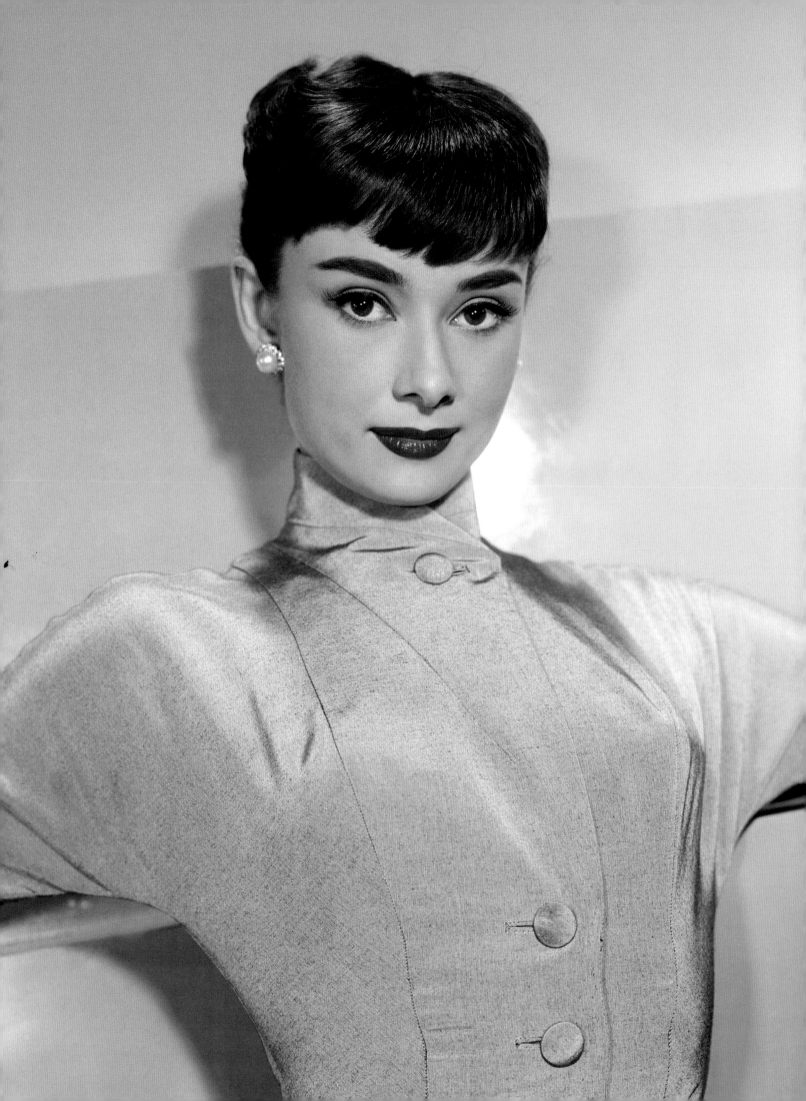

"What a burden she lifted from women! Here was proof that looking good need not be synonymous with looking bimbo. Thanks to their first glimpse of Audrey Hepburn, in *Roman Holiday,* half a generation of young females stopped stuffing their bras and teetering on stiletto heels."

THE NEW YORK TIMES

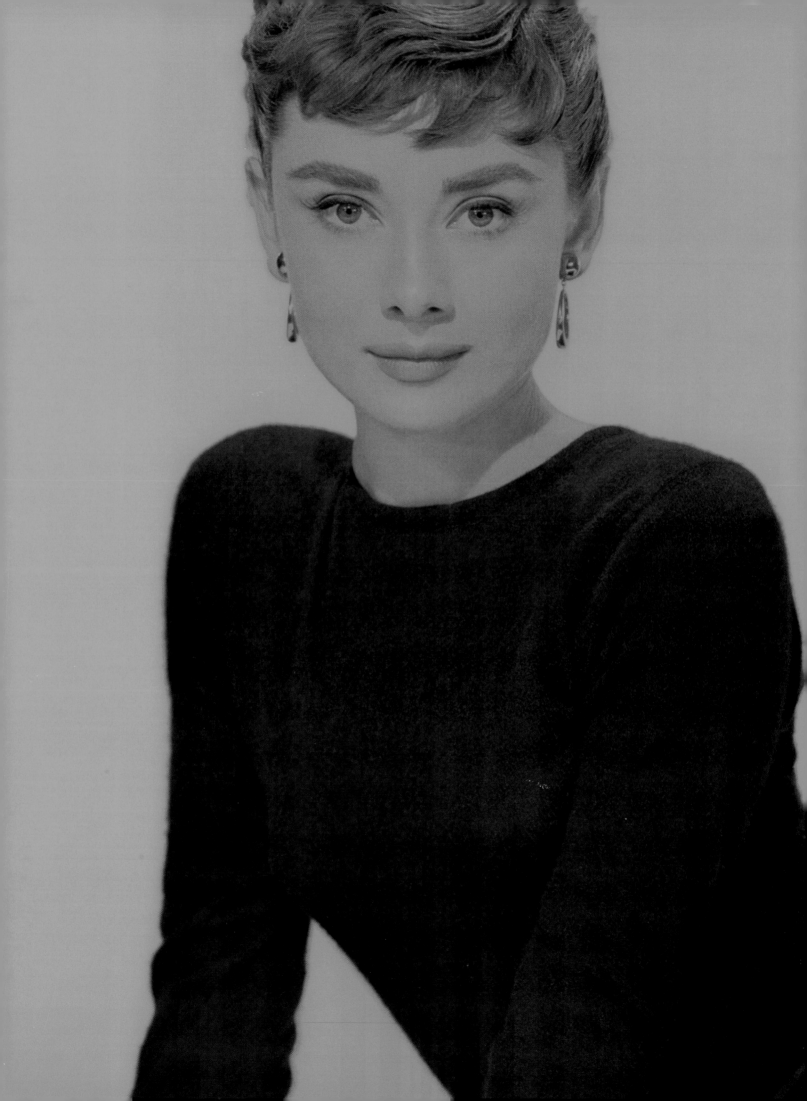

Sabrina

1954

William Holden as David Larrabee and Audrey Hepburn as Sabrina Fairchild in *Sabrina*. Directed by Billy Wilder, Paramount, 1954. (Photo courtesy Independent Visions/MPTV.)

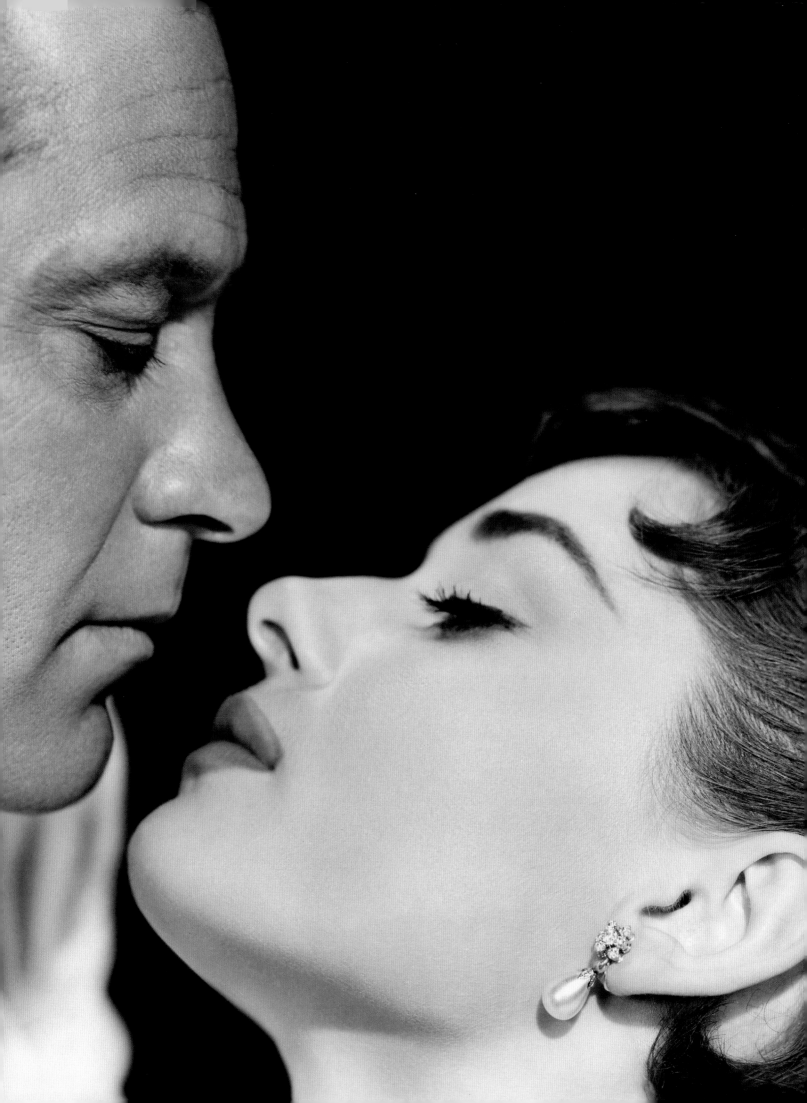

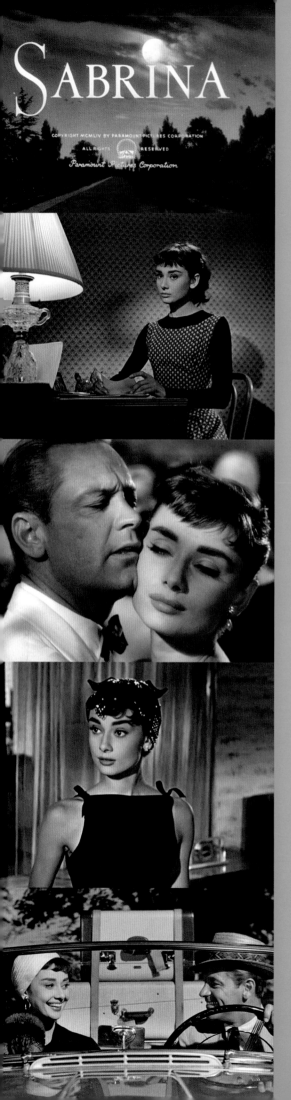

"Before I even met Audrey, I had a crush on her, and after I met her, just a day later, I felt as if we were old friends.... Most men who worked with her felt both fatherly and brotherly about her, while harboring romantic feelings about her....She was the love of my life."

WILLIAM HOLDEN (Costar, *Sabrina*, 1954)

LEFT *Sabrina*, 1954. **OPPOSITE** With Humphrey Bogart as Linus Larrabee, *Sabrina*. (Photo courtesy Independent Visions/MPTV.)

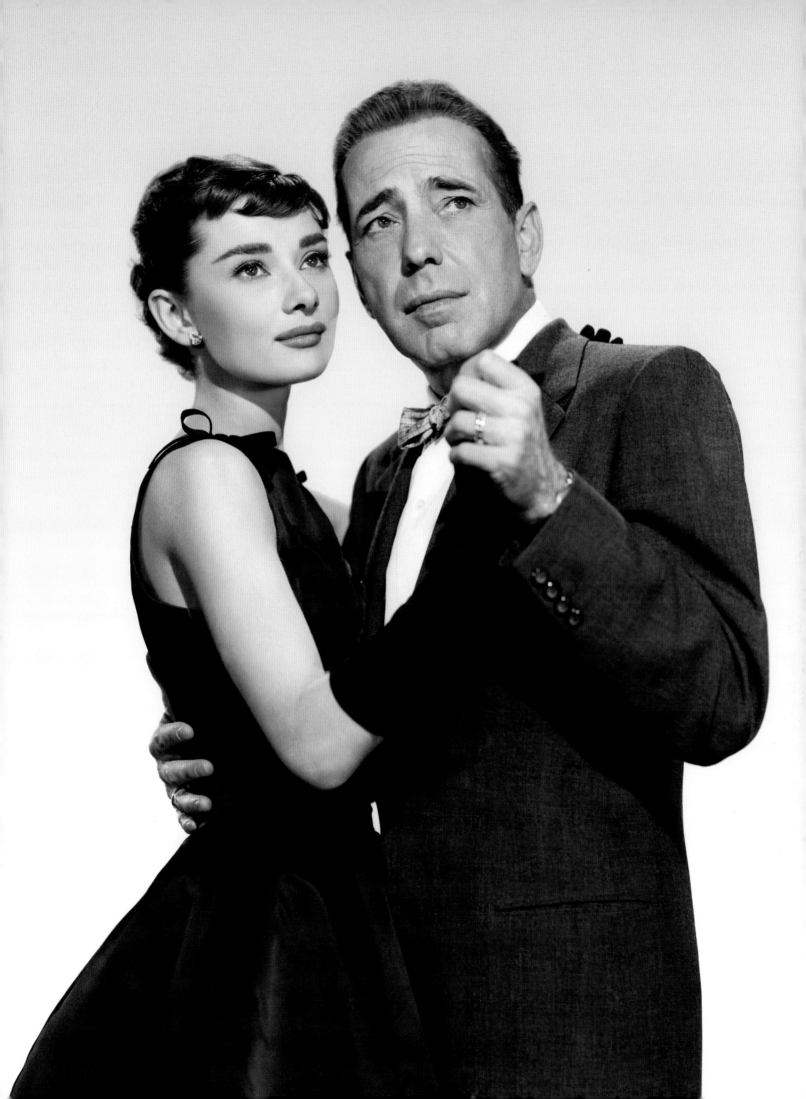

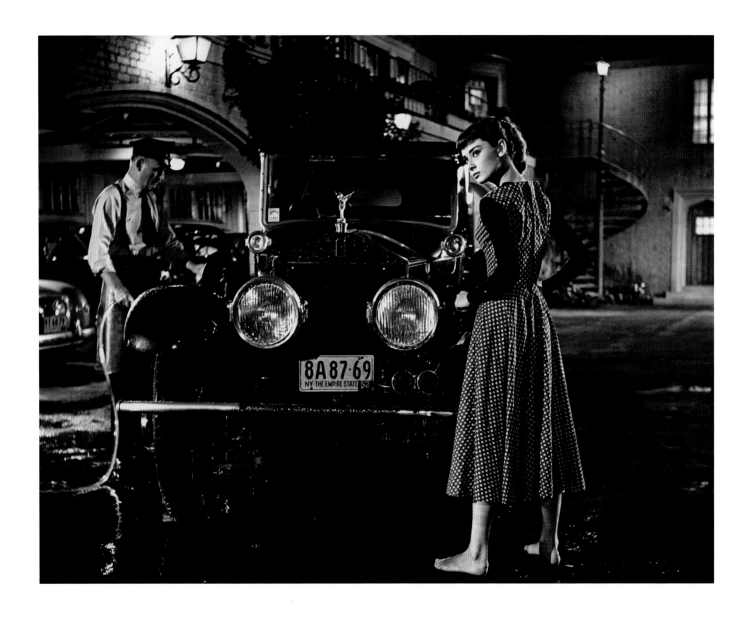

"Sabrina was a dreamer who lived a fairy tale, and she was a romantic, an incorrigible romantic, which I am."

AUDREY HEPBURN

"Audrey always added a twist, something piquant, amusing, to the clothes. Though of course I advised her, she knew precisely what she wanted. She knew herself very well—for example, which is her good profile and which is her bad. She was very professional. No detail ever escaped her. Billy Wilder approved of everything she chose.... Billy's only concern was that the clothes adapt to the form of her face—they had to all correspond to the visage."

HUBERT DE GIVENCHY (Fashion designer, *Sabrina*, 1954)

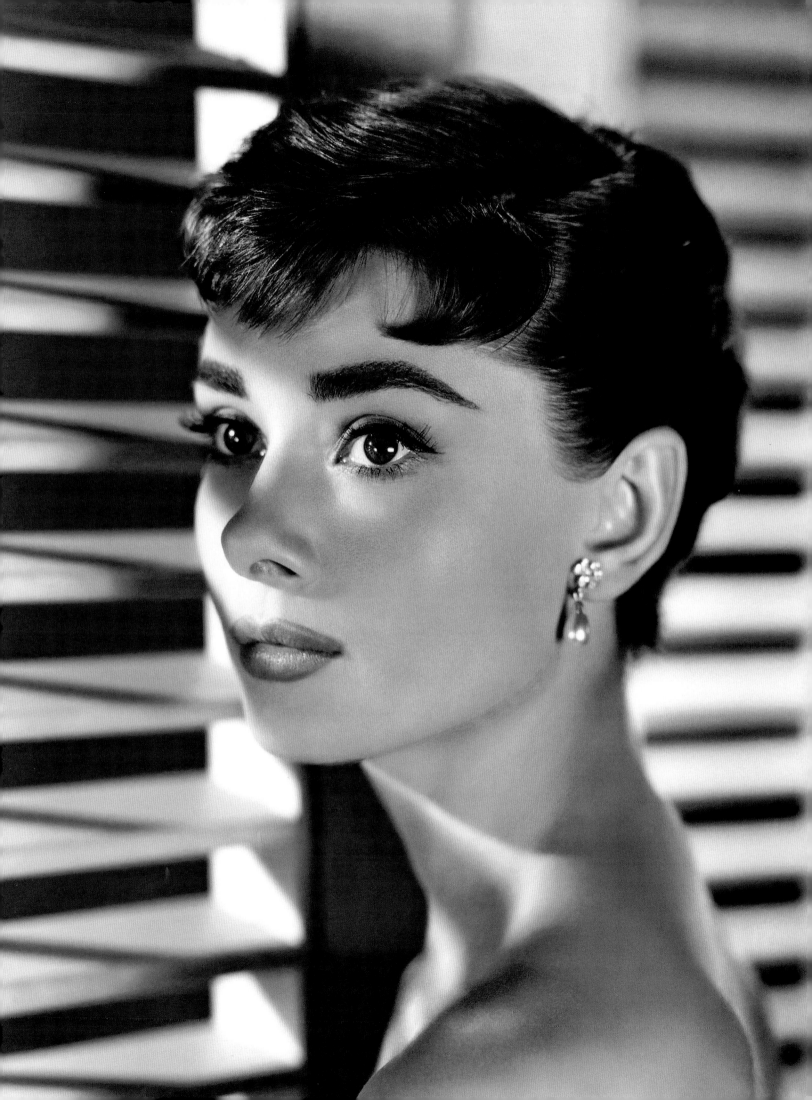

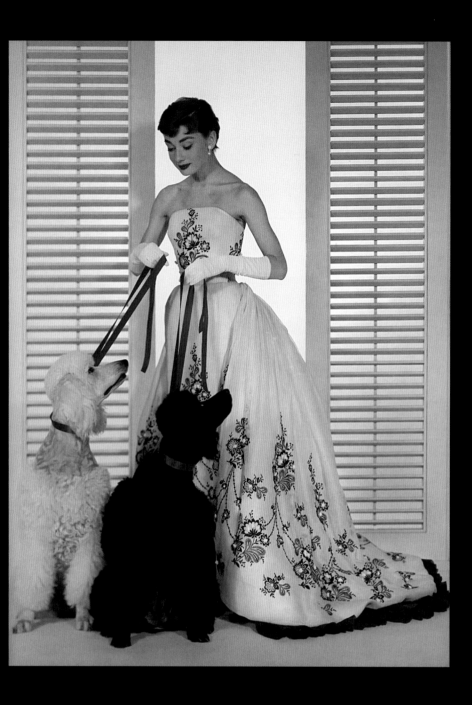

"She was something unreal—a fairy tale."

DREDA MELE (Directrice, Givenchy, speaking of the
white double-skirted gown with black embroidery that
Sabrina wears to the Larrabee soiree)

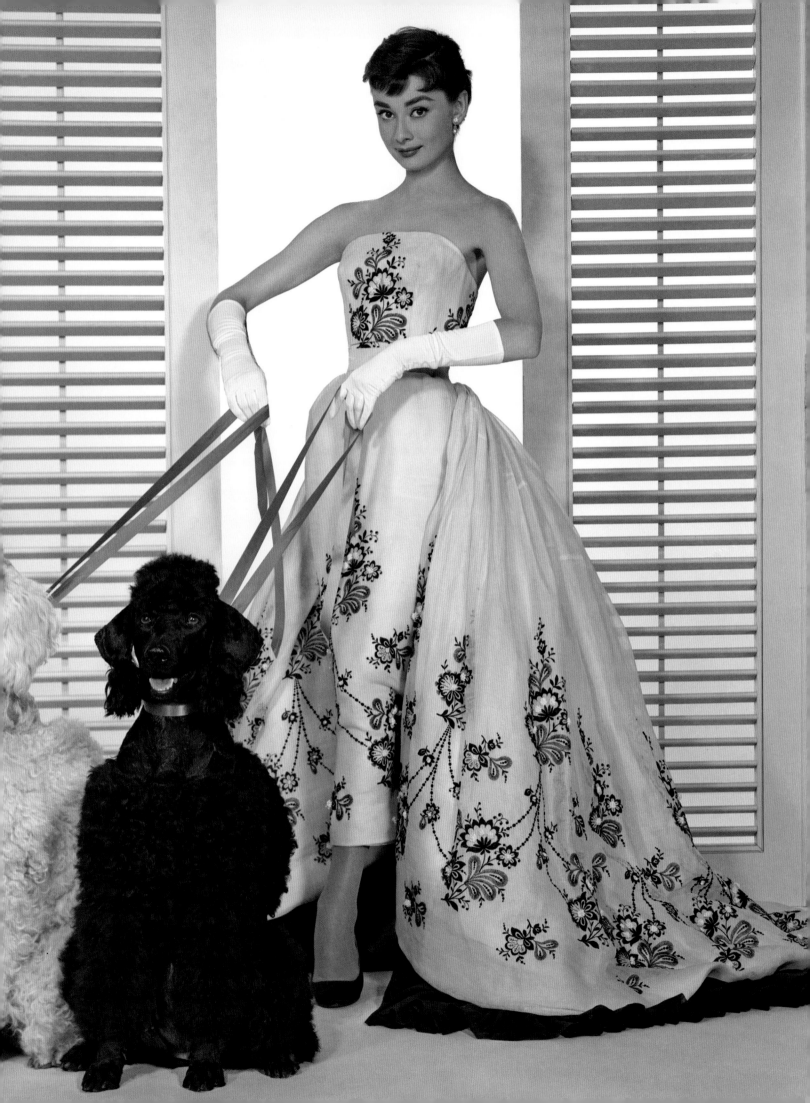

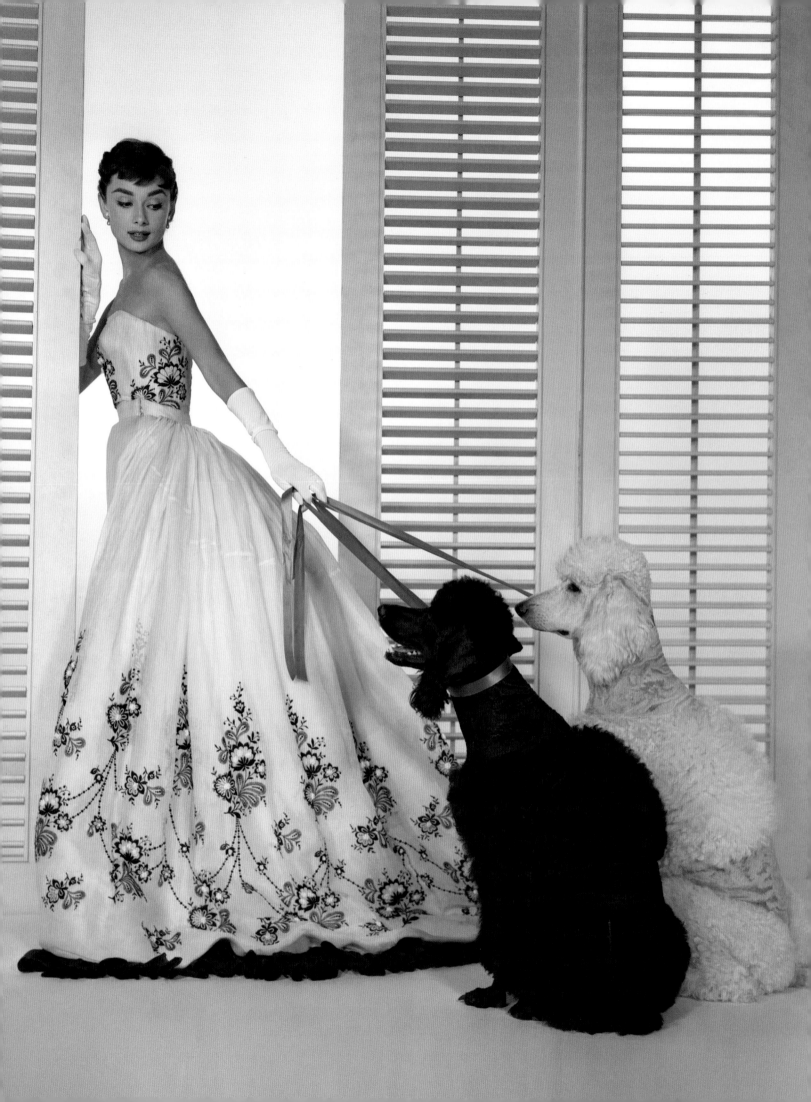

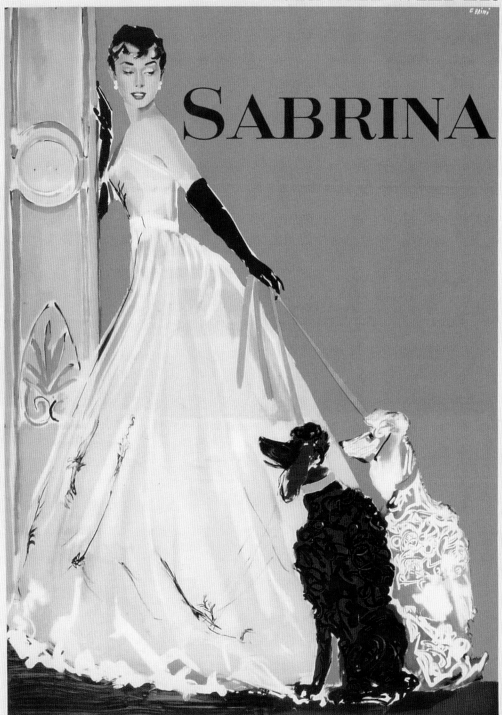

un film di BILLY WILDER

SABRINA

Humphrey BOGART Audrey HEPBURN
William HOLDEN

WALTER HAMPDEN · JOHN WILLIAMS
MARTHA HYER · JOAN VOHS

È un film Paramount

PROD. E DIRETTO DA BILLY WILDER
SCRITTO PER LO SCHERMO DA B. WILDER, S. TAYLOR, E. LEHMAN
TRATTO DA UNA COMMEDIA DI SAMUEL TAYLOR

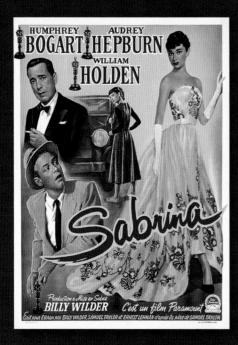

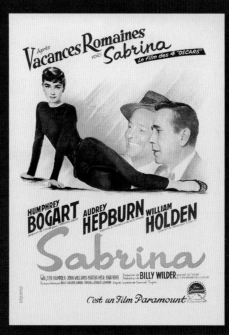

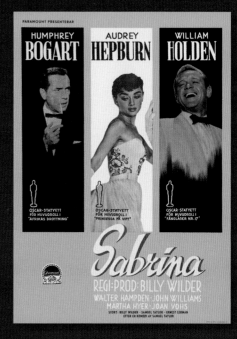

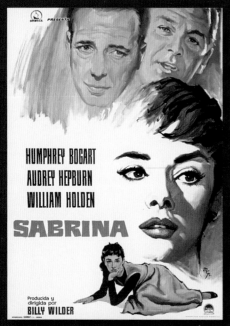

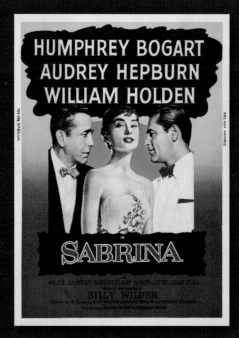

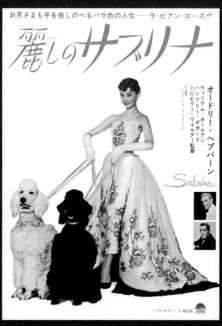

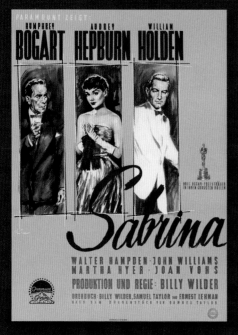

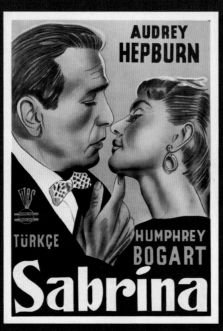

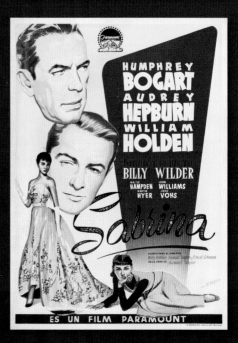

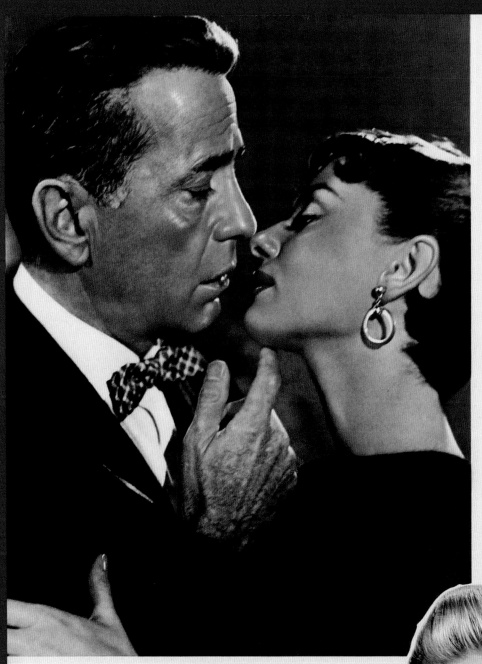

WILLIAM
HOLDEN

AUDREY
HEPBURN

HUMPHREY
BOGART

in un film di
BILLY
WILDER

È un film Paramount Films Paramount

Sabrina

con
**WALTER HAMPDEN · JOHN WILLIAMS
MARTHA HYER · JOAN VOHS**

scritto per lo schermo da
**BILLY WILDER · SAMUEL TAYLOR
e ERNEST LEHMAN**

prodotto da **BILLY WILDER**

da una commedia di **SAMUEL TAYLOR**

AGARRUTOCALCO · ROMA · 1962 AVVERTENZA

OPPOSITE AND ABOVE *Sabrina* film posters from Belgium, France, Sweden, Spain, Germany, Japan, Turkey, and Italy.
OVERLEAF *Sabrina*. Photo by Bud Fraker (courtesy Independent Visions/MPTV).

63

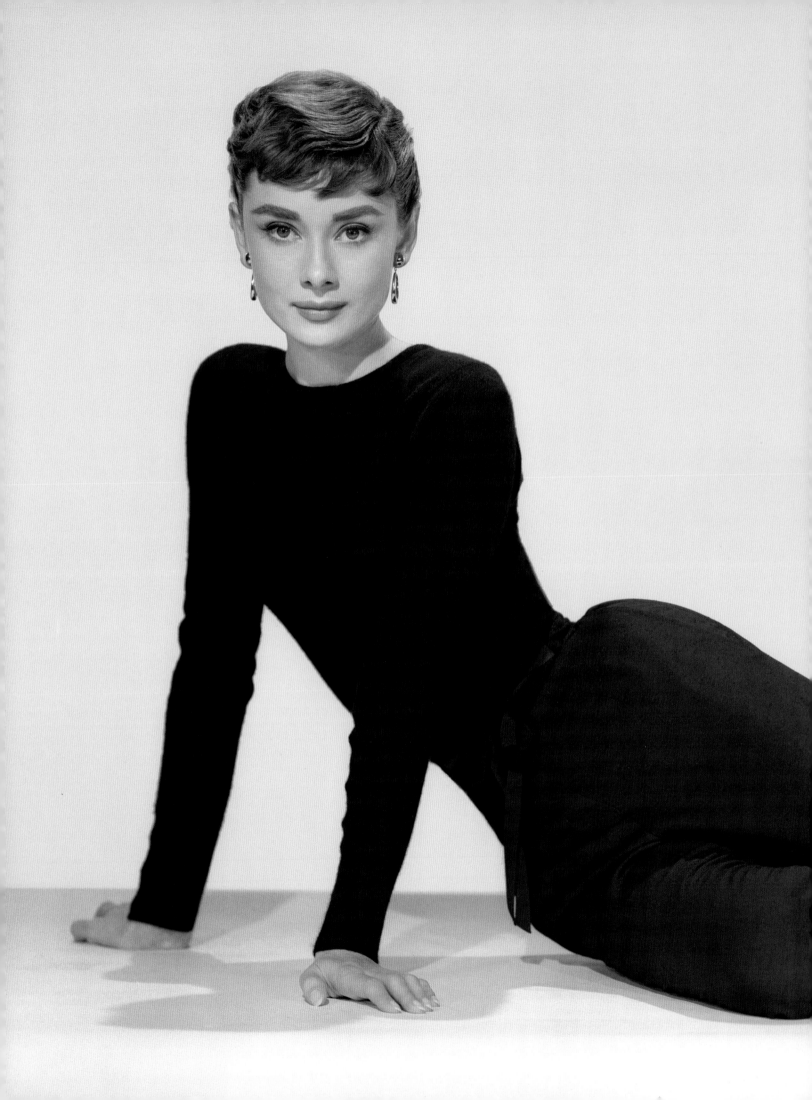

"Everyone in the street was copying Audrey's hair, the way she moved, the way she spoke. She became a person of a whole generation. They copied her for ten solid years after. She created an image above her movie image."

DREDA MELE (Directrice, Givenchy)

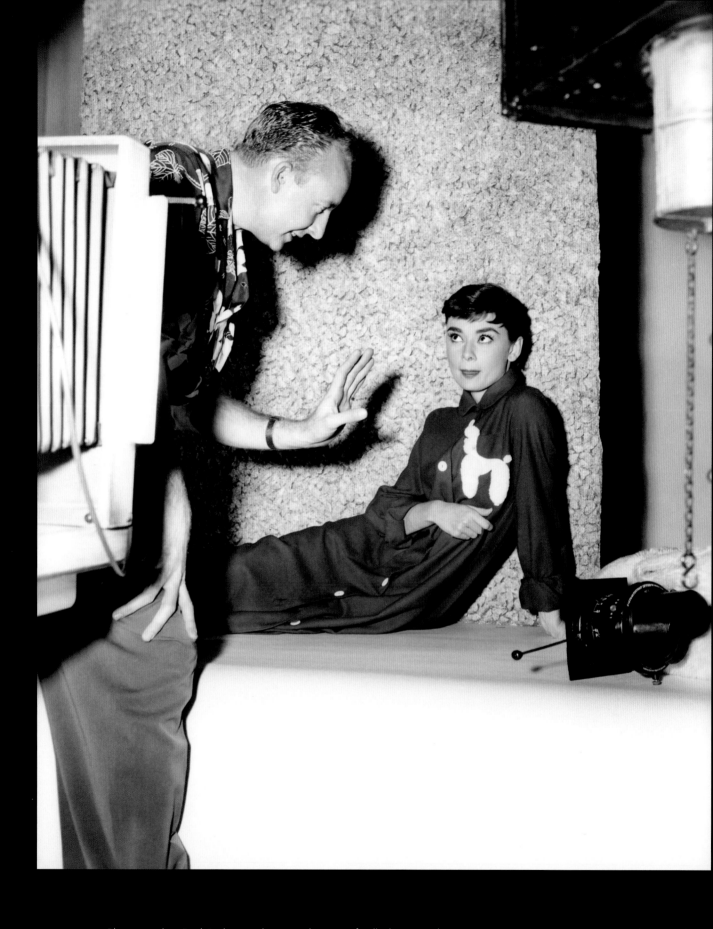

ABOVE Photographer Bud Fraker, at the time director of still photography at Paramount Pictures, instructs Audrey Hepburn during a promotional photo shoot for *Sabrina* in 1954. During her years at Paramount, Fraker took some of Hepburn's most iconic portraits. (Photo courtesy Independent Visions/MPTV.) **OPPOSITE** *Sabrina.* Photo by Bud Fraker.

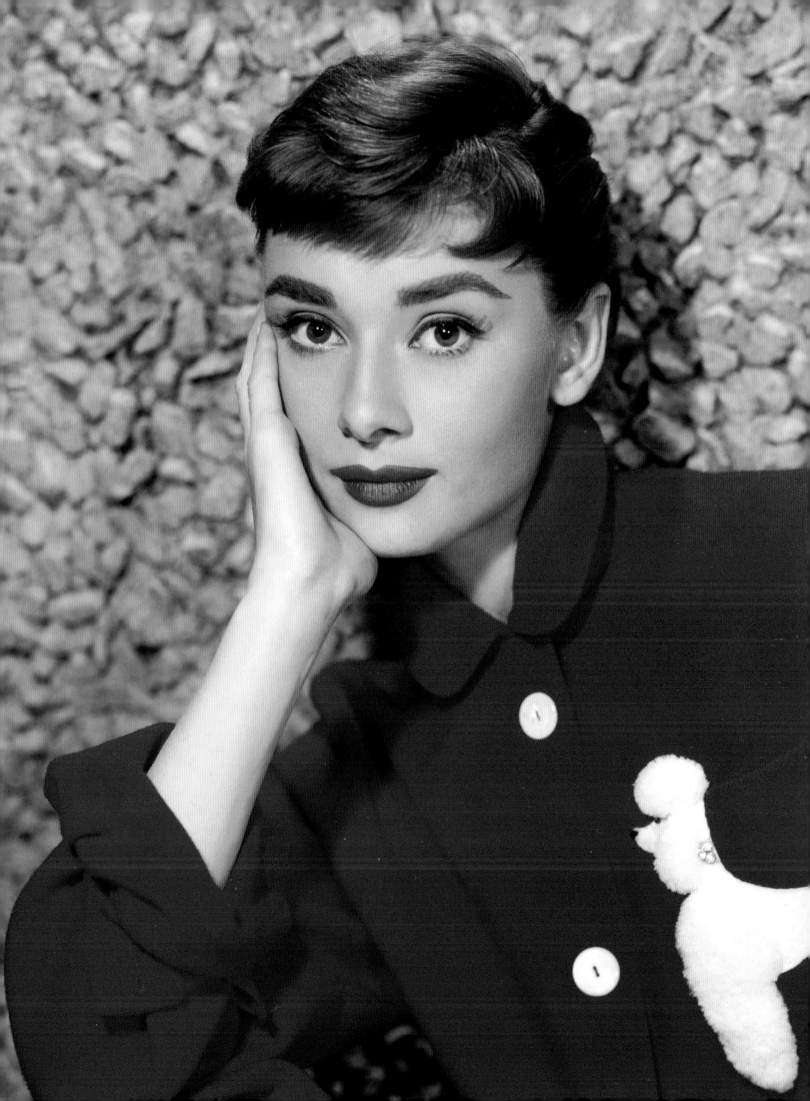

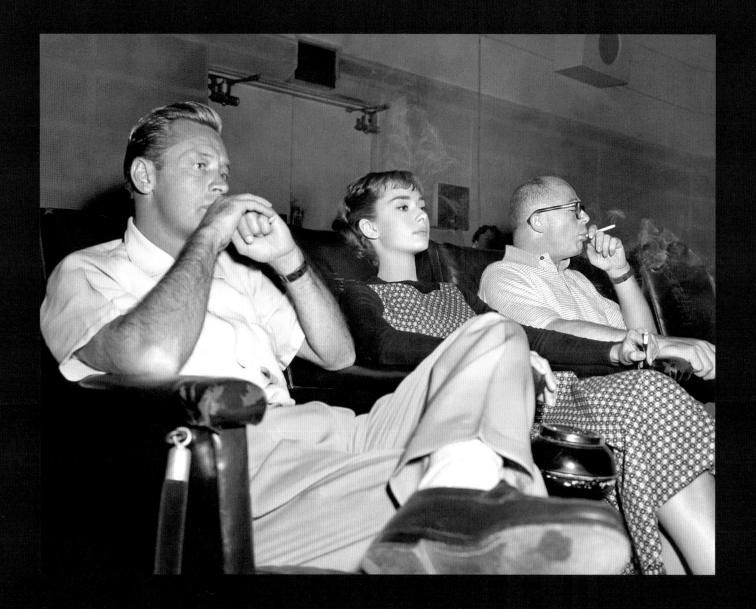

"I have a natural sense of rhythm, and I enjoy dancing. I was going to show Audrey how Sabrina should dance in a scene, but she was a great dancer, much better than me. Her feet hardly touched the ground. She was floating. I didn't have to guide her. I forgot the camera, the set, I was transported to the ball."

BILLY WILDER (Director, *Sabrina*)

ABOVE With costar William Holden and director Billy Wilder in the Paramount screening room.
OPPOSITE Audrey and Wilder in discussion on the set of *Sabrina*. (Photos courtesy Independent Visions/MPTV.)

68

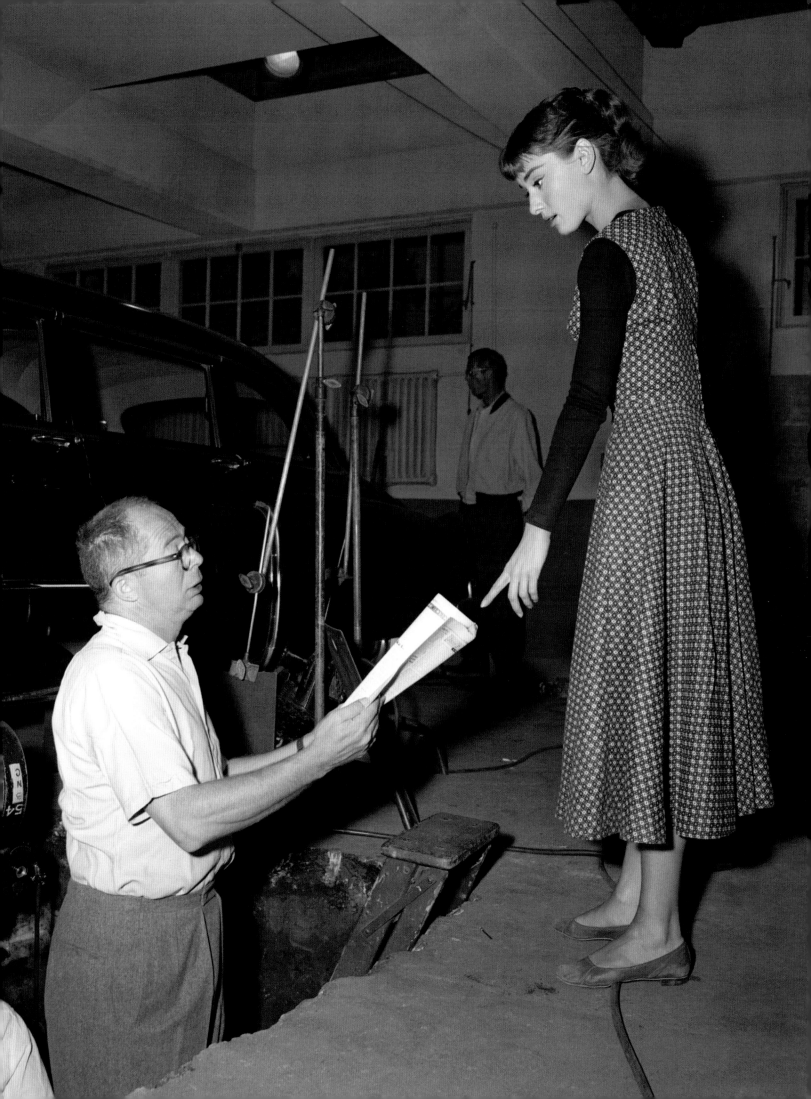

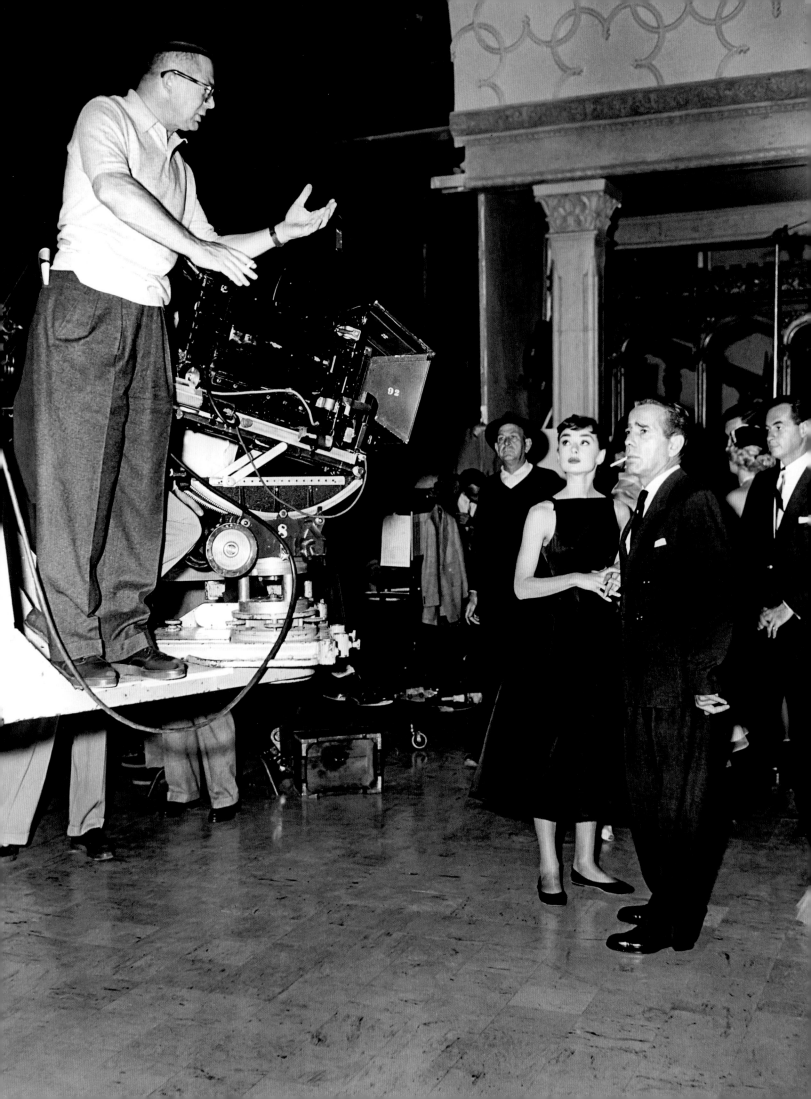

"Audrey Hepburn knew more about fashion than any actress except Marlene Dietrich.…This was a girl way ahead of high fashion. She deliberately looked different from other women and dramatized her own slenderness into her chief asset.… What impressed me most was her body. I knew she would be the perfect mannequin for anything I would make."

EDITH HEAD (Costume designer, *Sabrina*)

OPPOSITE Billy Wilder directing Audrey and Humphrey Bogart in *Sabrina*. **ABOVE** Marlene Dietrich visits the set of *Sabrina*, 1954. (Photos courtesy Independent Visions/MPTV.)

"We had a set made of the Glen Cove railroad station, and the scene was already half-way shot when I told Billy to stop everything—that it [Audrey's costume] had to be redone. It's hard to believe now, but until that moment Bill Holden was supposed to recognize Sabrina immediately as the chauffeur's daughter.... The clothes almost made the woman. They were extremely helpful to the character, the mood, the movie. They made the transformation believable."

ERNEST LEHMAN (Screenwriter, *Sabrina*)

ABOVE With William Holden, *Sabrina*. **OPPOSITE** Audrey and costar William Holden between takes on the set of *Sabrina*. (Photo courtesy Independent Visions/MPTV.)

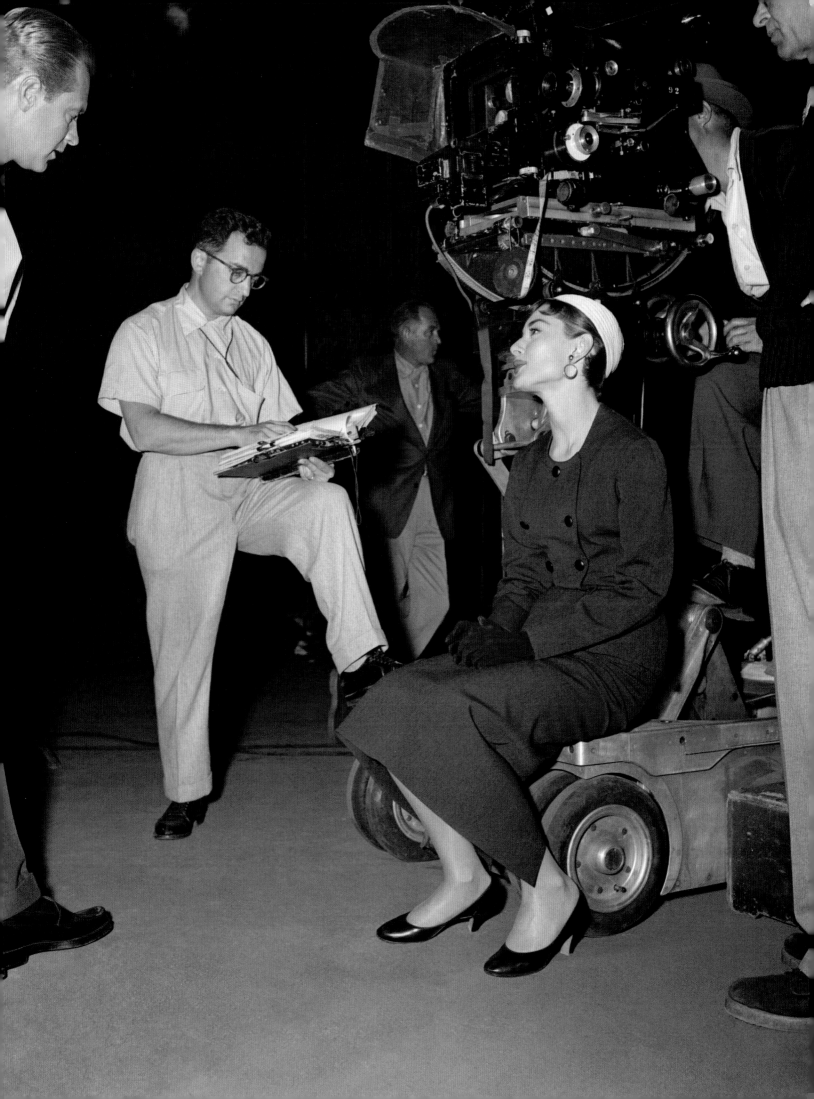

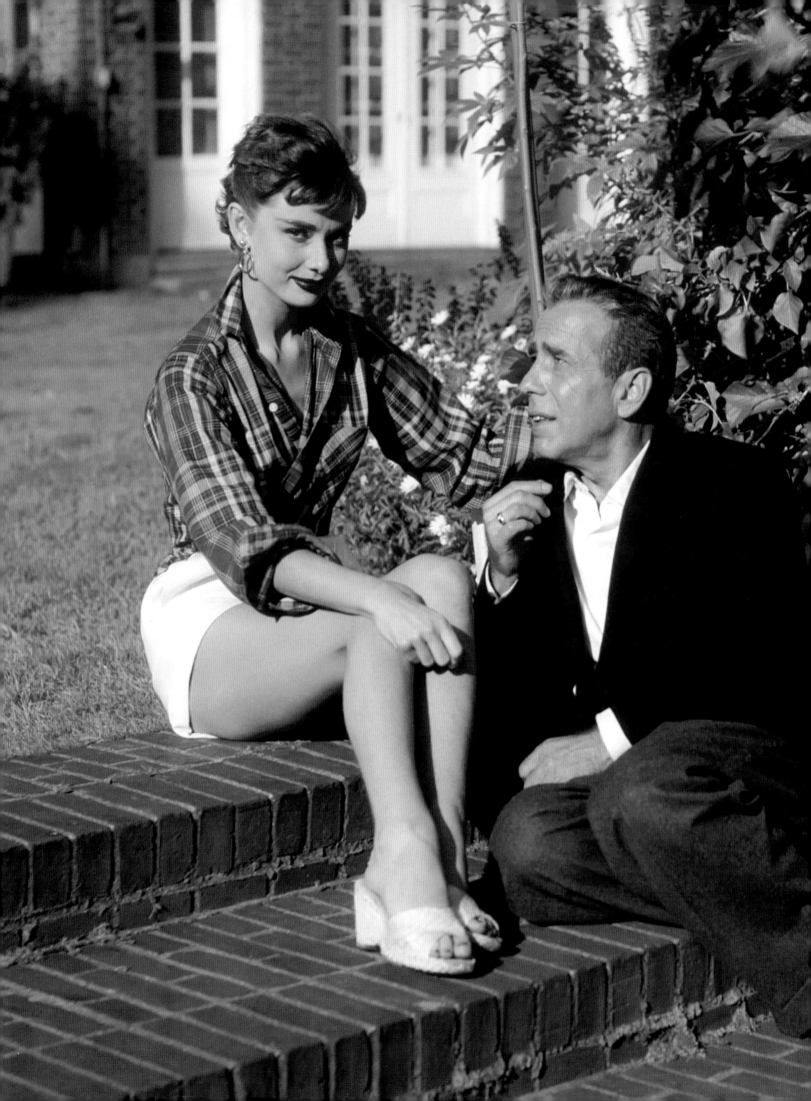

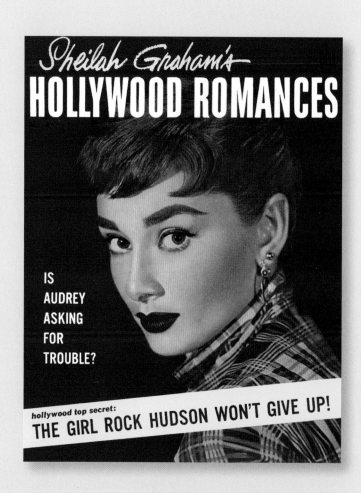

LEFT Audrey with Humphrey Bogart, *Sabrina*.
ABOVE *Hollywood Romances*, 1954.

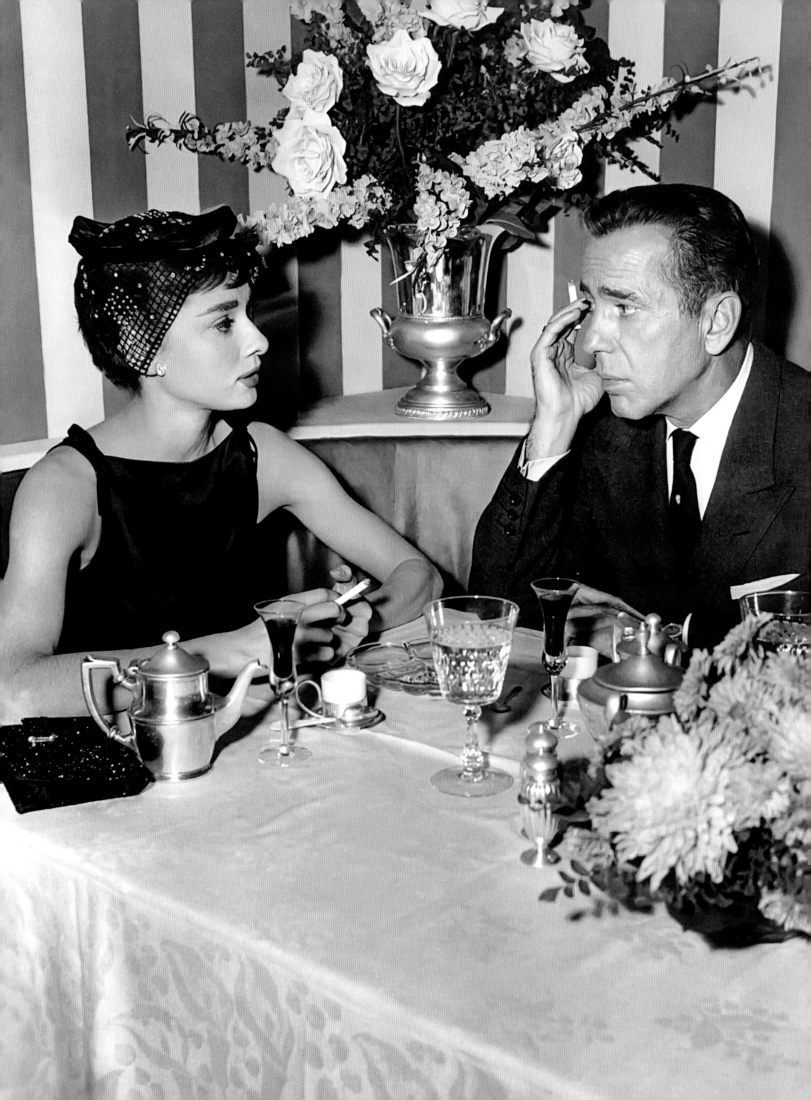

"I can't think of any other picture before *Sabrina* that made use of clothes in the same way. It was a real breakthrough. The way Audrey looked in *Sabrina* had an effect on the roles she later played. It's fair to say that if she had never gone to Paris she wouldn't have had that role in *Breakfast at Tiffany's*. The *Sabrina* clothes fixed her image forever."

ERNEST LEHMAN (Screenwriter, *Sabrina*)

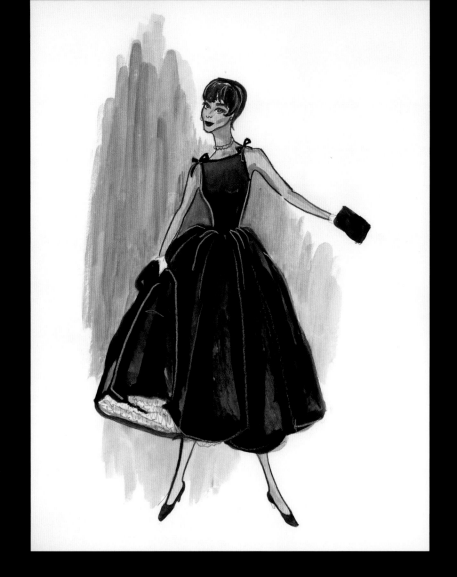

"Every designer wishes for the perfect picture in which he or she can really show off design magic. My one chance was in *Sabrina*. . . . It was the perfect set-up. Three wonderful stars, and my leading lady looking like a Paris mannequin."

EDITH HEAD (Costume designer, *Sabrina*, recalling first meeting with Audrey in the summer of 1953, before she knew the Paris wardrobe would be provided by Givenchy)

ABOVE Costume sketch of an original design by Givenchy for *Sabrina*, from the office of Edith Head. **OPPOSITE** *Sabrina*. (Photo courtesy Independent Visions/MPTV.)

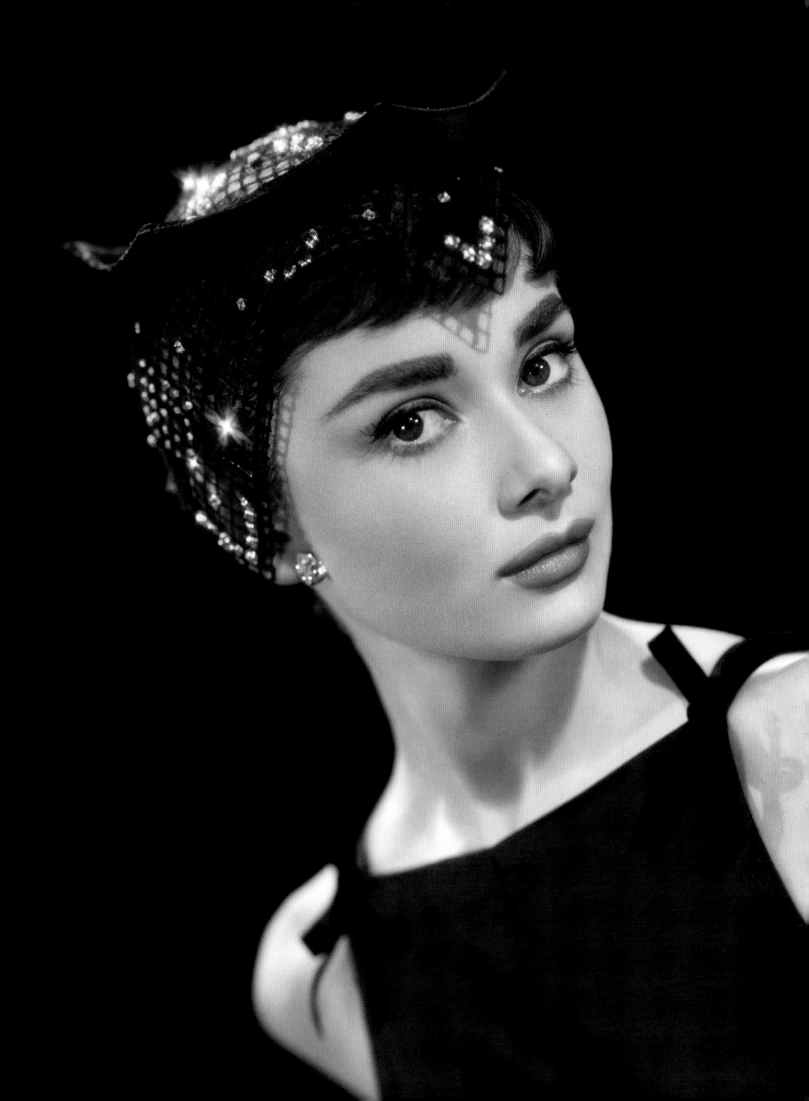

ABOVE AND OPPOSITE With William Holden on location in Manhattan, 1954.

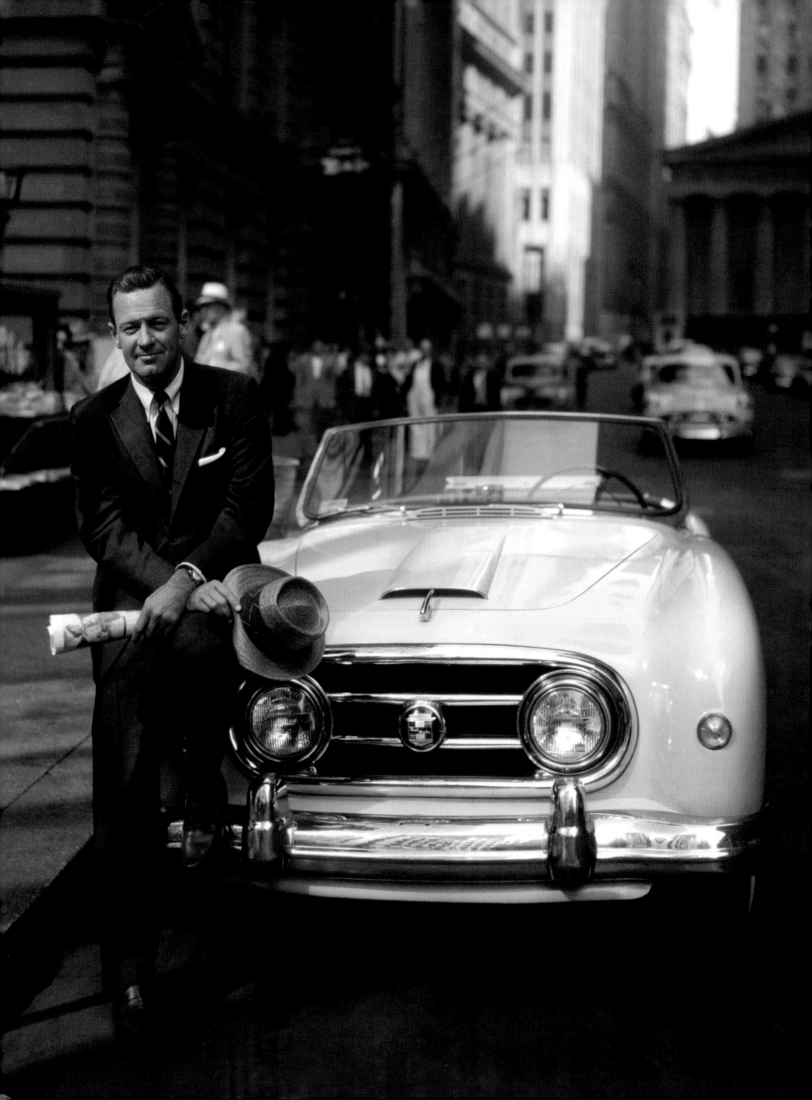

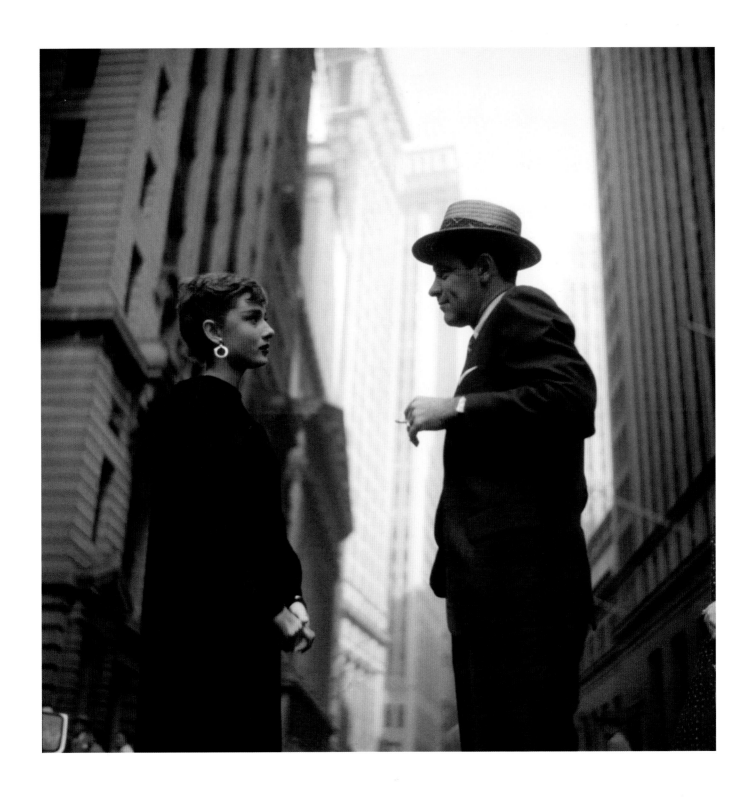

"Bill Holden was my guardian angel.... The most handsome man I've ever met."

AUDREY HEPBURN

OPPOSITE AND ABOVE With William Holden on location in Manhattan, 1954.

83

"A knockout.... One of those smooth escapist films, which, when done with supreme sophistication, is one of the happiest resources in Hollywood.... Audrey Hepburn, the magical young lady...flows beautifully into the character of the chauffeur's lovely daughter."

BOSLEY CROWTHER (Film critic, the *New York Times*, September 26, 1954)

ABOVE Terry Moore and James Dean attend the premiere of *Sabrina*, September 22, 1954.
OPPOSITE *Sabrina* premiere, Paramount Theatre, Los Angeles. The largest movie theater ever built in Los Angeles, the Paramount (opened in 1923 and originally located at Sixth and Hill Streets in downtown L.A.) was unfortunately demolished in 1961. (Photos courtesy Independent Visions/MPTV.)

HUMPHREY BOGART
AS THE "BIG WHEEL"

AUDREY HEPBURN
AS THE CHAUFFEUR'S DAUGHTER

WILLIAM HOLDEN
AS THE PLAYBOY

Sabrina

with

WALTER HAMPDEN JOHN WILLIAMS
MARTHA HYER JOAN VOHS

Produced and Directed by

BILLY WILDER

Written for the Screen by BILLY WILDER • SAMUEL TAYLOR
and ERNEST LEHMAN • From the play by SAMUEL TAYLOR

A PARAMOUNT PICTURE

PARAMOUNT

4 ACADEMY AWARD WINNERS! HUMPHREY **BOGART** AUDREY **HEPBURN** WILLIAM **HOLDEN** *Sabrina* Produced and Directed by **BILLY WILDER**

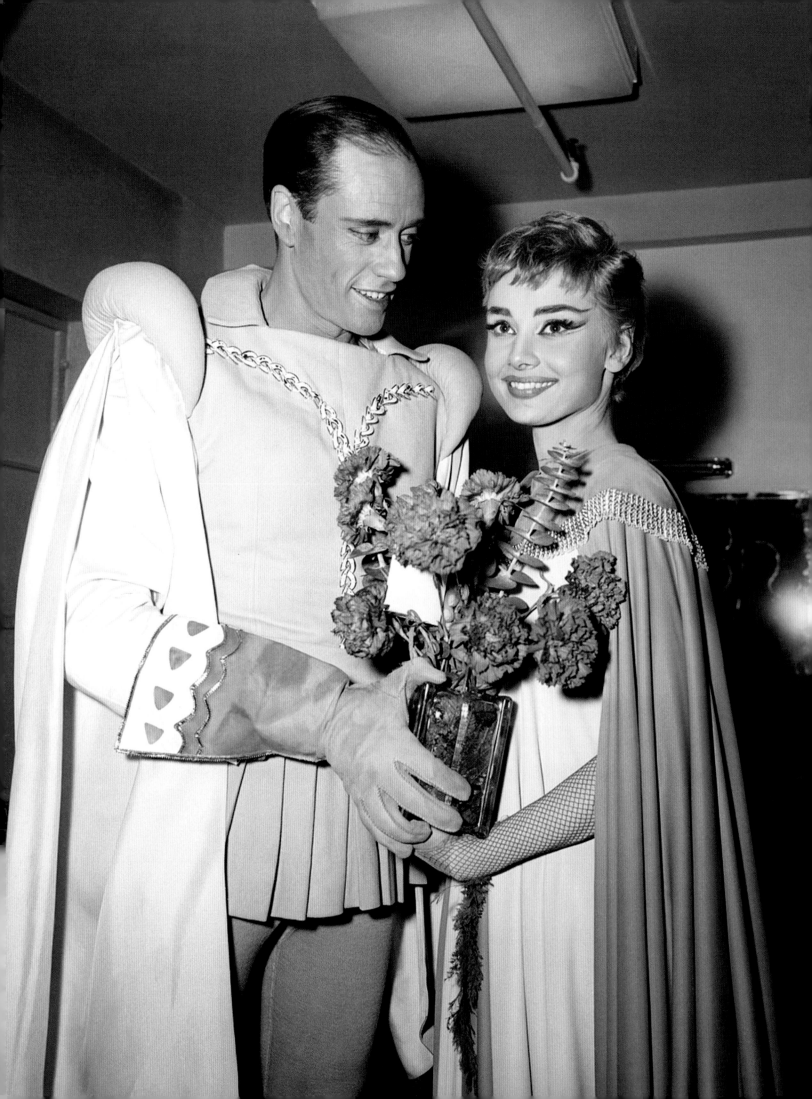

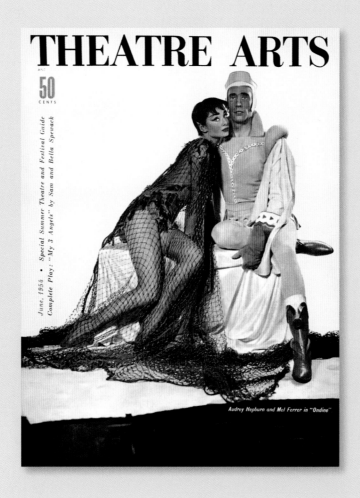

THEATRE ARTS

50 CENTS

June, 1954 • Special Summer Theatre and Festival Guide
Complete Play: "My 3 Angels" by Sam and Bella Spewack

Audrey Hepburn and Mel Ferrer in "Ondine"

"She is tremulously lovely. She gives a pulsating performance that is all grace and enchantment, disciplined by an instinct for the realities of the stage. Everyone knows that Audrey Hepburn is an exquisite young lady, and no one has ever doubted her talent for acting. But the part of Ondine is a complicated one. It is compounded of intangibles—of moods and impressions, mischief and tragedy. See how Miss Hepburn is able to translate them into the language of the theater without artfulness or precociousness."

BROOKS ATKINSON (*Ondine* review, the *New York Times*, February 20, 1954)

OPPOSITE Original news caption: "New York, New York—Costars Audrey Hepburn and Mel Ferrer hold flowers backstage at the opening of the play *Ondine*, February 18th, at the 46th Street Theater. Presented by the Playwrights' Company, *Ondine* is a romance written in 1938 by Jean Giraudoux." **ABOVE** *Theatre Arts* magazine, June 1954.

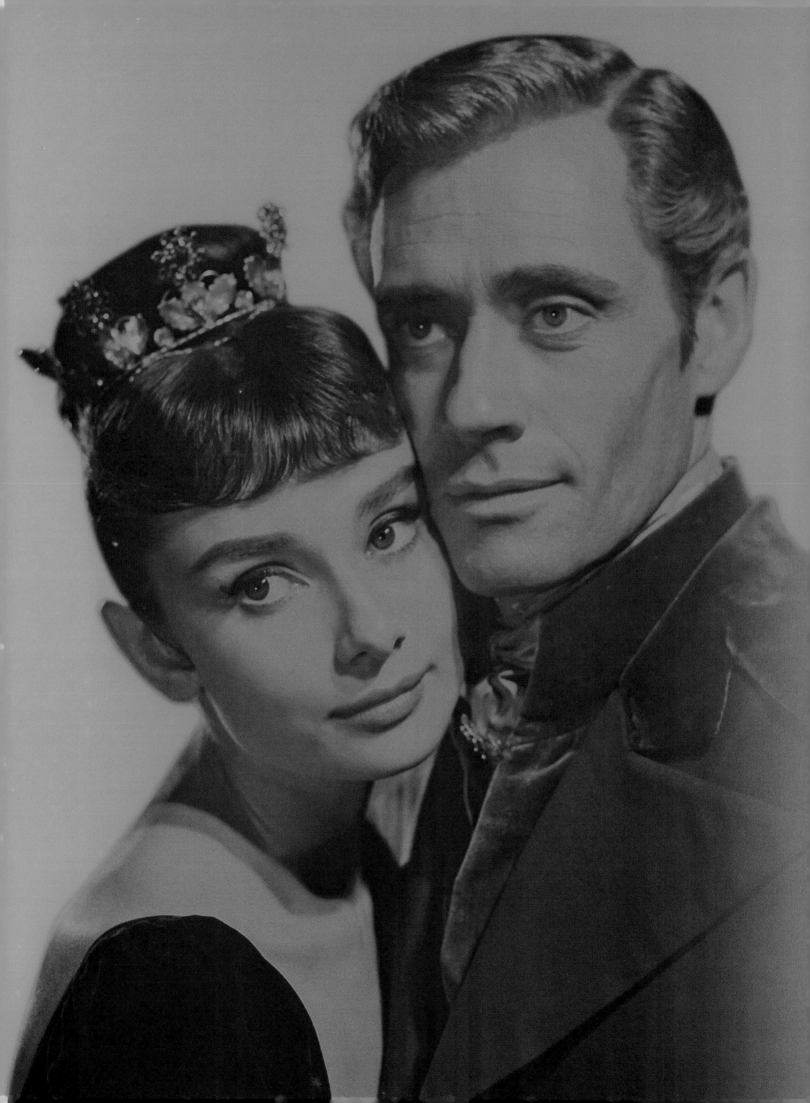

War and Peace

1956

Audrey Hepburn as Natasha Rostova and Mel Ferrer as Prince Andrei Bolkonsky in *War and Peace*. Directed by King Vidor, Paramount / Dino De Laurentiis Cinematografica, 1956.

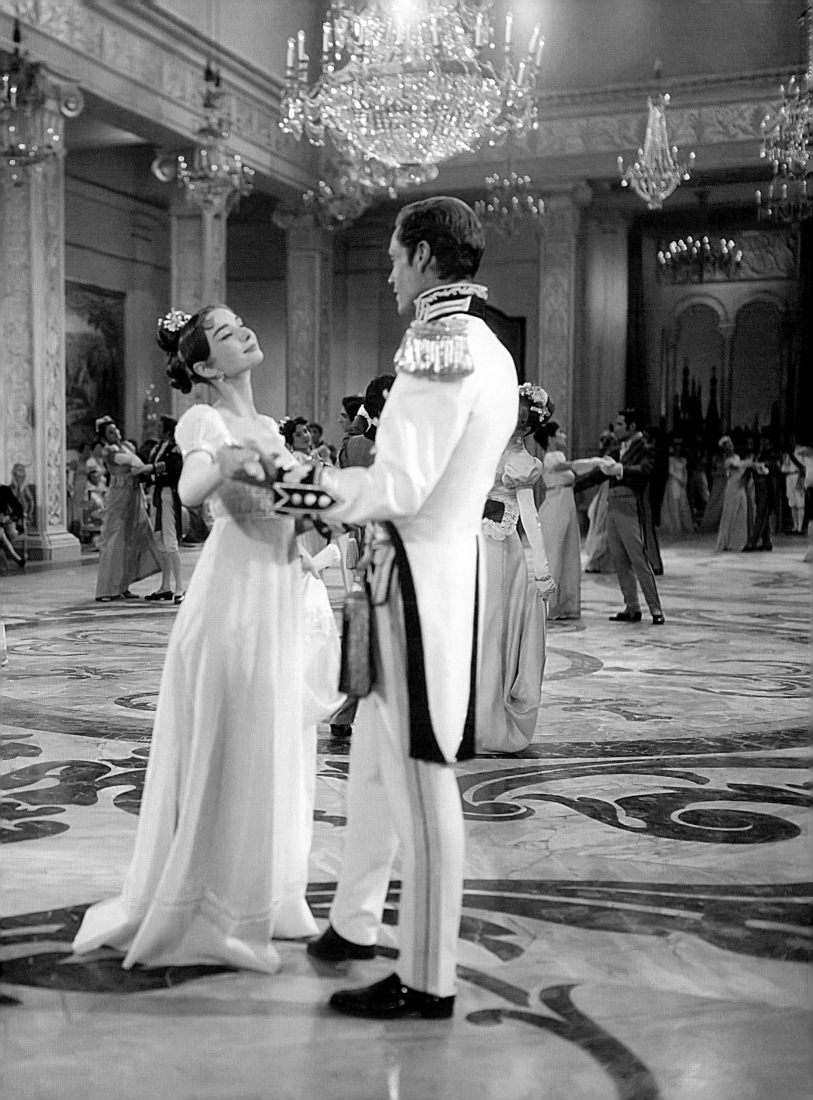

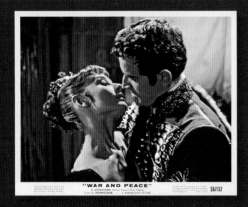

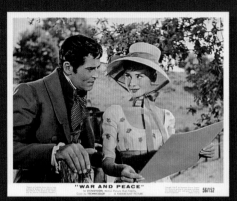

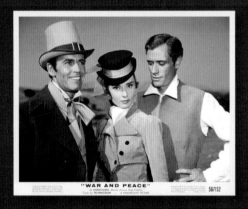

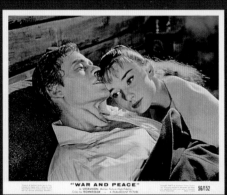

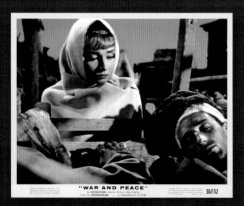

"She dominates an epic picture by refusing to distort her character to the epic mould, letting her... littleness in the face of history captivate us by its humanity contrasted with the inhumanity of war. She incarnates all that is worth fighting for."

FILMS IN REVIEW

LEFT AND OPPOSITE Lobby cards and film poster for *War and Peace*. The film was based on Leo Tolstoy's 1869 novel of the same name.

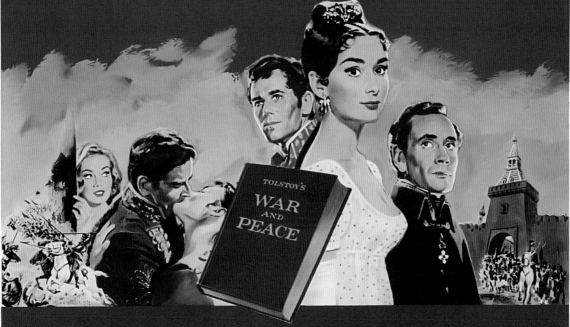

PARAMOUNT PRESENTS

AUDREY **HEPBURN** HENRY **FONDA** MEL **FERRER**

LEO TOLSTOY'S

War and PEACE

A PONTI · De LAURENTIIS PRODUCTION

Color by
TECHNICOLOR
VistaVision
MOTION PICTURE HIGH FIDELITY

CO-STARRING VITTORIO

GASSMAN HERBERT LOM · OSCAR HOMOLKA · ANITA EKBERG

HELMUT DANTINE · BARRY JONES
ANNA MARIA FERRERO **MILLS**
MILLY VITALE · JEREMY BRETT AND JOHN

Produced by DINO DeLAURENTIIS · Directed by KING VIDOR
Based on the novel "War And Peace" by LEO TOLSTOY

56/152

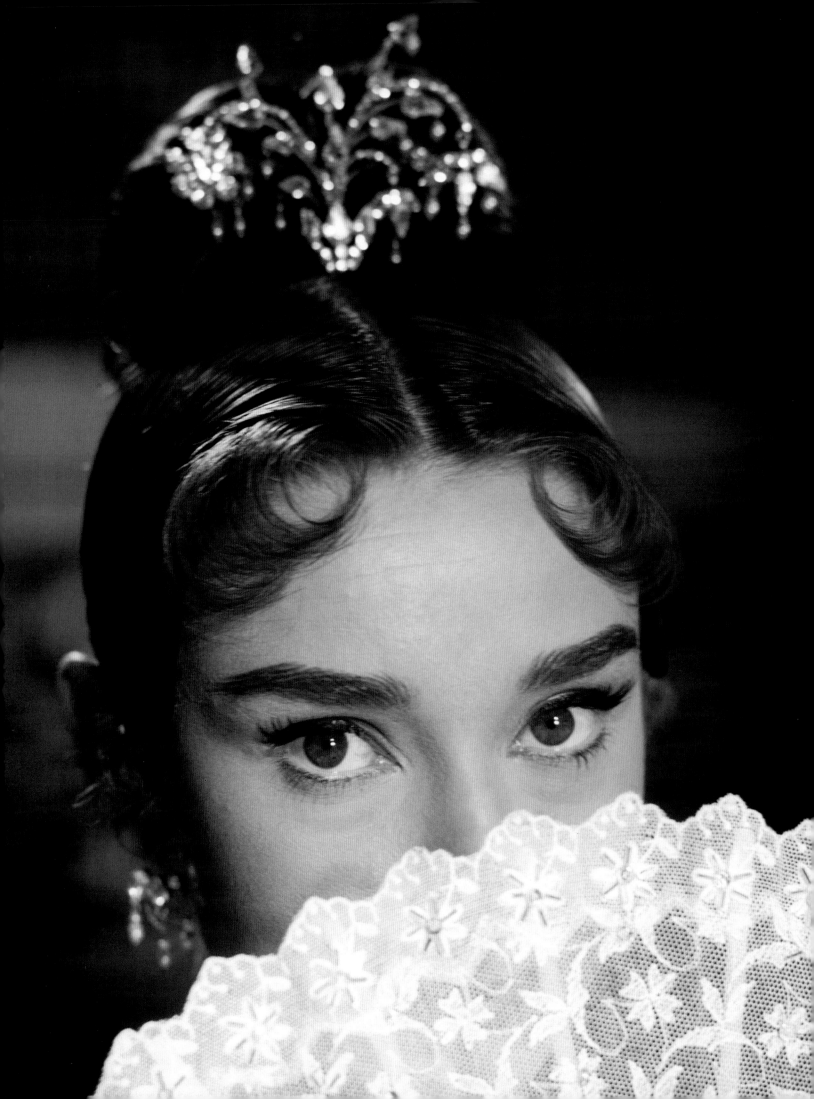

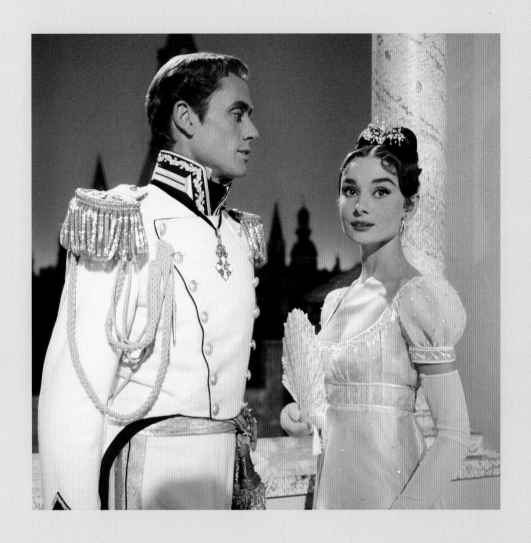

"Audrey had a perfect face and her ballet training made her walk with sleek grace. She radiated elegance. It was a joy to work with her on *War and Peace*. . . . [Audrey was wearing] a low-cut gown that revealed her clavicle, upper ribs and hyoid bone. She really had no breasts—she was a model and very thin. I suggested she wear a necklace or something with this low-cut dress, but she said, 'Jack, I'm just me. I am what I am, and I haven't done too badly like this.'"

JACK CARDIFF (Cinematographer, on the ballroom sequence)

OPPOSITE Audrey as Natasha. When Hepburn was notified of her salary for *War and Peace*, the highest ever paid to an actress at that time, she modestly told her agent, "I'm not worth it. It's impossible. Please don't tell anyone." **ABOVE** Mel Ferrer and Audrey in the ballroom scene from *War and Peace*, filmed in August 1955 at Cinecittà studios in Rome. (Photo courtesy Independent Visions/MPTV.)

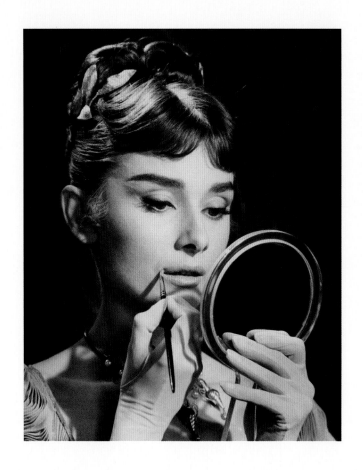

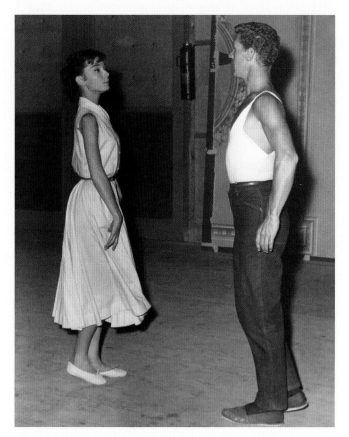

"Audrey was born photogénique. She had such beautiful bone structure that her features did not need a lot of work. She had a very strong jawline, which in a sense I reversed by emphasizing her temples. She had thick eyebrows that always needed to be thinned out. Every picture we made together, I tried to reduce them a bit more . . . but without going to extremes. She had the kind of face that needed eyebrows."

ALBERTO DE ROSSI (Makeup artist, *War and Peace*)

ABOVE LEFT Audrey perfects her lip line between takes. **ABOVE RIGHT** With choreographer Aurel Milloss during rehearsals for the ballroom scene. **OPPOSITE** Publicity photo for *War and Peace* later used as a reference for potential poster art. Note that Audrey is actually holding her rolled call sheet in place of a purse. Photo by Bud Fraker. (Photos courtesy Independent Visions/MPTV.)

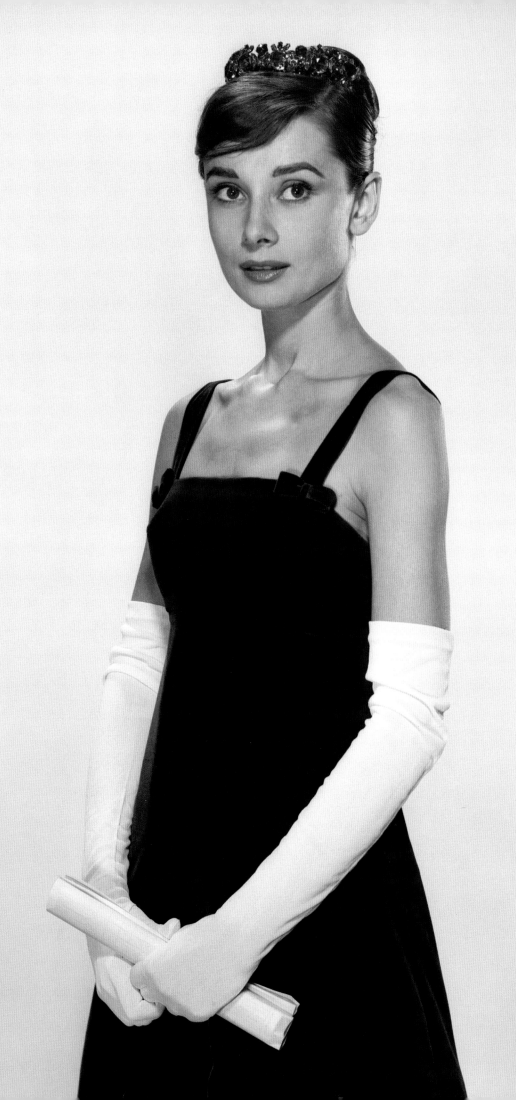

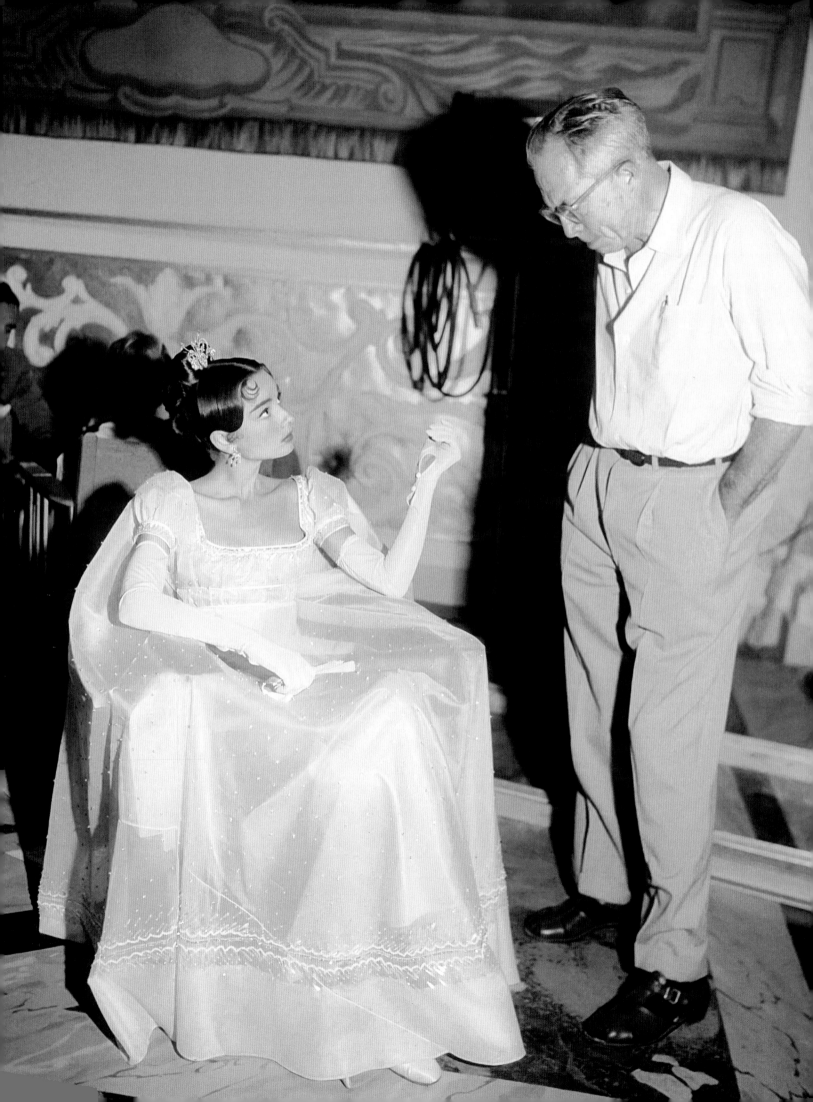

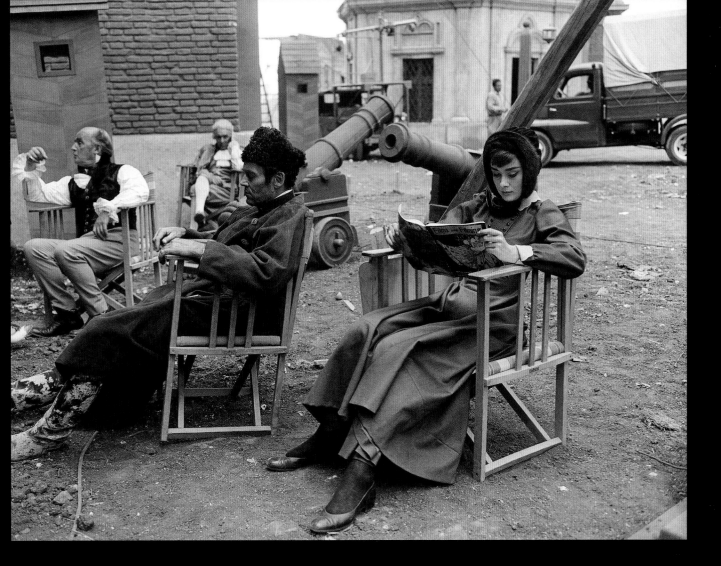

"It was of course inconceivable to have anyone other than Audrey Hepburn as Natasha. She has a rhythmic grace that is a director's delight."

KING VIDOR (Director, *War and Peace*)

OPPOSITE Audrey with director King Vidor. **ABOVE** Original news caption: "Decked out in 19th-century Russian regalia, film stars Audrey Hepburn and Henry Fonda relax to their individual tastes on the set of *War and Peace*, in Rome, Italy, on Sept. 7, 1955. Miss Hepburn scans a magazine [*Films and Filming*] while Fonda grabs 40 winks. The celluloid version of the Tolstoi novel is reportedly a five million dollar production. (Photo by Mario Torrisi.)"

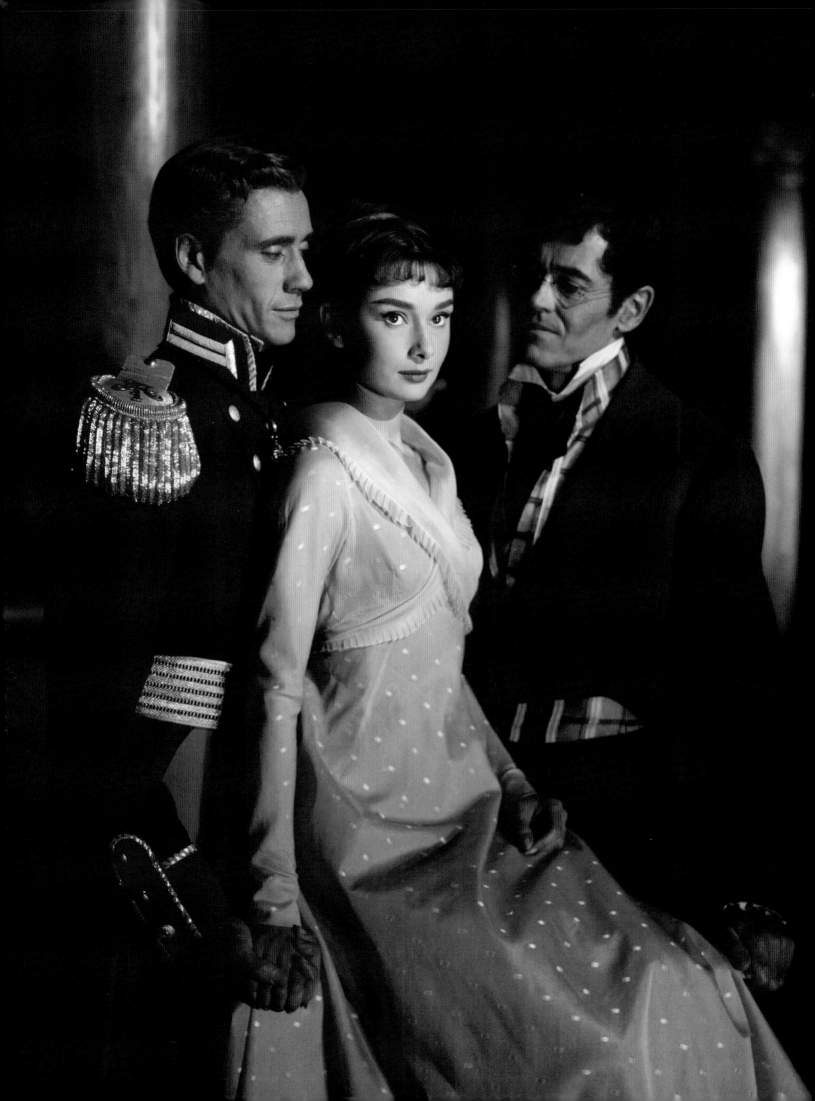

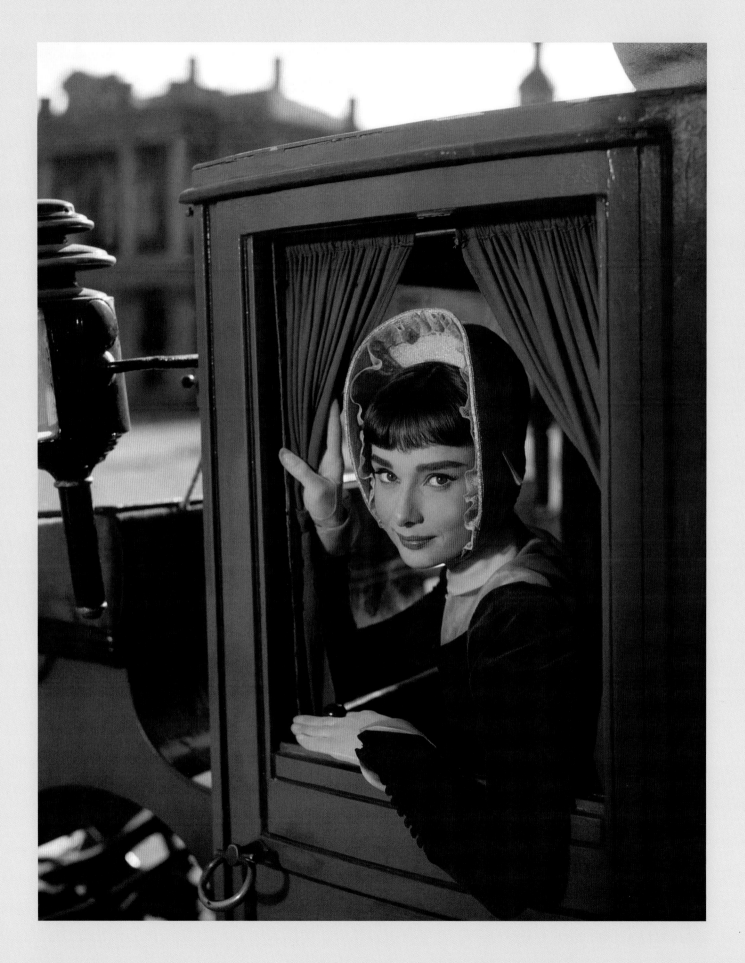

OPPOSITE Audrey with costars Mel Ferrer as Prince Andrei Bolkonsky and Henry Fonda as Pierre Bezukhov. Fonda later claimed that producer Dino De Laurentiis would go into fits of rage whenever he saw him wearing eyeglasses, as the character of Pierre is supposed to do; this, De Laurentiis argued, was not proper heroic attire. **ABOVE** Audrey as Natasha, *War and Peace*.

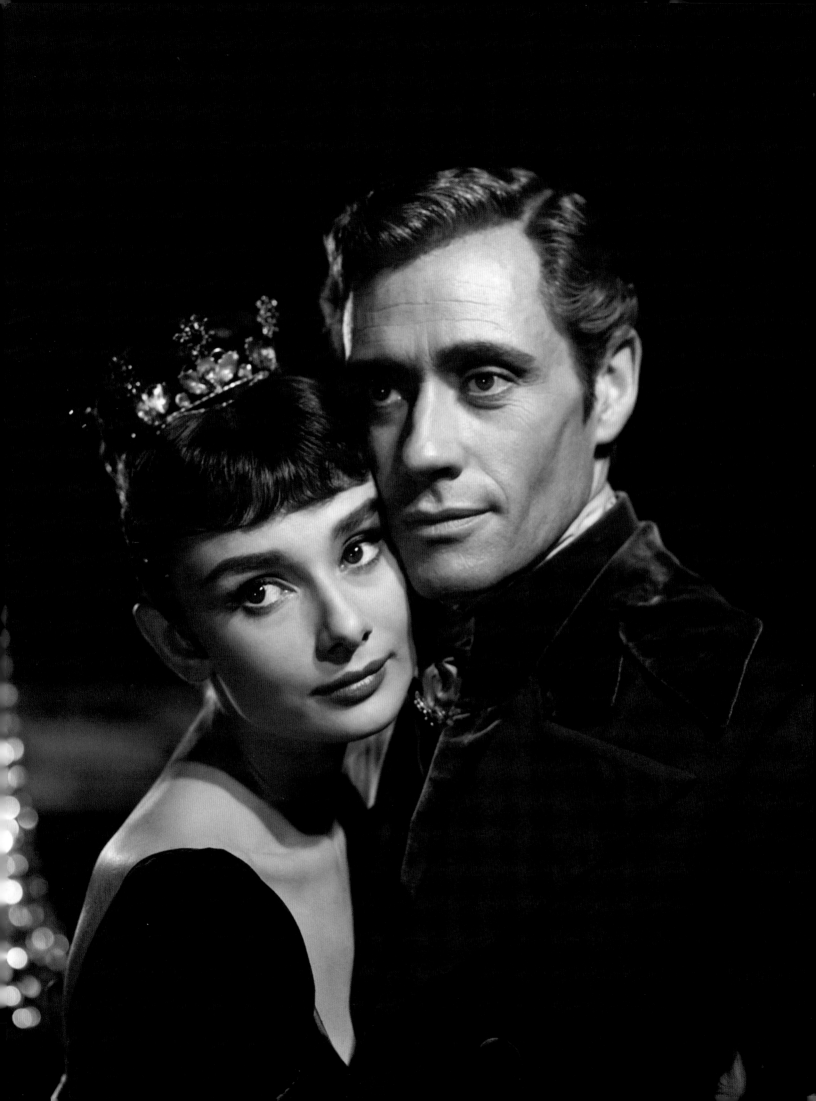

"At fittings, Audrey liked to try out the motions of walking, sitting, dancing. This meant not only the clothes themselves but the underthings, the shoes, the hats, the gloves. . . . Once she worked out the mechanics, she was happy. Sometimes this took ten minutes, sometimes ten hours. She knew exactly what she wanted, and there were no limits to the time or work that went into it."

HUBERT DE GIVENCHY (Audrey's costume consultant for *War and Peace*)

OPPOSITE AND ABOVE With Mel Ferrer, *War and Peace.*

"I did *War and Peace* in velvets and furs in August. In the hunting scene where I'm in the velvet and a high hat, the family was plodding across a big field in the blazing Roman sunshine and, all of a sudden, my horse fainted out from under me. They quickly got me out of the saddle so I didn't end up being rolled over. So when they say I'm strong as a horse, I am. I'm stronger! I didn't faint. The horse did."

AUDREY HEPBURN

Audrey and "costar" during the hunting scene in *War and Peace*.

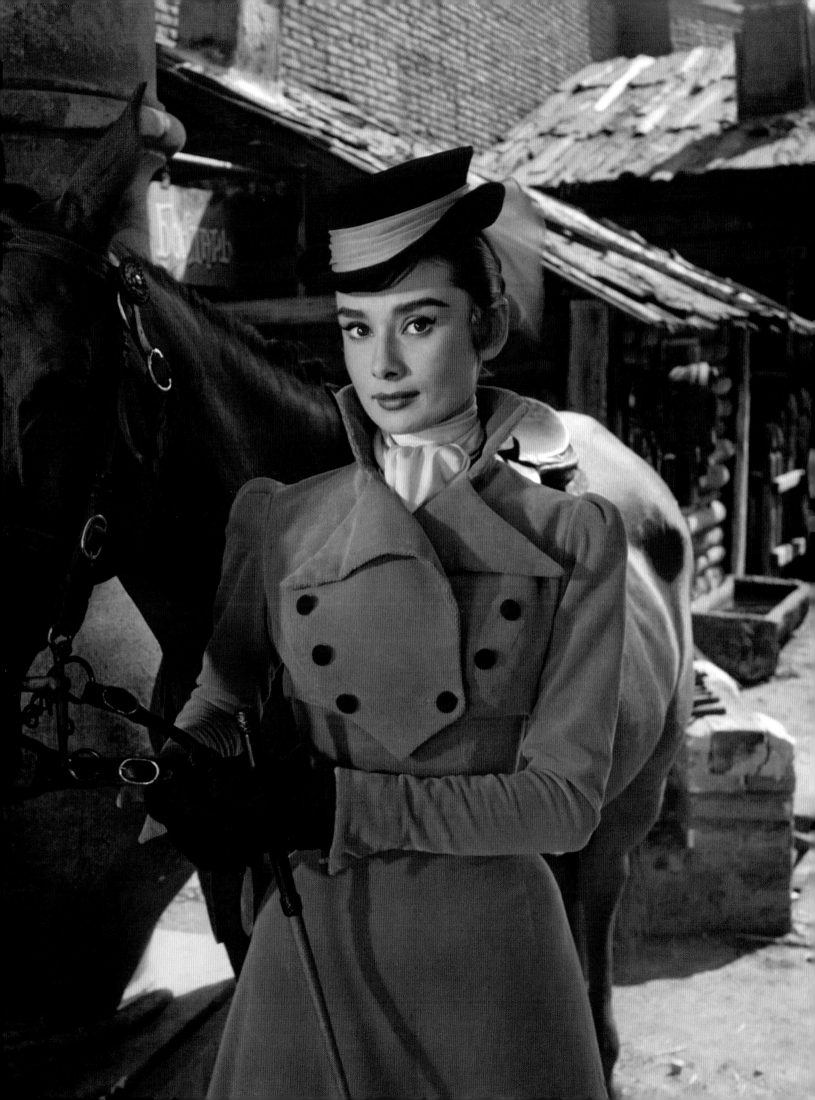

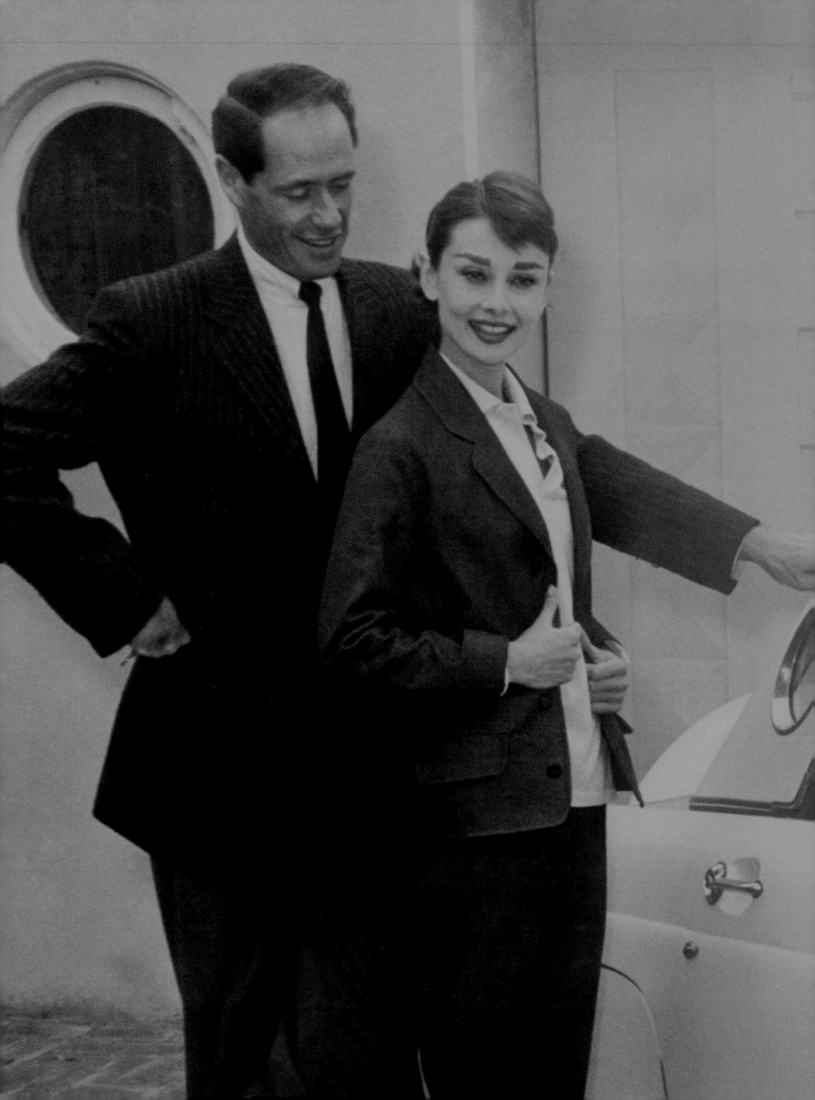

Audrey
à la Maison

1954 – 1956

Audrey with husband Mel Ferrer vacationing at their rented beach house in Malibu, CA, 1956. Photo by Bill Avery (courtesy Independent Visions/MPTV).

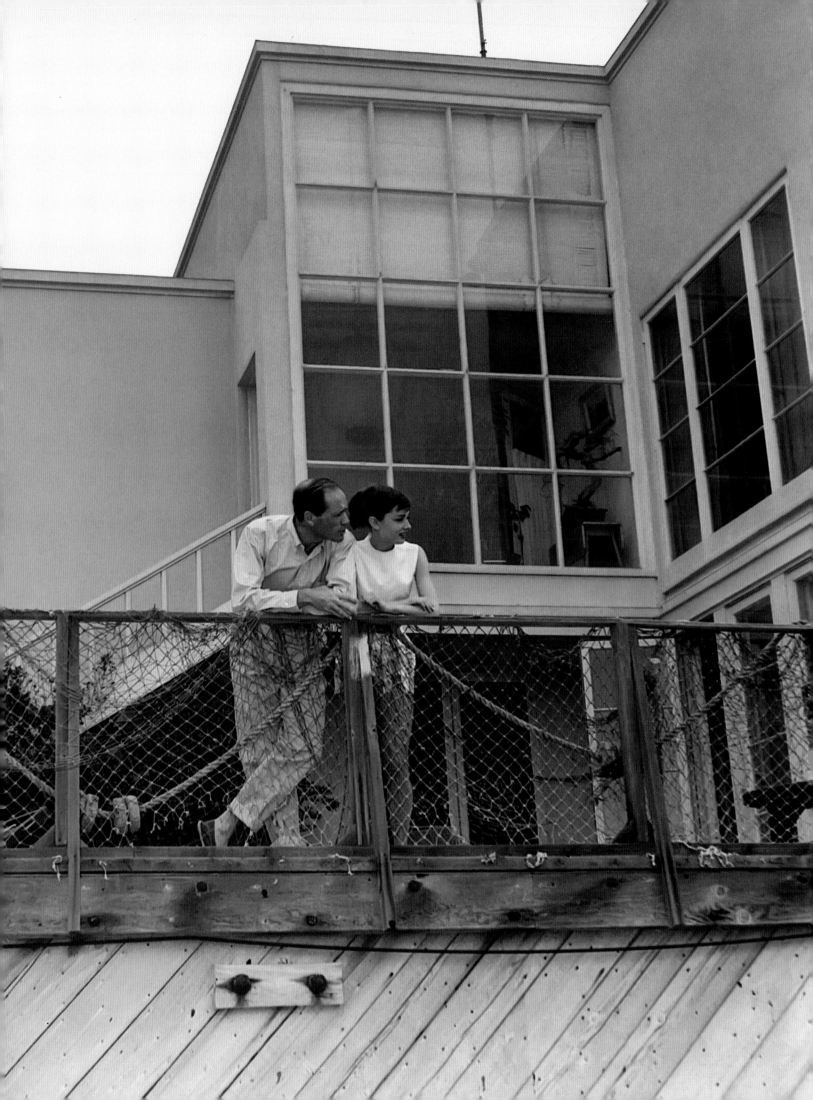

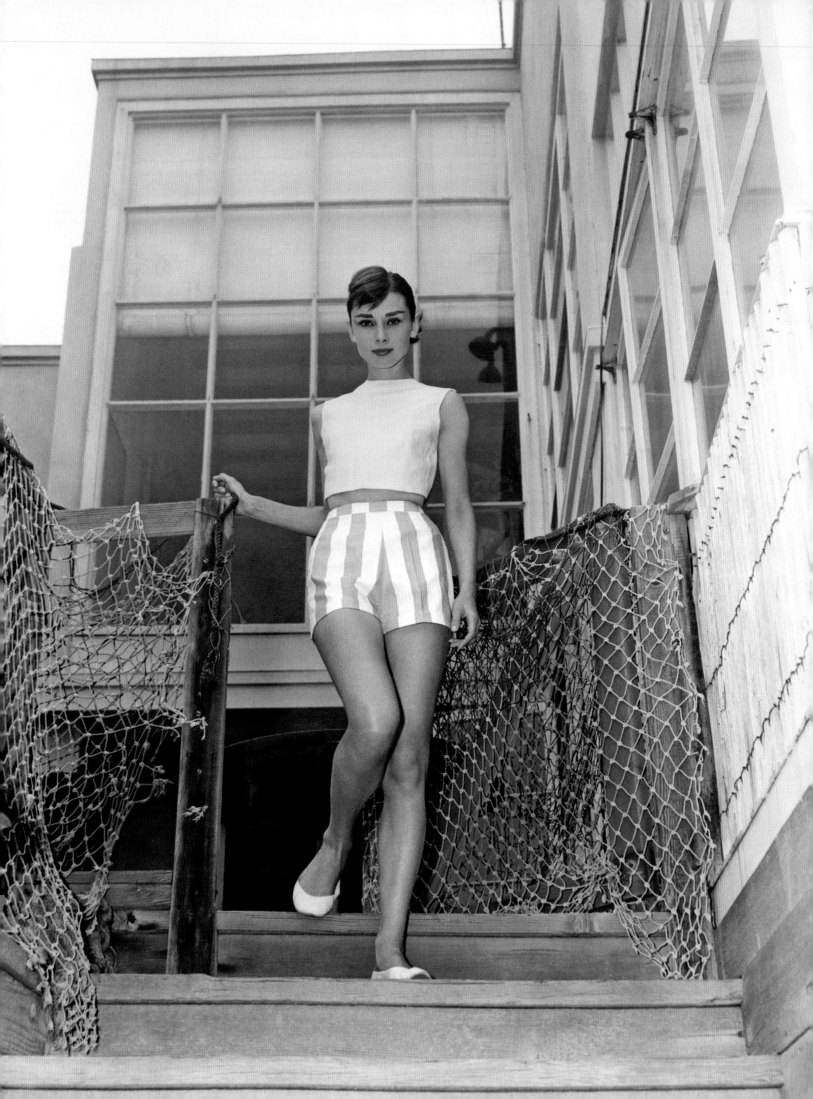

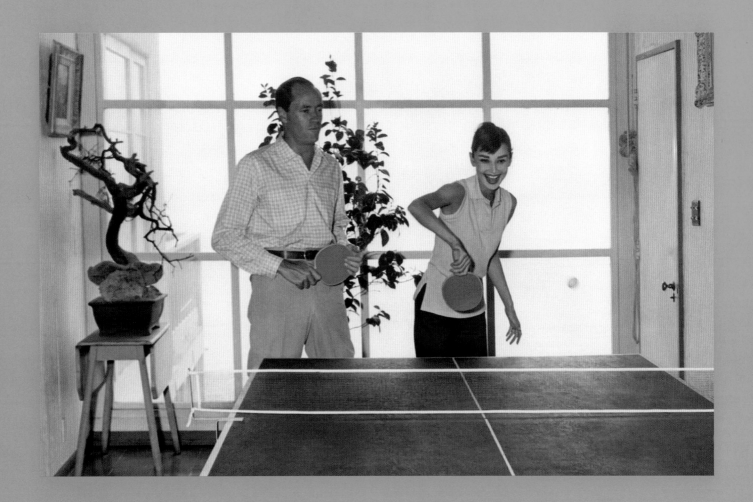

"She was the last Hollywood actress whose presence as the star of a film always sold tickets and made the studios great profits. . . . I once went to a small party at her apartment in Rome. She was sweet and charming and instantly made someone feel at ease. Though she was one of the few movie stars I ever met who looked exactly in the flesh like she did on screen, there was a humility about her that never made you feel you were in the presence of one of the last superb artists of the golden years of the great Hollywood studio system."

PAUL MORRISSEY (Producer, writer, and director)

OPPOSITE Audrey in Malibu, CA, 1956. **ABOVE** Audrey with Mel Ferrer enjoying a game of Ping-Pong while on vacation at their rented beach house in Malibu, 1956. Photos by Bill Avery (courtesy Independent Visions/MPTV).

ABOVE Audrey in the kitchen of her apartment, Manhattan, NY, 1954. **OPPOSITE** Original news caption: "June 30, 1954, New York, NY. Pixyish Audrey Hepburn, Academy Award actress, beats the Manhattan heat with a cool play suit as she does chores in her New York apartment. Miss Hepburn, who will soon be seen in the movie *Sabrina*, leaves July 6th for a two month vacation in Holland, Switzerland and England." **OVERLEAF** Audrey relaxes on the terrace of her apartment, Manhattan, 1954. (Photos courtesy Independent Visions/MPTV.)

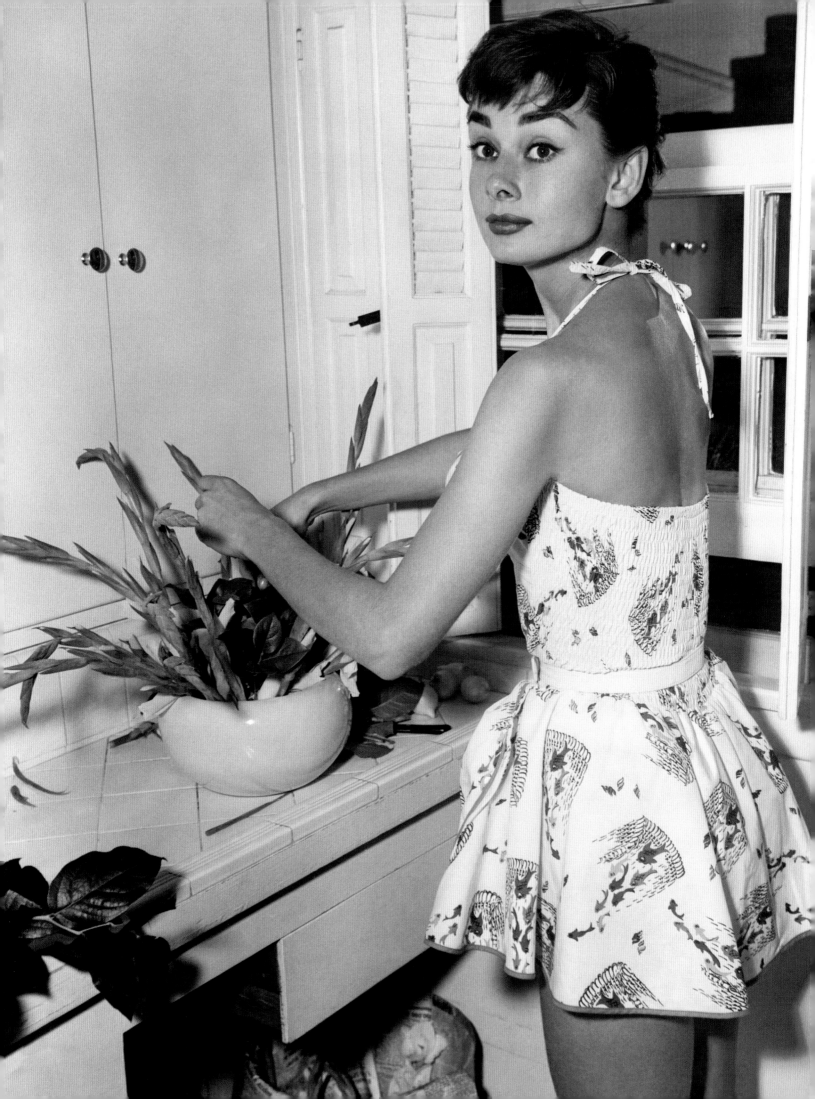

"Those first few weeks were heaven. I remember we would talk for hours and then say nothing for the same amount of time. Time, in fact, was irrelevant. There was no yesterday and no tomorrow. It was only the present, and the present was perfect."

AUDREY HEPBURN (On the time just after marrying Mel Ferrer, when they lived at a farmhouse in the Alban Hills, near Anzio beach, Italy)

OPPOSITE Audrey and Mel Ferrer at home, Beverly Hills, 1956. (Photo courtesy Independent Visions/MPTV.)

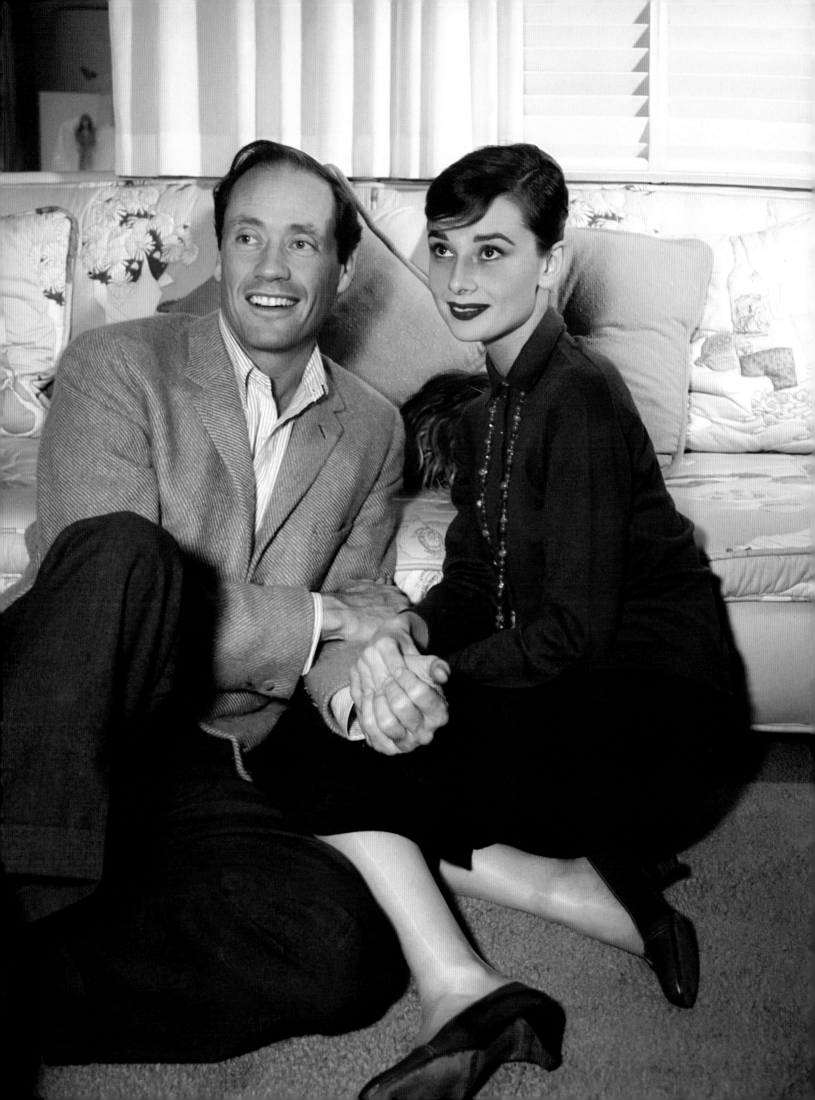

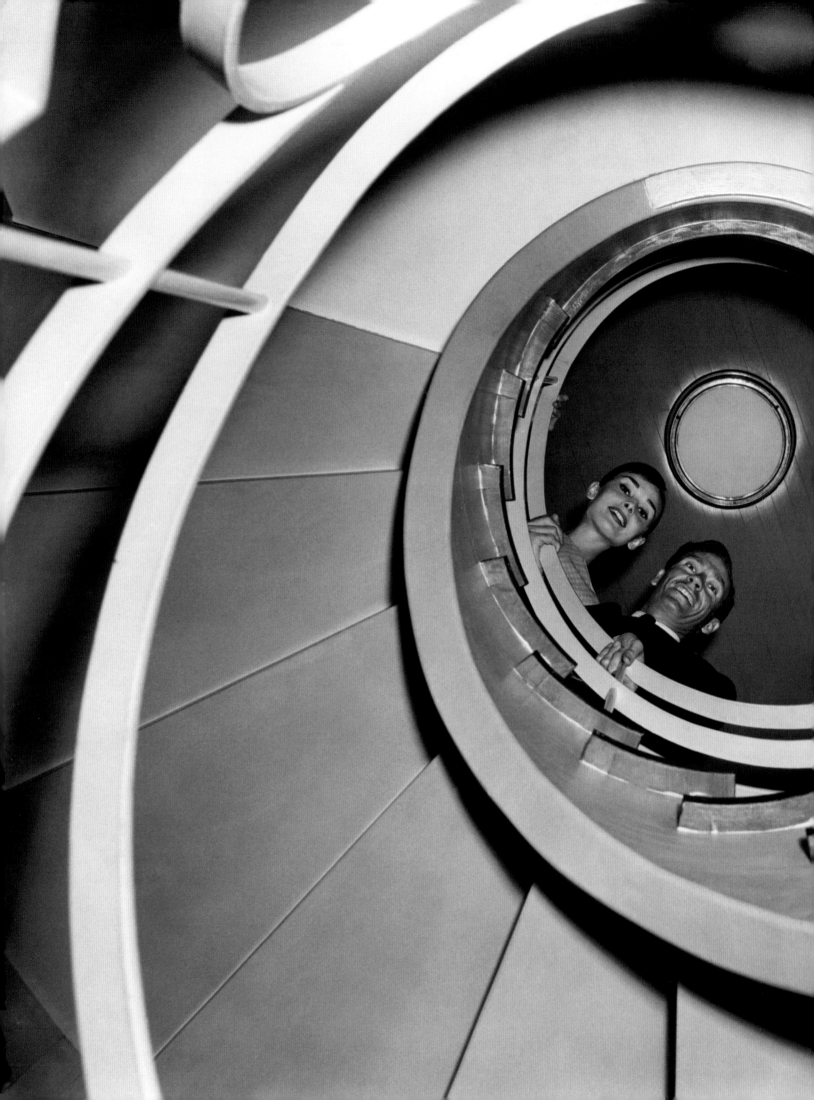

The Ferrers assume a unique perspective at their rented beach house in Malibu, CA, 1956. Photo by Bill Avery (courtesy Independent Visions/MPTV).

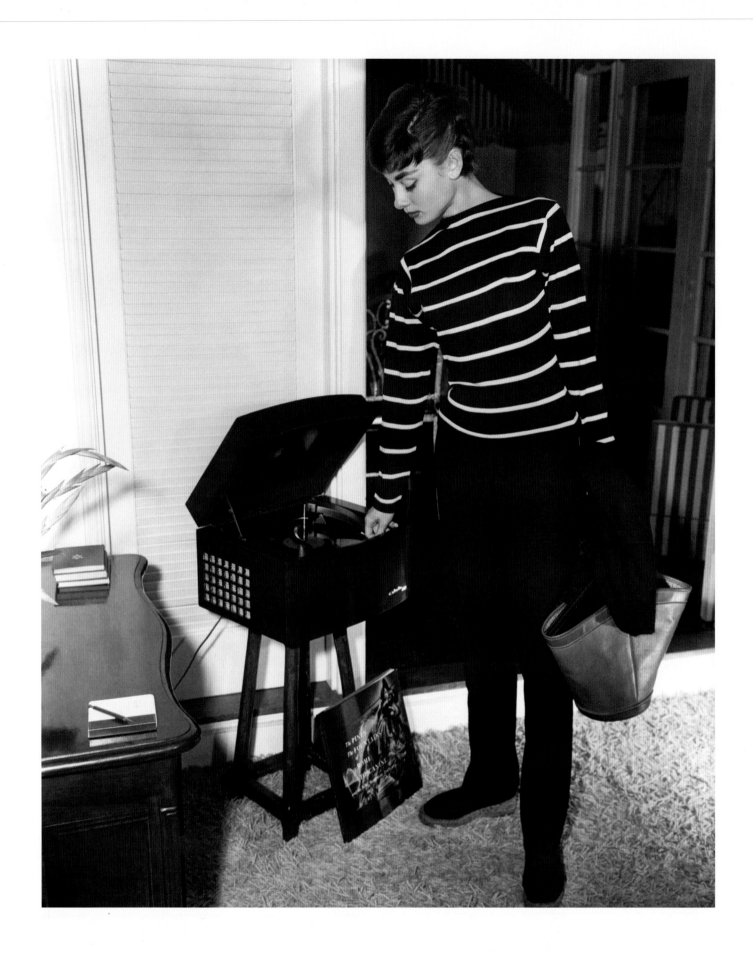

ABOVE AND OPPOSITE Audrey in her apartment, Manhattan, NY, June 30, 1954.
OVERLEAF Audrey and Mel Ferrer with their 1956 Ford Thunderbird outside their home in Beverly Hills, 1956. Photo by Bill Avery. (Photos courtesy Independent Visions/MPTV.)

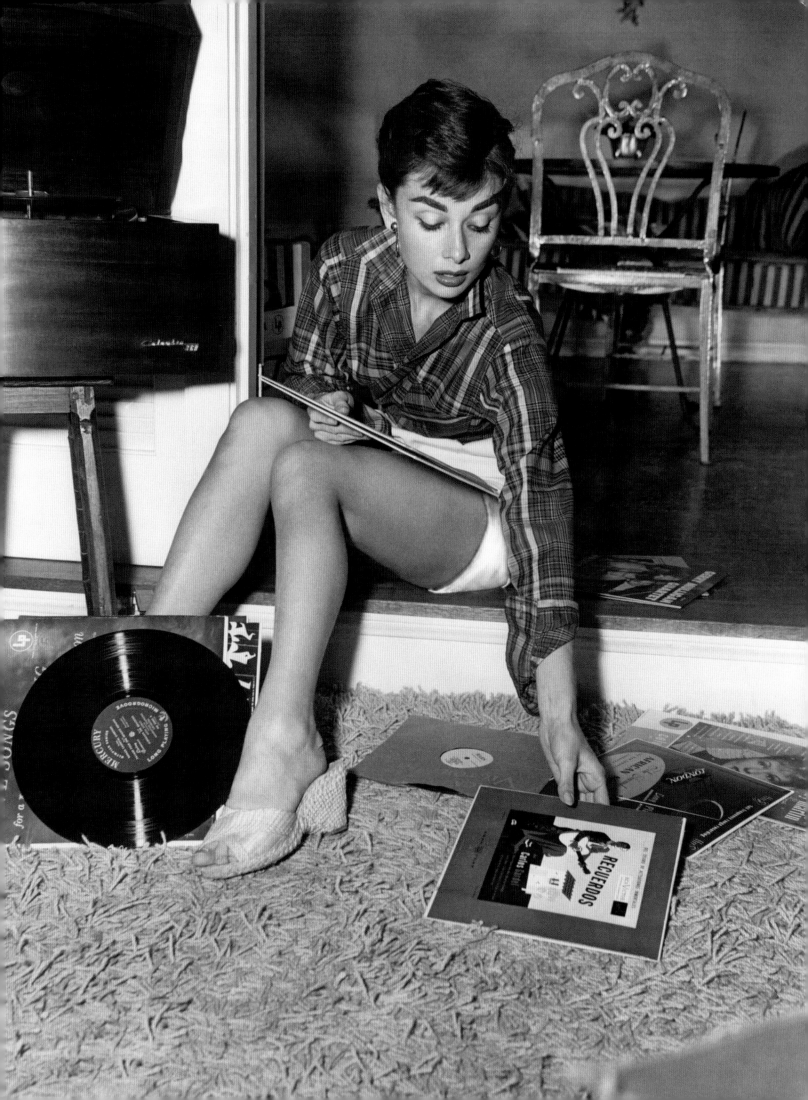

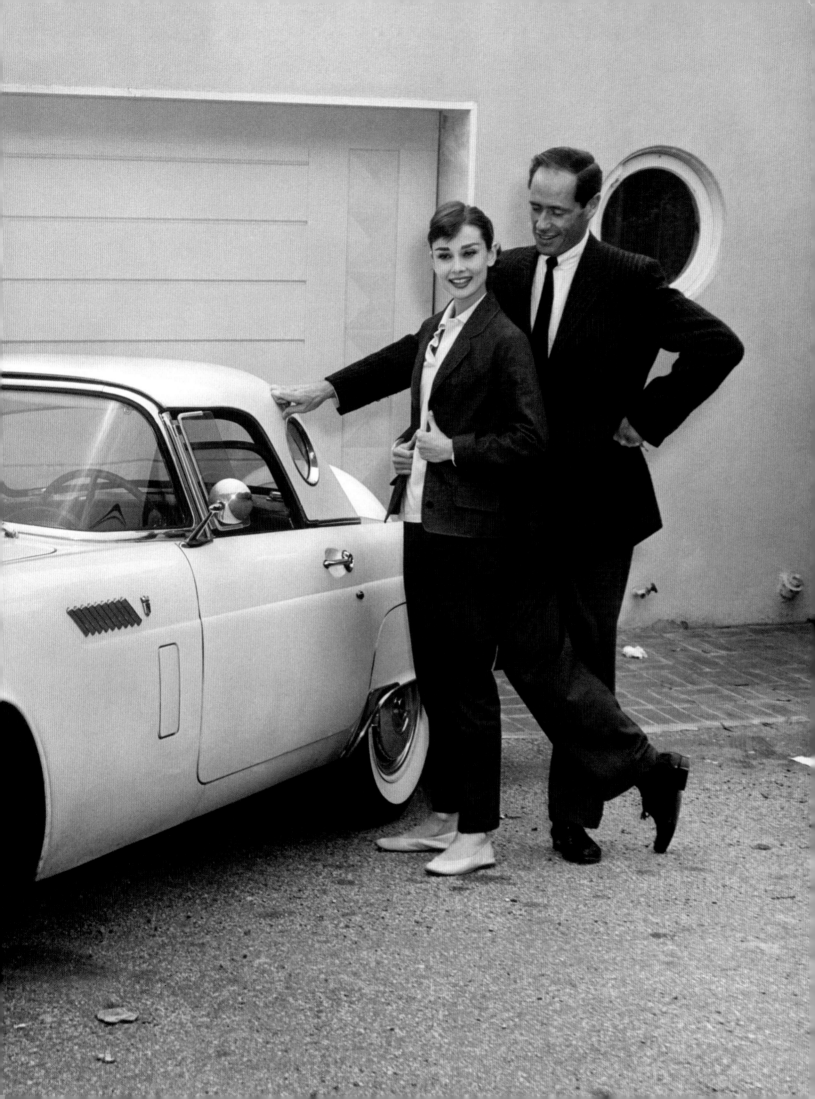

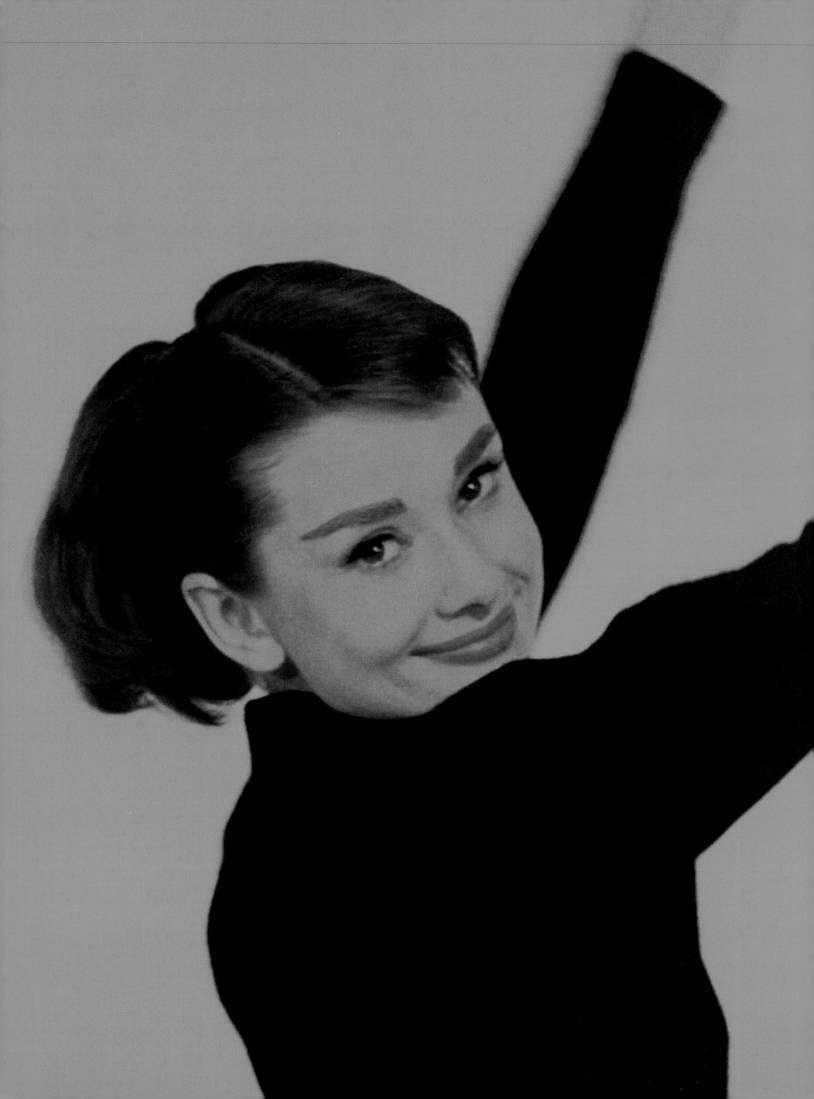

Funny Face

1957

Audrey Hepburn as Jo Stockton in *Funny Face*.
Directed by Stanley Donen, Paramount, 1957.
(Photo courtesy Independent Visions/MPTV.)

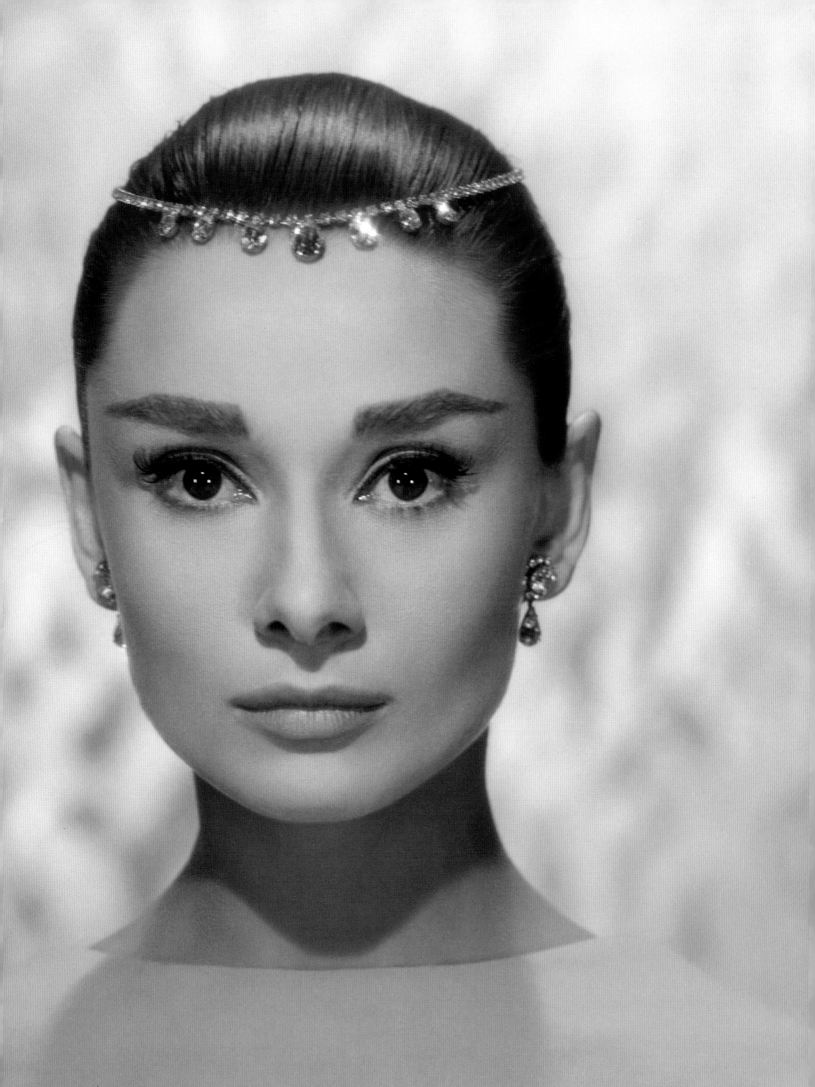

"I didn't think that was going to be hard at all, and it really wasn't. But I did have to look vastly different before I became a model. Edith and Hubert focused on colors. In the early parts of the movie, I am dressed in drab, muddy tones."

AUDREY HEPBURN (Recalling having to be made to look plain for the early scenes in *Funny Face*)

ABOVE Audrey as Jo gets cut down to size by the fashion editors at *Quality* magazine, *Funny Face*.
OPPOSITE With legendary Avedon muse Dovima, here playing the intellectually challenged model Marion, as *Quality* magazine takes over the Embryo Concepts bookstore, *Funny Face*.

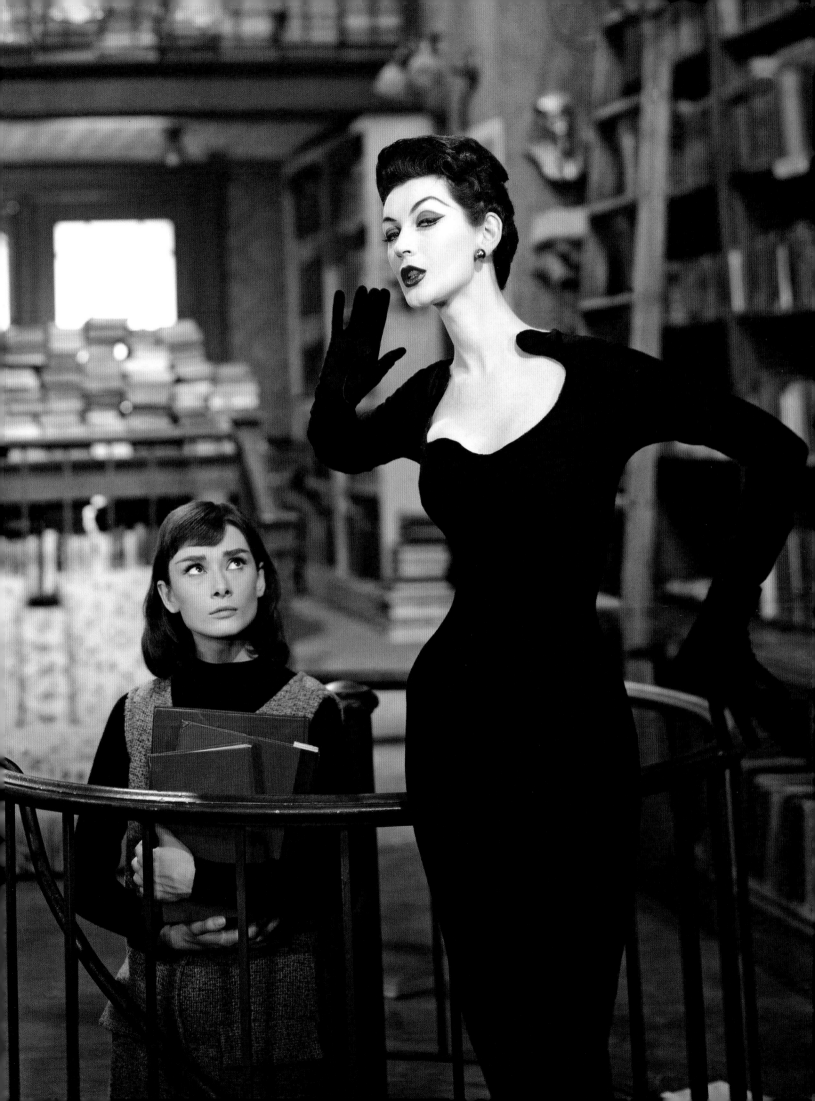

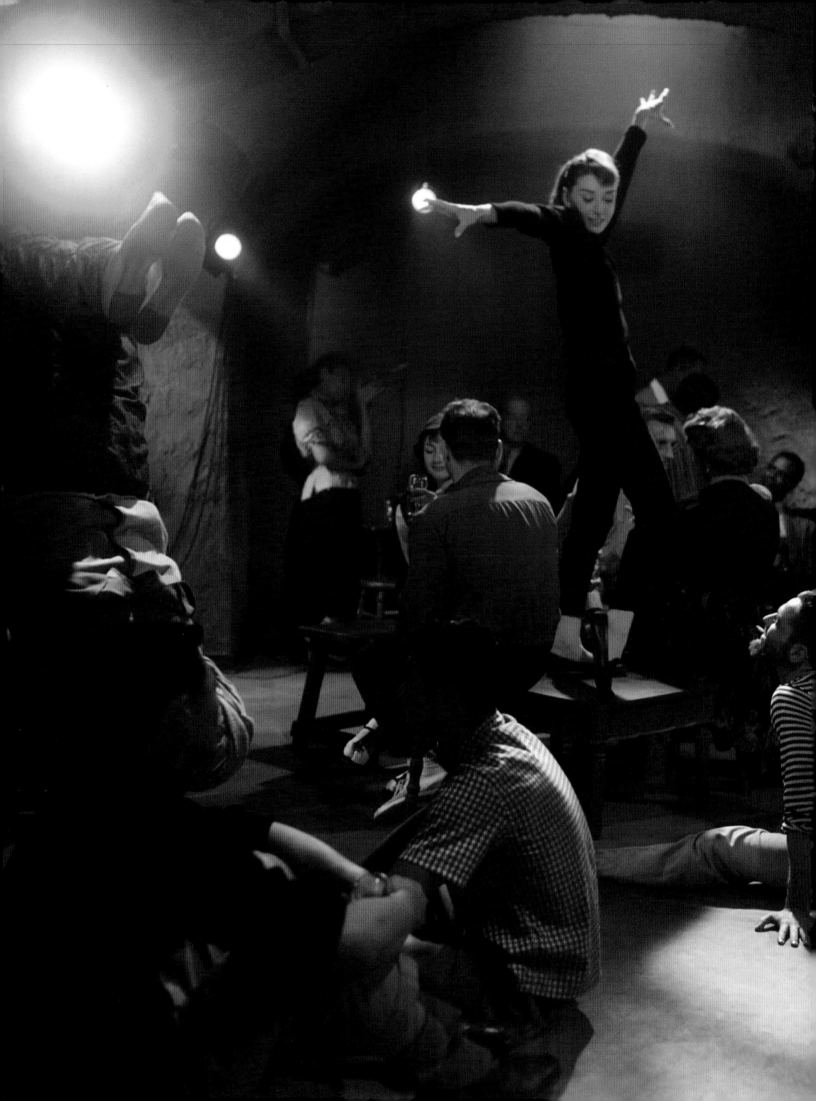

Audrey performing the musical number "Basal Metabolism" from *Funny Face*. (Photo courtesy Independent Visions/MP

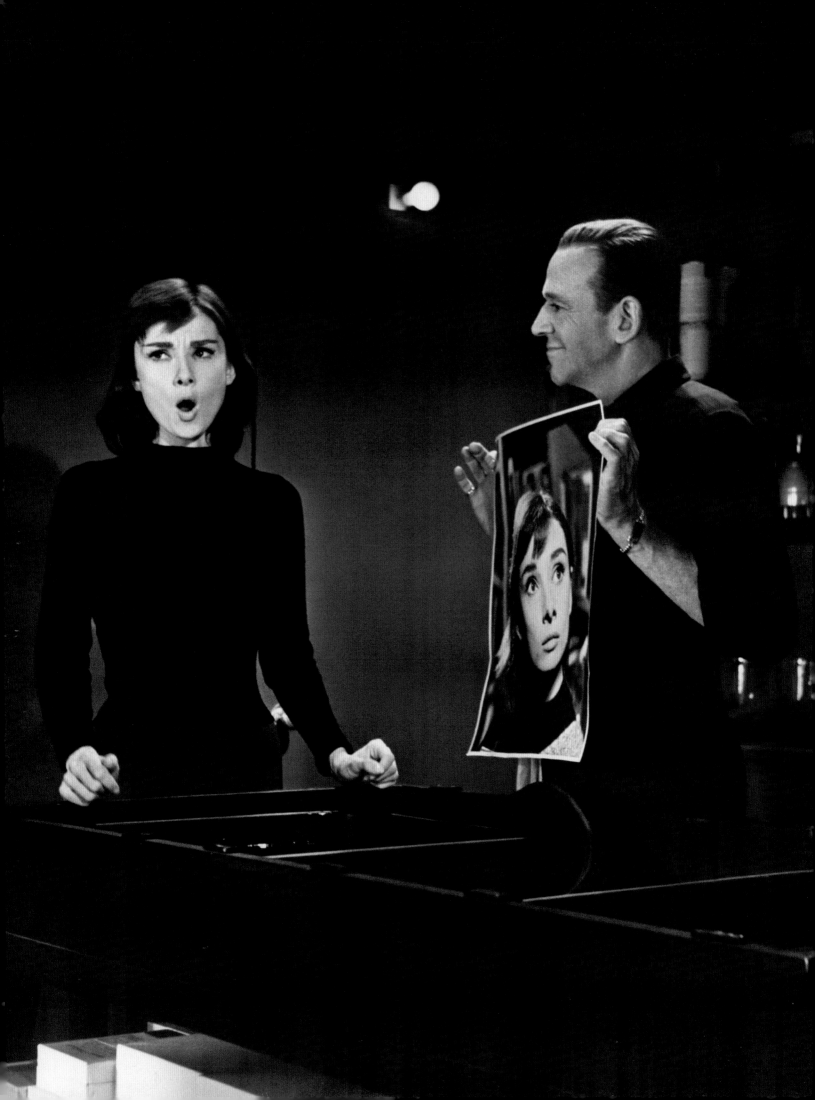

"[Ensuring that the movie was not] painfully silly, I made sure most of the things that happened could at least have really happened. But I found the whole piece so charming, so light and refreshing, that I didn't have too many objections. How could you, when you got to see Audrey Hepburn every day?"

RICHARD AVEDON (Photographer and visual consultant, *Funny Face*)

OPPOSITE With costar Fred Astaire as fashion photographer Dick Avery (a character more than loosely based on legendary lensman Richard Avedon), *Funny Face*. **ABOVE** With Richard Avedon on the set of *Funny Face*. (Photo courtesy Independent Visions/MPTV.)

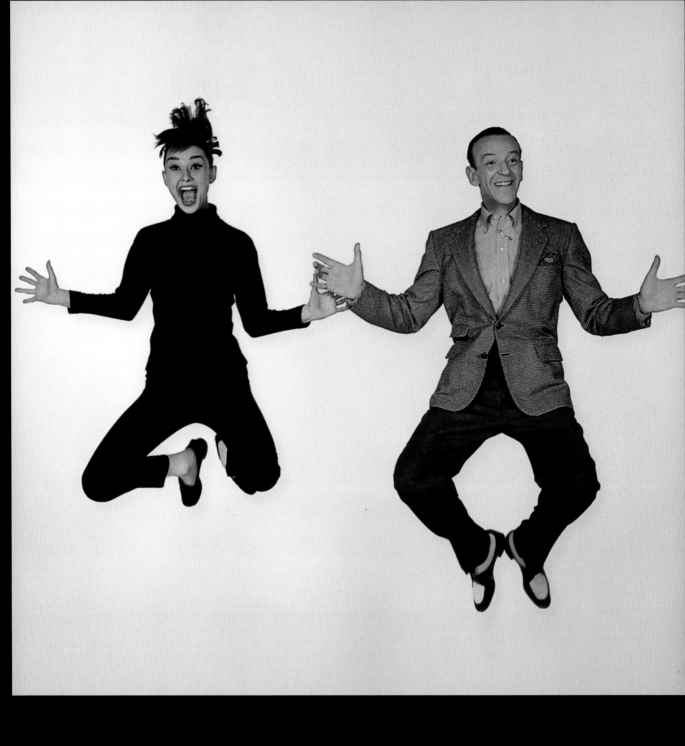

"When Audrey rocks—you'll roll!"

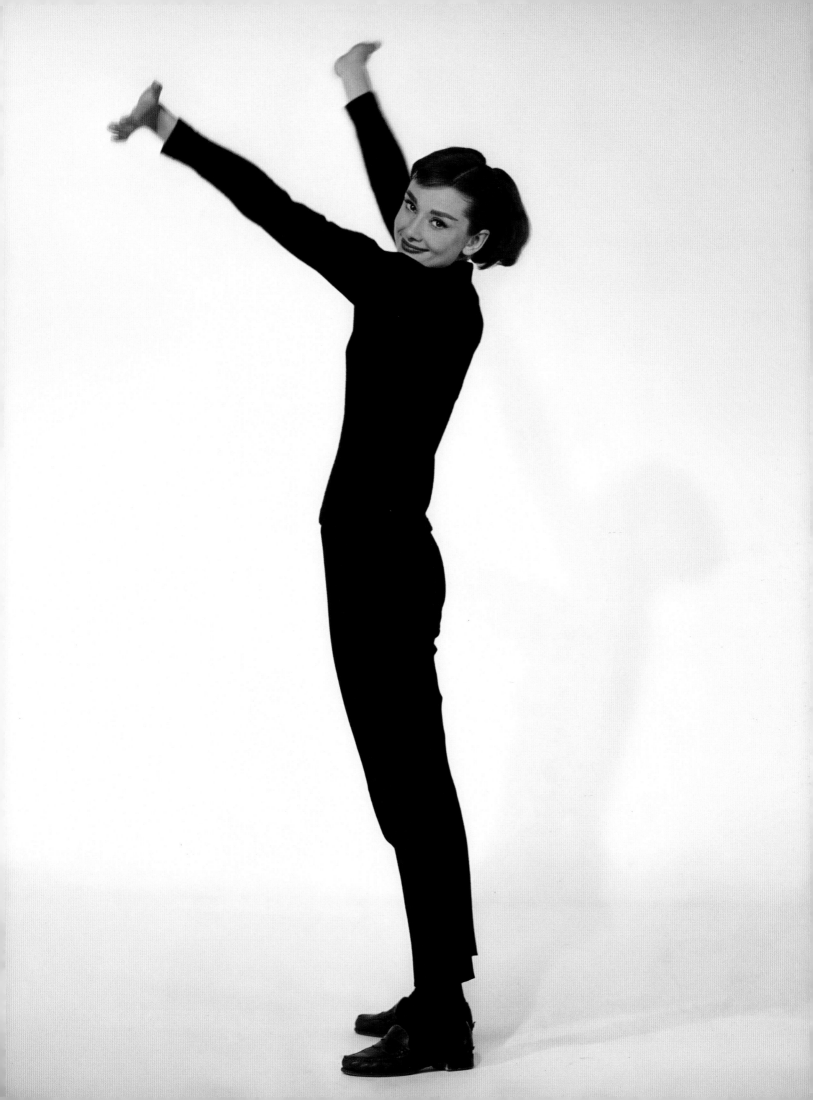

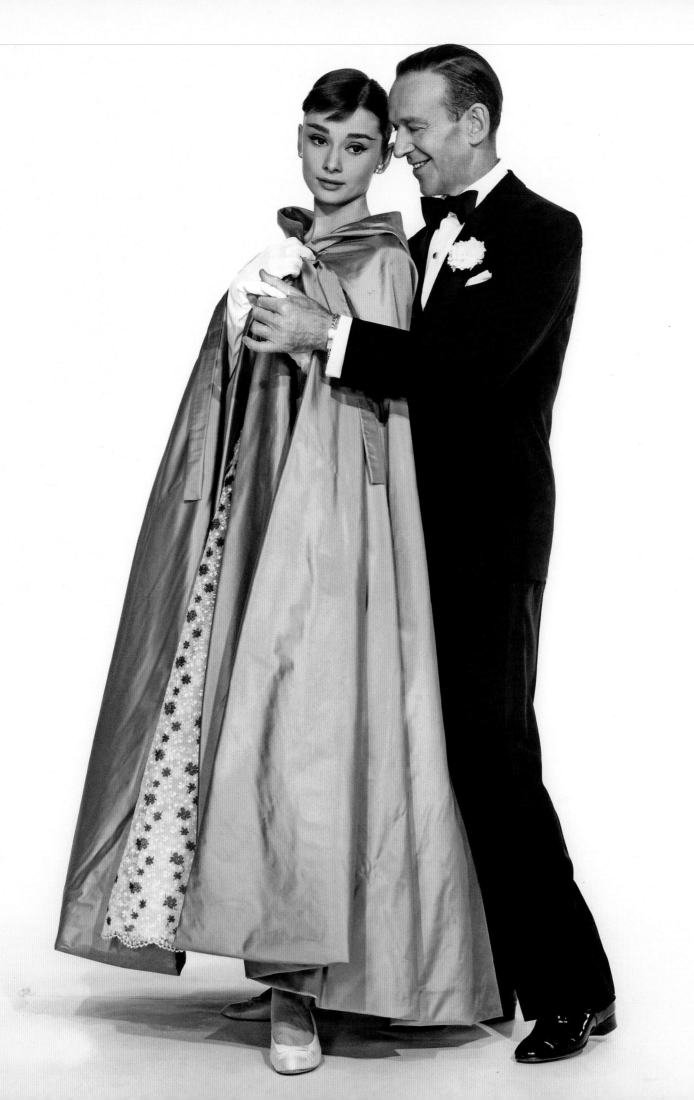

"Audrey was very serious. There was no coziness, no demanding to speak to Stanley on the side, no secret conversations, no anything like that. The poor thing was doing something monumental in a hurry. Fortunately, the songs were perfect for her. That one with the hat? Heaven! Stanley had Audrey pretend something from the very start of the picture. He had her do a whole thing of young-girl attitudes toward Fred, so she felt that she was really half in love with him from the beginning."

KAY THOMPSON (Costar, *Funny Face*)

Audrey with costars Kay Thompson (as the Diana Vreeland–inspired fashion magazine publisher and editor Maggie Prescott) and Fred Astaire on location at the Eiffel Tower in Paris for the filming of the musical number "Bonjour, Paris" from *Funny Face*. (Photo courtesy Independent Visions/MPTV.)

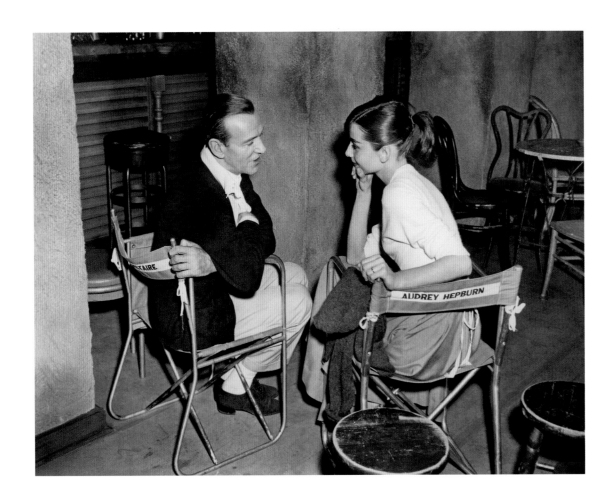

"Fred would assure Audrey that she was a wonderful dance partner, and she would assure him that he was not too old for her. What held it together was that both thought the other was near perfection."

STANLEY DONEN (Director, *Funny Face*)

ABOVE Audrey with Fred Astaire relaxing between takes on the set of *Funny Face*.
OPPOSITE *Funny Face*. Photo by Bud Fraker. (Photos courtesy Independent Visions/MPTV.)

"Nearly half of the picture was shot in Paris, where we spent many extra days waiting for good weather. It rained so much that one of the fashion model scenes at the Tuileries was shot in the rain by force of circumstances. This lent an effective and unusual touch photographically which probably never would have been preconceived."

FRED ASTAIRE (Costar, *Funny Face*)

OPPOSITE AND OVERLEAF Audrey posing on location at the Jardin des Tuileries in Paris, *Funny Face*. Dresses by Givenchy. (Photos courtesy Independent Visions/MPTV.)

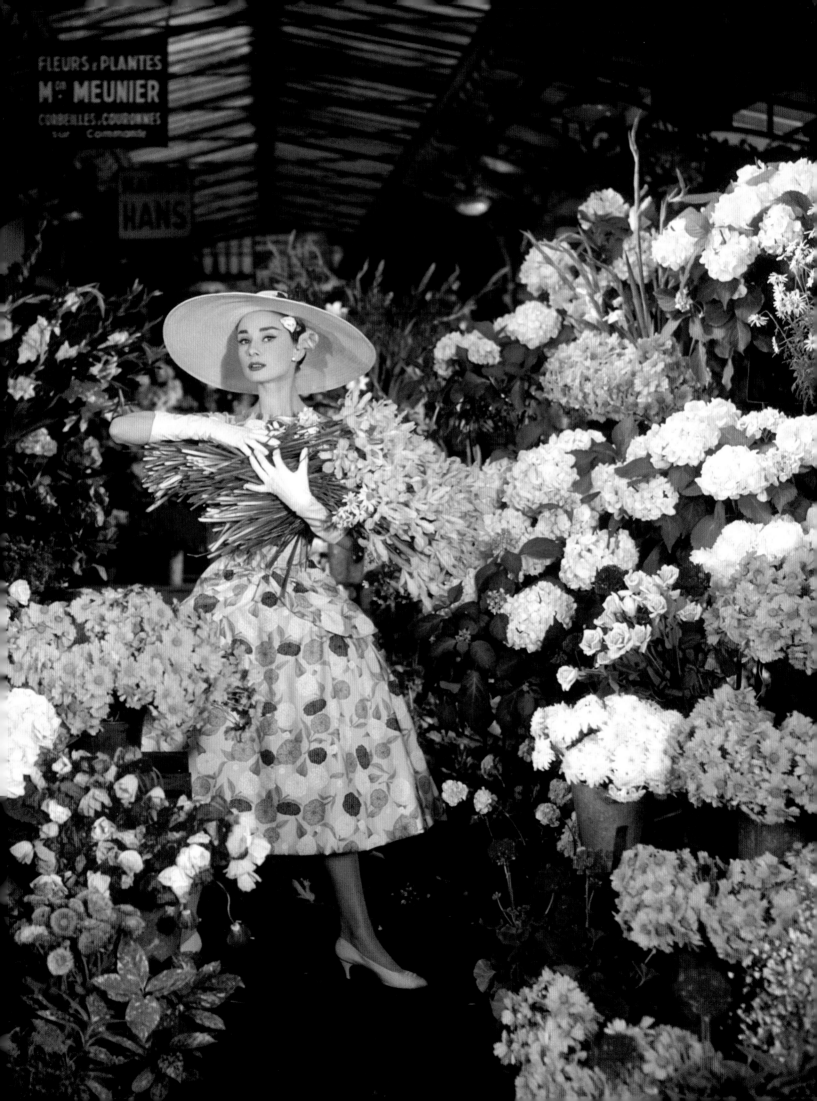

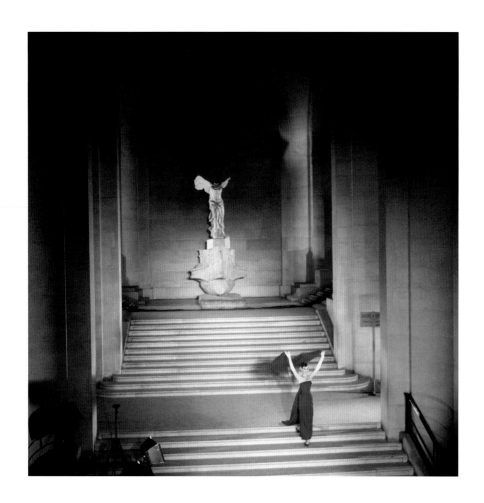

"Gazelles have elegance—and Audrey Hepburn, magnificently."

DIANA VREELAND (Editor in chief, *Vogue*, 1963–1971)

ABOVE AND OPPOSITE Descending the Daru Steps below the Winged Victory of Samothrace at the Louvre, Paris, *Funny Face*. Gown by Givenchy. (Photos courtesy Independent Visions/MPTV.)

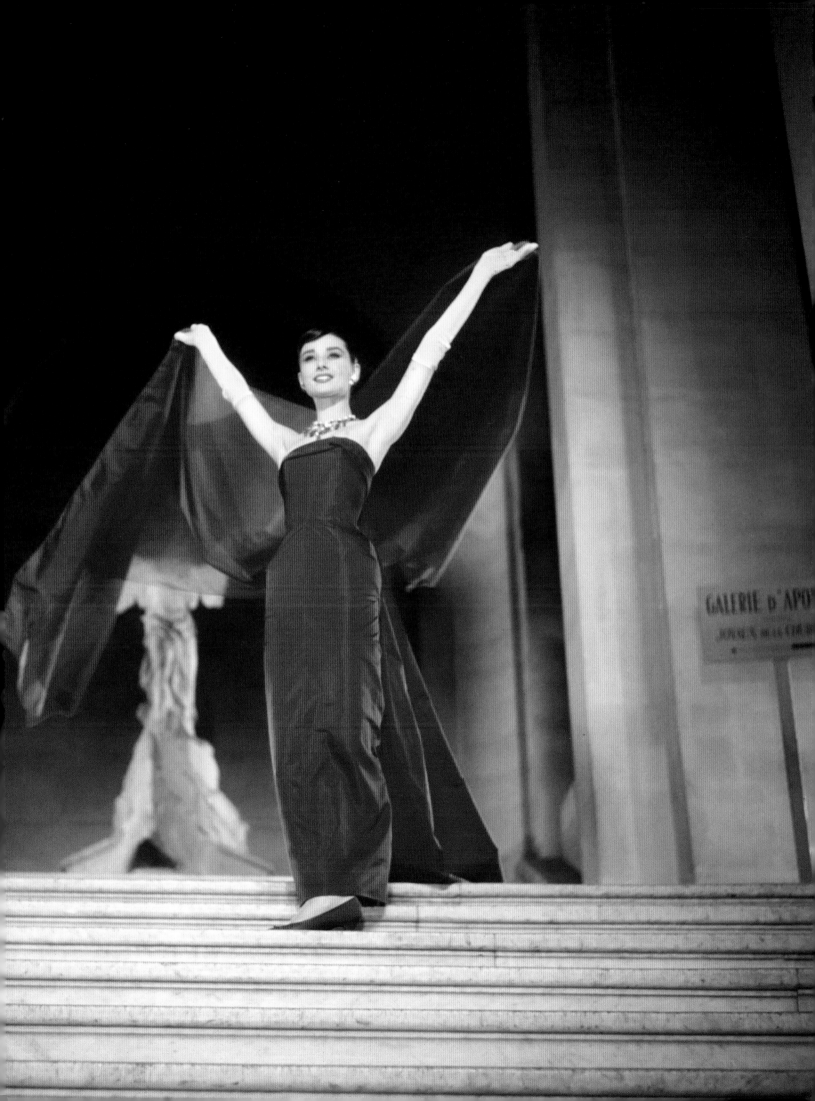

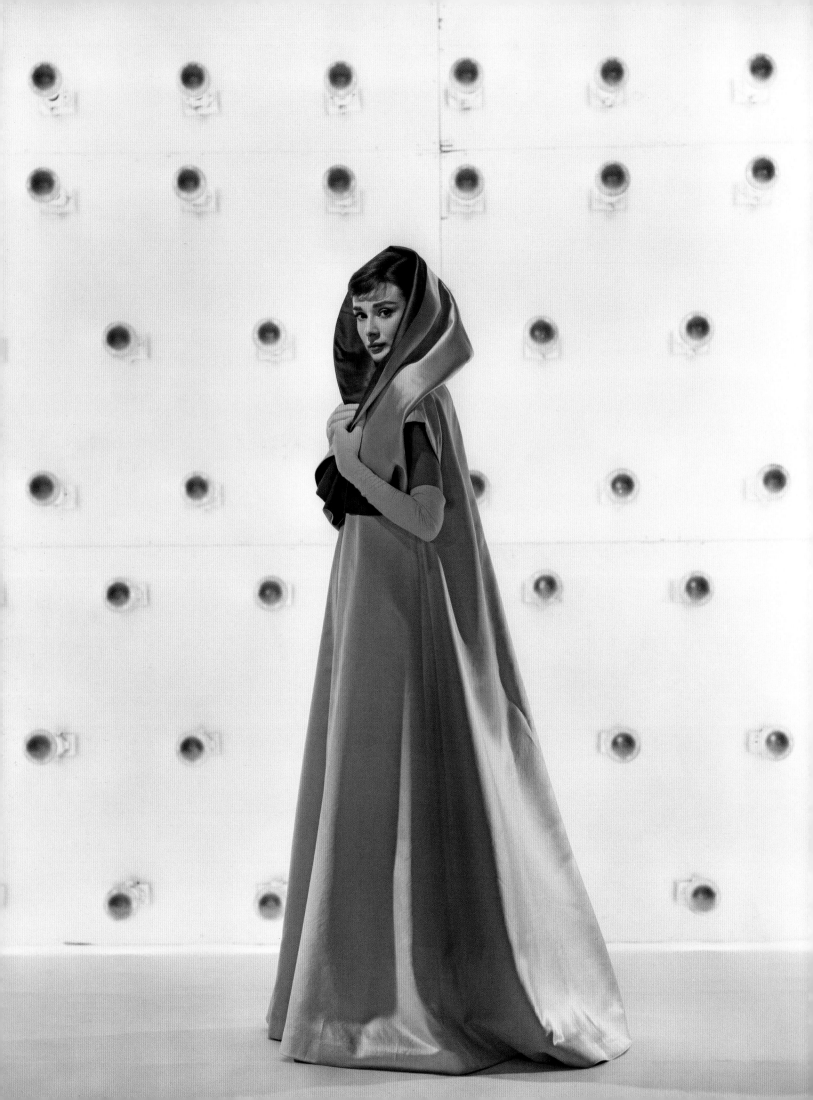

"Balenciaga once said, 'the secret of elegance is elimination.' I believe that. That's why I love Hubert de Givenchy....[His are] clothes without ornament, with everything stripped away.... There are few people I love more. He is the single person I know with the most integrity."

AUDREY HEPBURN

On the Grand Staircase of Palais Garnier in Paris, *Funny Face*. Evening cloak and dress by Givenchy. (Photo courtesy Independent Visions/MPTV.)

"Stanley was very visually minded and we went over what would make good pictures for the fashion montage—the train, the flower market. If you froze a motion picture frame in those days, the grain would be enormous, so we couldn't go to that large a frame in 35mm. So, we took my actual 8×10 camera, attached it to the movie camera, and shot through a mirror, so I would take the picture with my camera at the exact same moment it was happening on film. In the lab they could locate the same frame, insert mine, and therefore have a much better quality image."

RICHARD AVEDON (Photographer and visual consultant, *Funny Face*)

ABOVE The Latona Fountain in the Gardens of Versailles, Paris, *Funny Face*. Dress by Givenchy. **OPPOSITE** With Audrey's Yorkshire terrier, "Mr. Famous," at Gare du Nord in front of la Fléche d'Or luxury boat train, Paris, *Funny Face*. Traveling suit by Givenchy. (Photo courtesy Independent Visions/MPTV.) **OVERLEAF** *Funny Face*. Photo by Bud Fraker.

"People associate me with a time when movies were pleasant, when women wore pretty dresses in films and you heard beautiful music. I always love it when people write to me and say, 'I was having a rotten time, and I walked into a cinema and saw one of your movies, and it made such a difference.'"

AUDREY HEPBURN

"I am fairly proud of my voice in *Funny Face*. A lot of people don't realize the movie wasn't dubbed. But Kay [Thompson] persuaded me I could hold my own. I'm so glad she did. I was so afraid of performing with Astaire that I felt I couldn't do anything. But I always went through enormous insecurities before I actually got to work on a picture. Once I got started, they would always melt away."

AUDREY HEPBURN

ABOVE Fishing off a barge on the Seine River near the Pont des Arts, Paris, *Funny Face*. Ensemble by Givenchy. **OPPOSITE** *Funny Face*. Photo by Bud Fraker.

"No one can doubt that Audrey Hepburn's appearance succeeds because it embodies the spirit of today. Audrey Hepburn has enormous heron's eyes and dark eye-brows slanted towards the Far East. Her facial features show character rather than prettiness: the bridge of the nose seems almost too narrow to carry its length, which bares into a globular tip with nostrils startlingly like a duck's bill. Her mouth is wide, with a cleft under the lower lip too deep for classical beauty, and the delicate chin appears even smaller by contrast with the exaggerated width of her jaw bones. Seen at the full, the outline of her face is perhaps too square; yet she intuitively tilts her head with a restless and perky asymmetry. She is like a portrait by Modigliani where the various distortions are not only interesting in themselves but make a completely satisfying composite."

CECIL BEATON (Photographer)

OPPOSITE *Funny Face*. Photo by Bud Fraker (courtesy Independent Visions/MPTV).

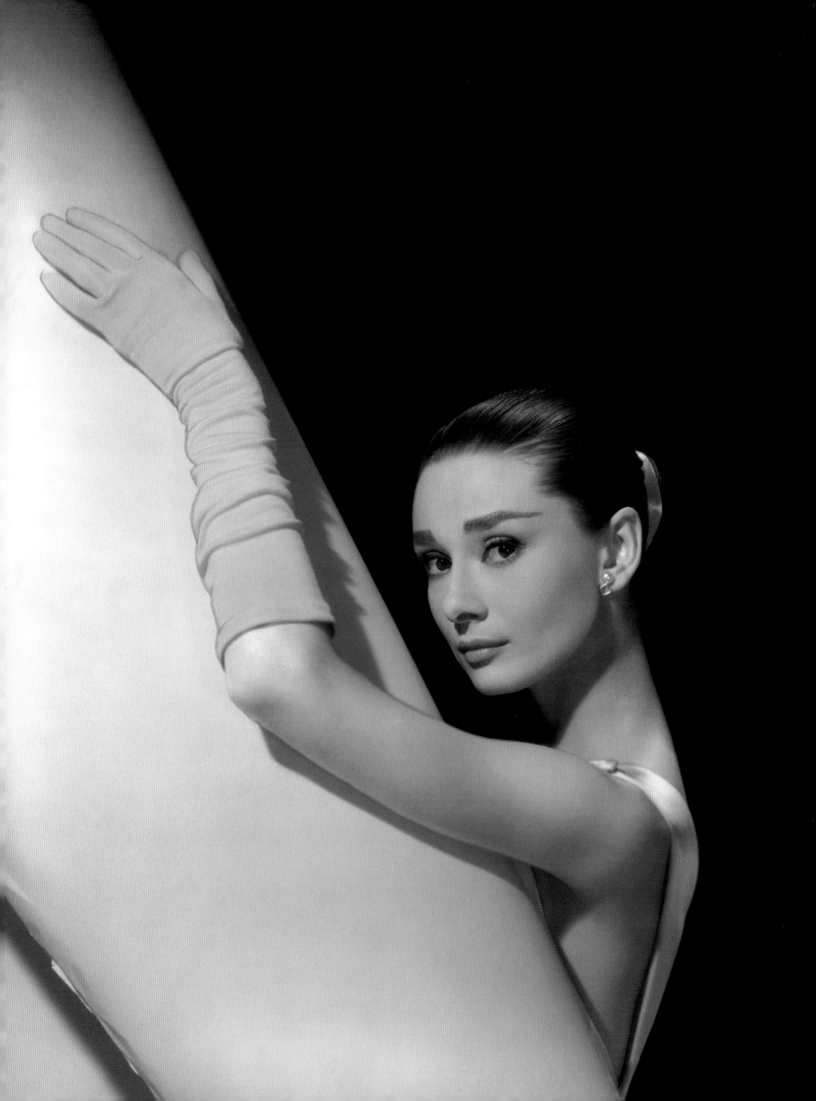

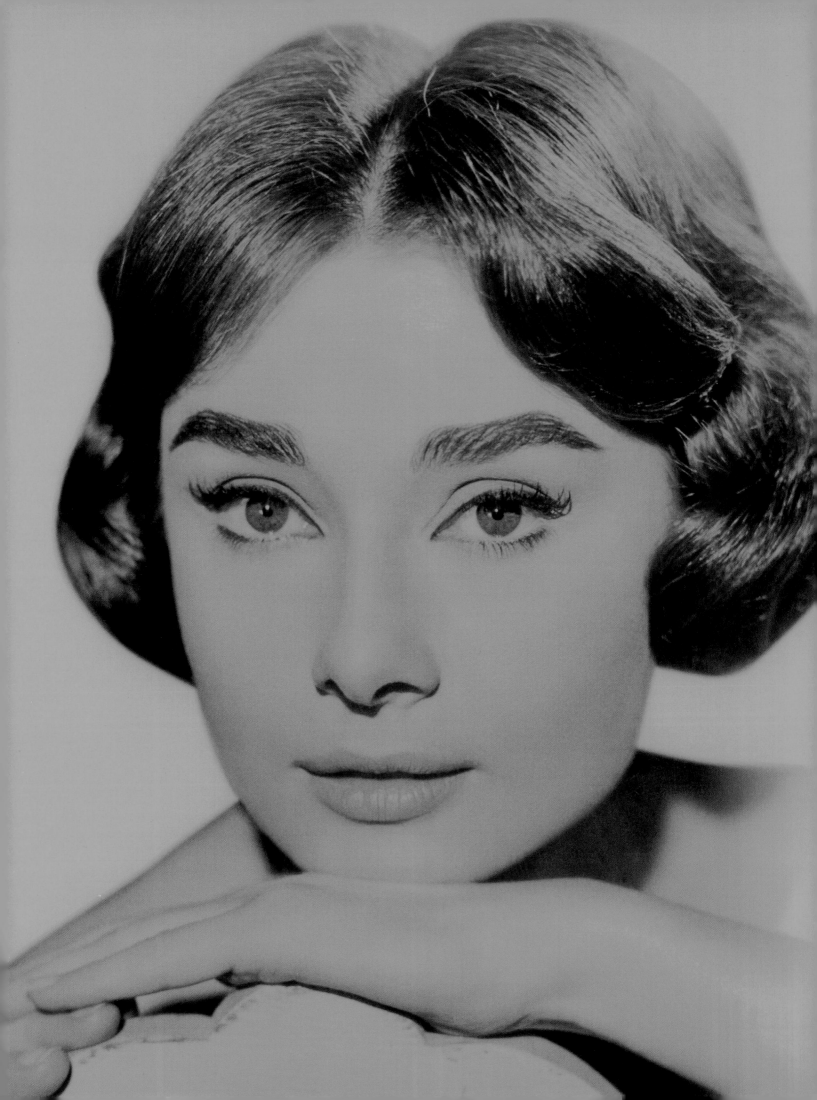

Love in the Afternoon

1957

Audrey Hepburn as Ariane Chavasse and Gary Cooper as Frank Flannagan in *Love in the Afternoon*. Directed by Billy Wilder, Allied Artists, 1957. Gown by Givenchy.

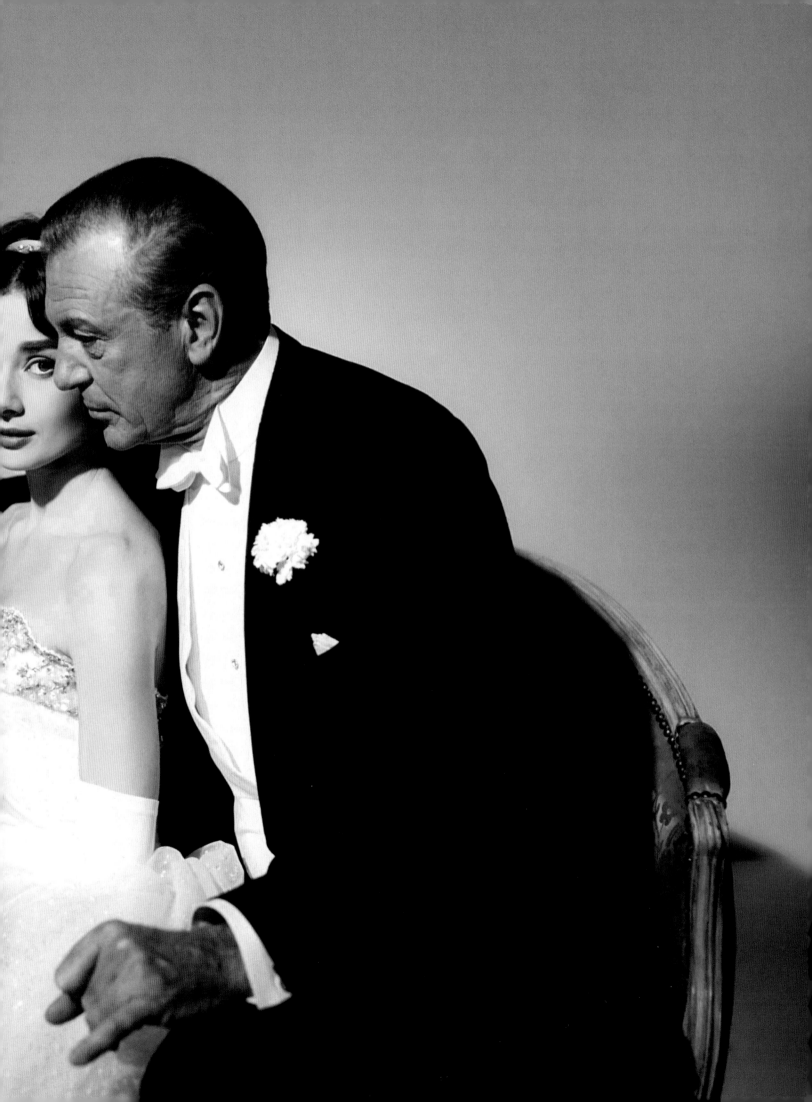

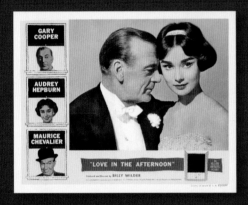

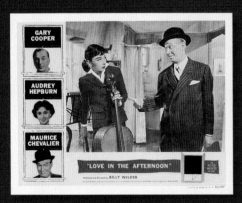

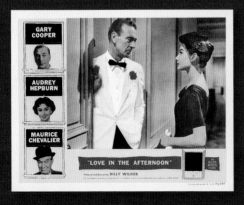

"The pedestal on which the reputation of Ernst Lubitsch has been sitting all these years will have to be relocated slightly to make room for another one. On this one we'll set Billy Wilder. Reason: *Love in the Afternoon....* And what delightful performances Audrey Hepburn and Gary Cooper give as the cleverly calculating couple who spar through the amorous afternoons!"

BOSLEY CROWTHER (Review in the *New York Times*, August 24, 1957)

LEFT AND OPPOSITE Lobby cards and film poster (Belgium) for *Love in the Afternoon.*

Audrey, with costars Gary Cooper and
Maurice Chevalier (who plays Audrey's
father, Claude Chavasse), looks on as
director Billy Wilder discusses the script
for *Love in the Afternoon*.

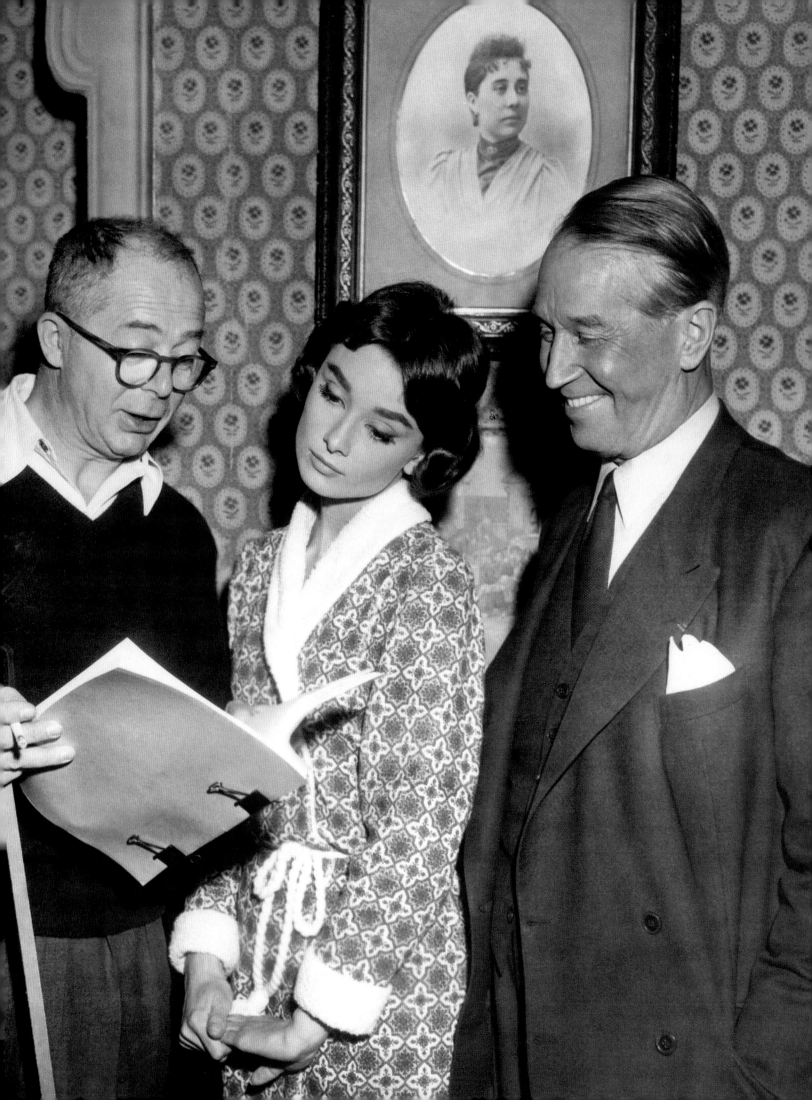

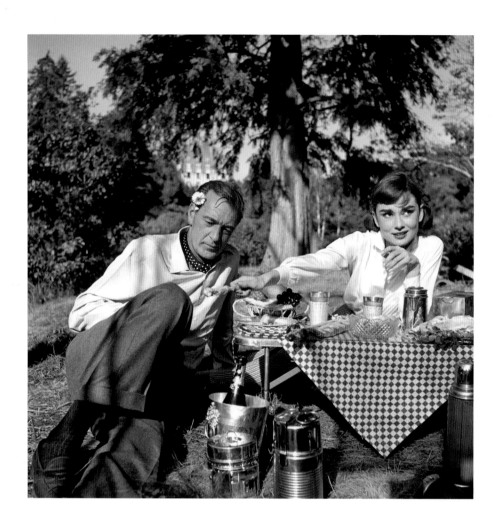

"I've been in pictures for thirty years and I've never had a more enthusiastic leading lady than Audrey. She puts more life and energy into her acting than anyone I've ever met."

GARY COOPER (Costar, *Love in the Afternoon*)

ABOVE, OPPOSITE, AND OVERLEAF Audrey with Gary Cooper on location near the Château de Vitry, Gambais, France, for *Love in the Afternoon*. Overleaf photo by Sam Shaw.

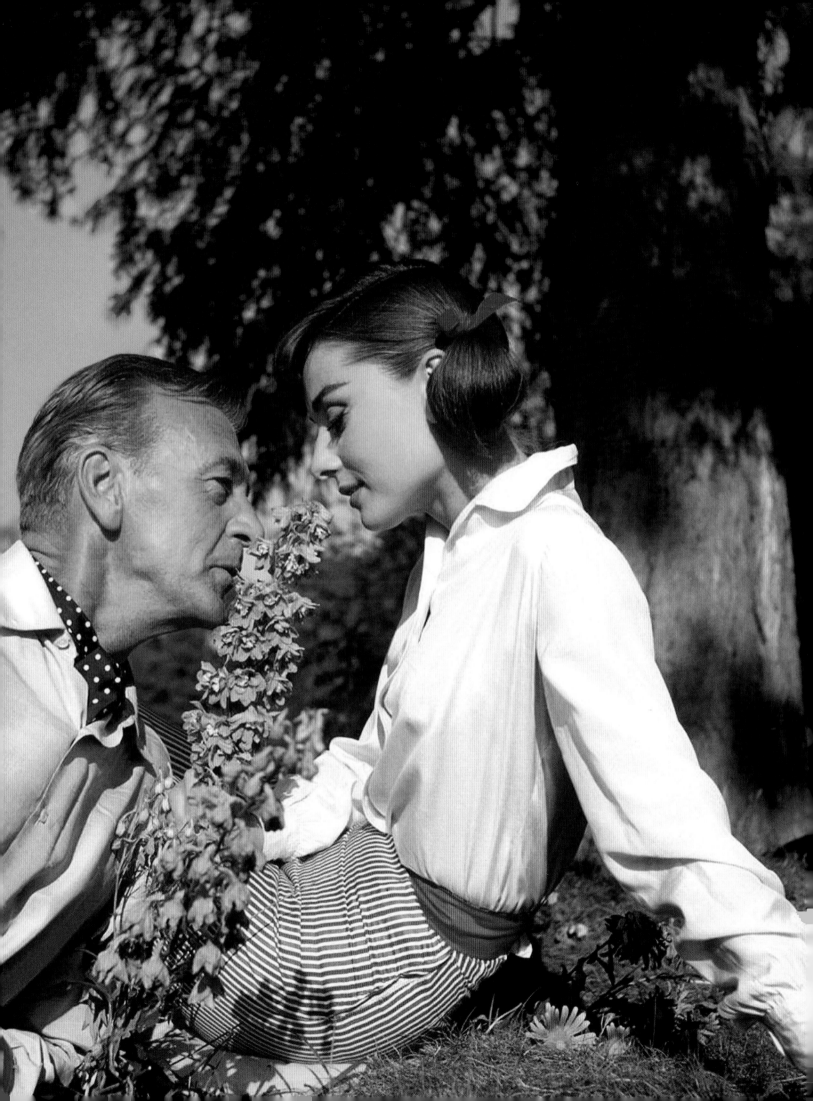

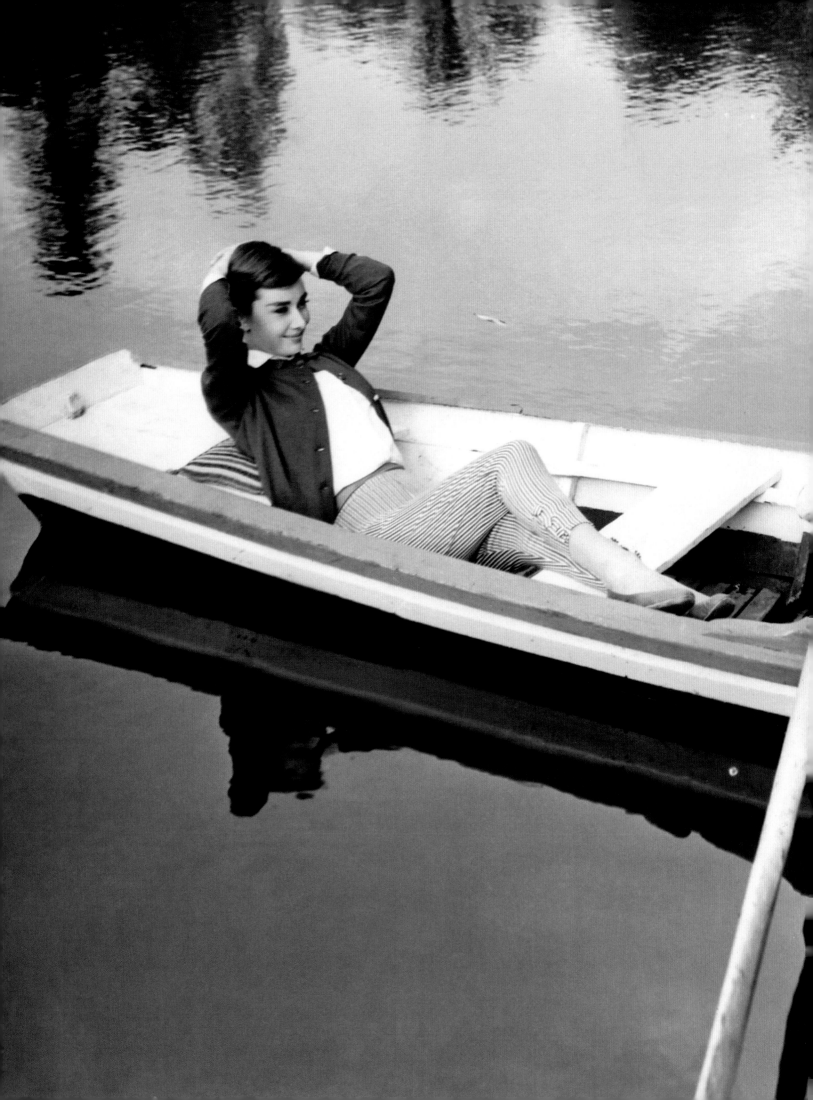

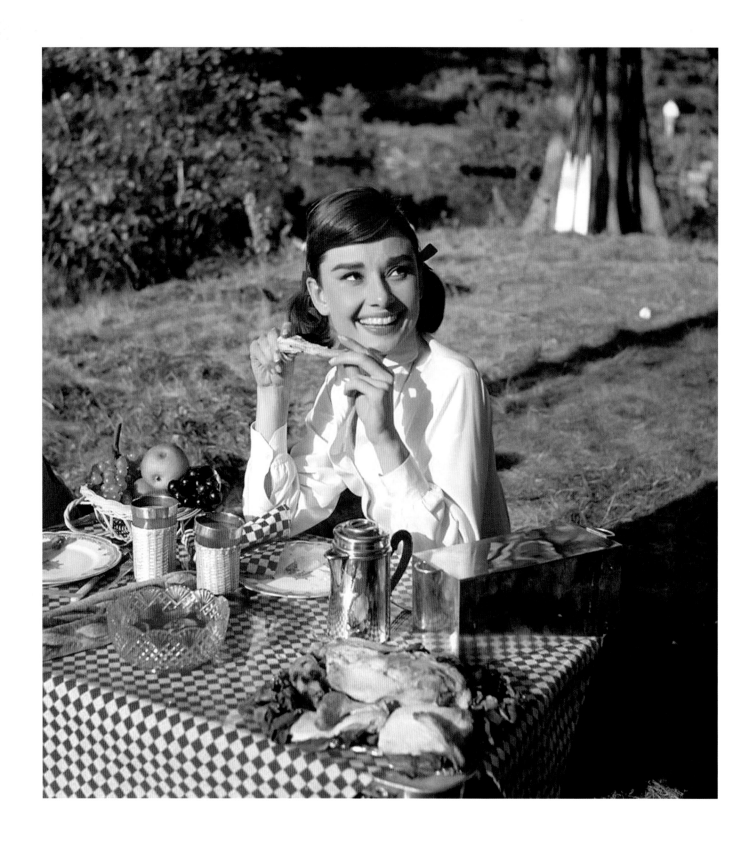

ABOVE AND OPPOSITE Audrey on location near the Château de Vitry, Gambais, France, for *Love in the Afternoon*. Opposite photo by Sam Shaw.

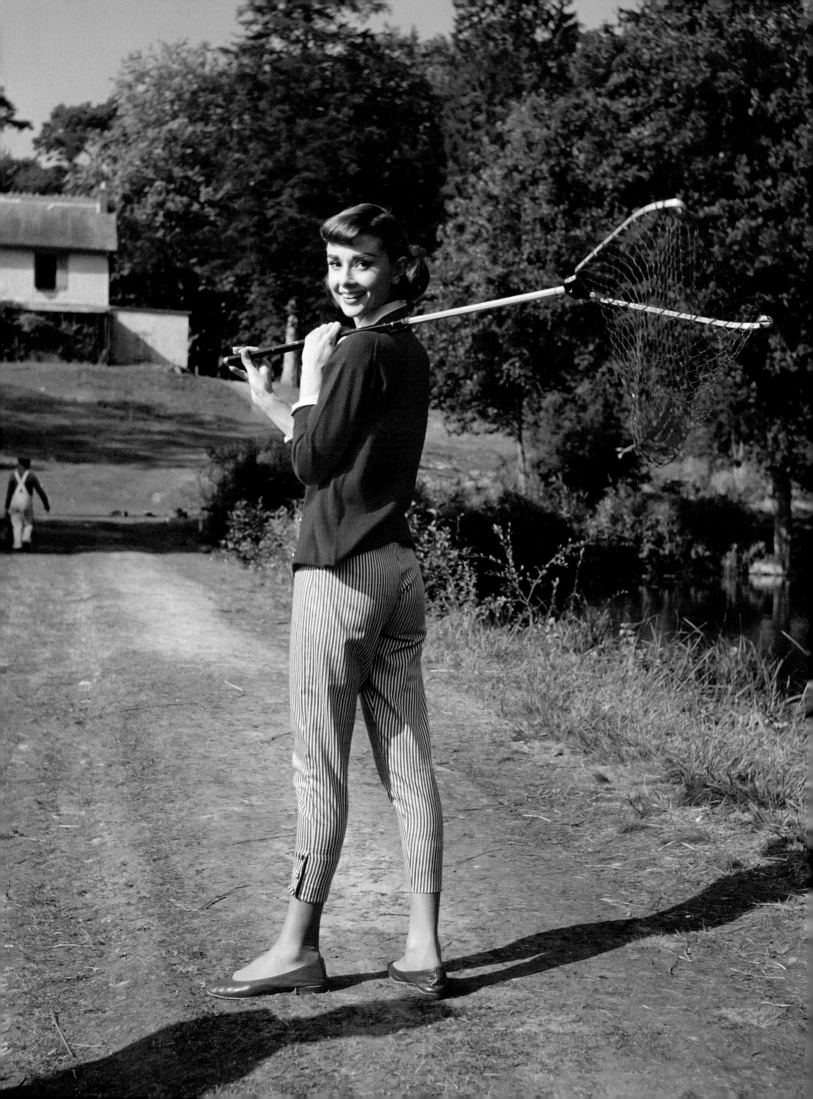

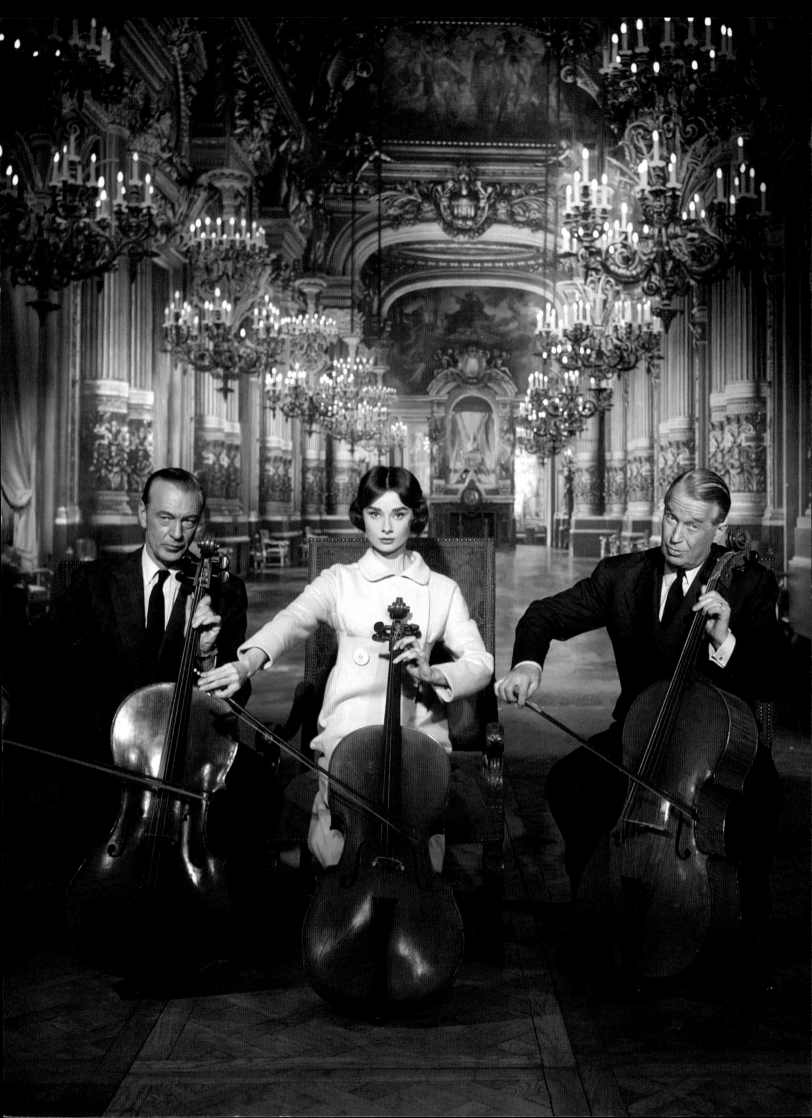

"His stumbling around was the best thing that could have happened in the beginning of the movie. I had to help him. Wilder suggested he take dancing lessons. The whole episode just put me at ease."

AUDREY HEPBURN (On a foxtrot sequence with Gary Cooper that Billy Wilder scheduled for the first day on the set, hoping for just this result)

OPPOSITE Audrey, as cello student Ariane, with Gary Cooper and Maurice Chevalier. Music plays an important role in *Love in the Afternoon*. Much of the prelude to the Richard Wagner opera *Tristan und Isolde* is heard during a sequence set in the Palais Garnier opera house. Composer Matty Malneck wrote three songs for the film, including the title tune. Also heard are "C'est si bon" by Henri Betti, "L'âme des poètes" by Charles Trenet, and "Fascination," which is hummed repeatedly by Ariane. **ABOVE** Audrey in a scene from *Love in the Afternoon*, filmed on location at the Hôtel Ritz in Paris.

Audrey in her dressing room in front of a
photograph of husband Mel Ferrer during the
production of *Love in the Afternoon*, Studios
de Boulogne, Paris. Dress by Givenchy.

182

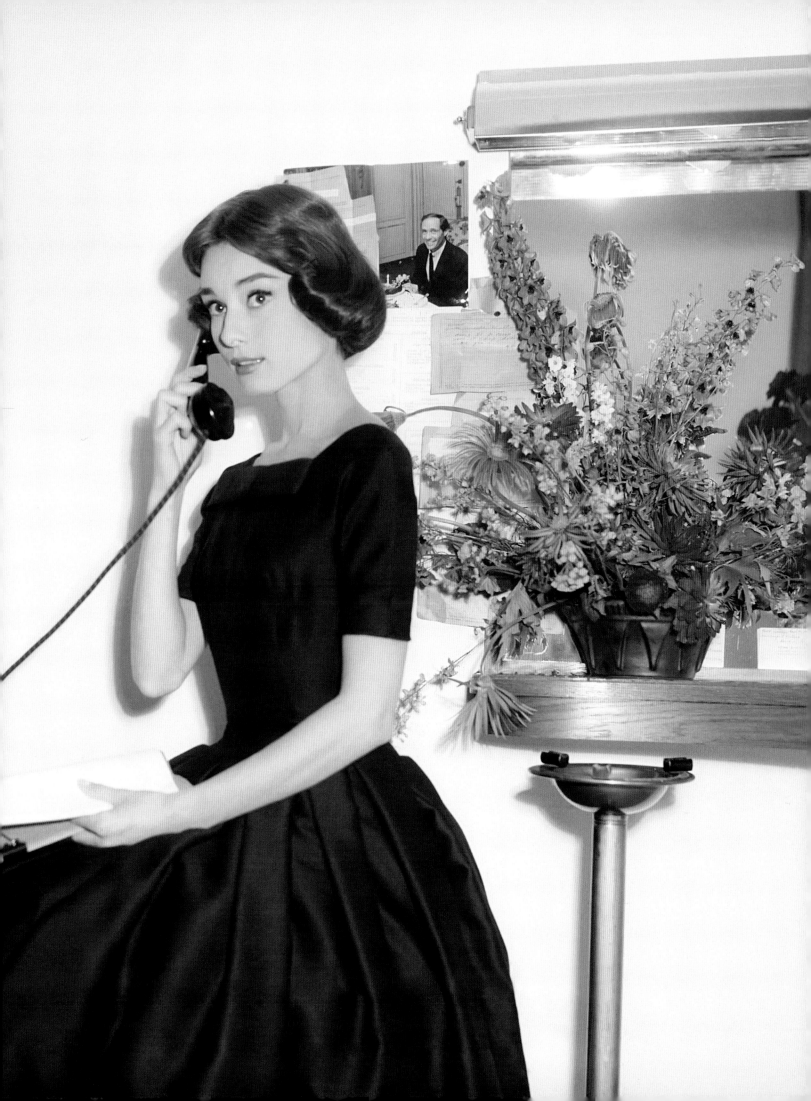

"How proud I would be, and full of love I would be, if I really had a daughter like you."

MAURICE CHEVALIER (In a telegram to Audrey on the first day of filming *Love in the Afternoon*)

ABOVE Original news caption: "September 12, 1956, Paris, France. Veteran screen and stage actor Maurice Chevalier gets some assistance from his charming costar Audrey Hepburn in celebrating his 68th birthday on the set of Billy Wilder's *Love in the Afternoon*. Chevalier, who has appeared in 30 motion pictures, made his stage debut in Paris in 1904." **OPPOSITE** On the set of *Love in the Afternoon* Audrey helps Chevalier switch his trademark straw hat for a bowler hat—more appropriate attire for his role as a private detective. (Photos courtesy Independent Visions/MPTV.)

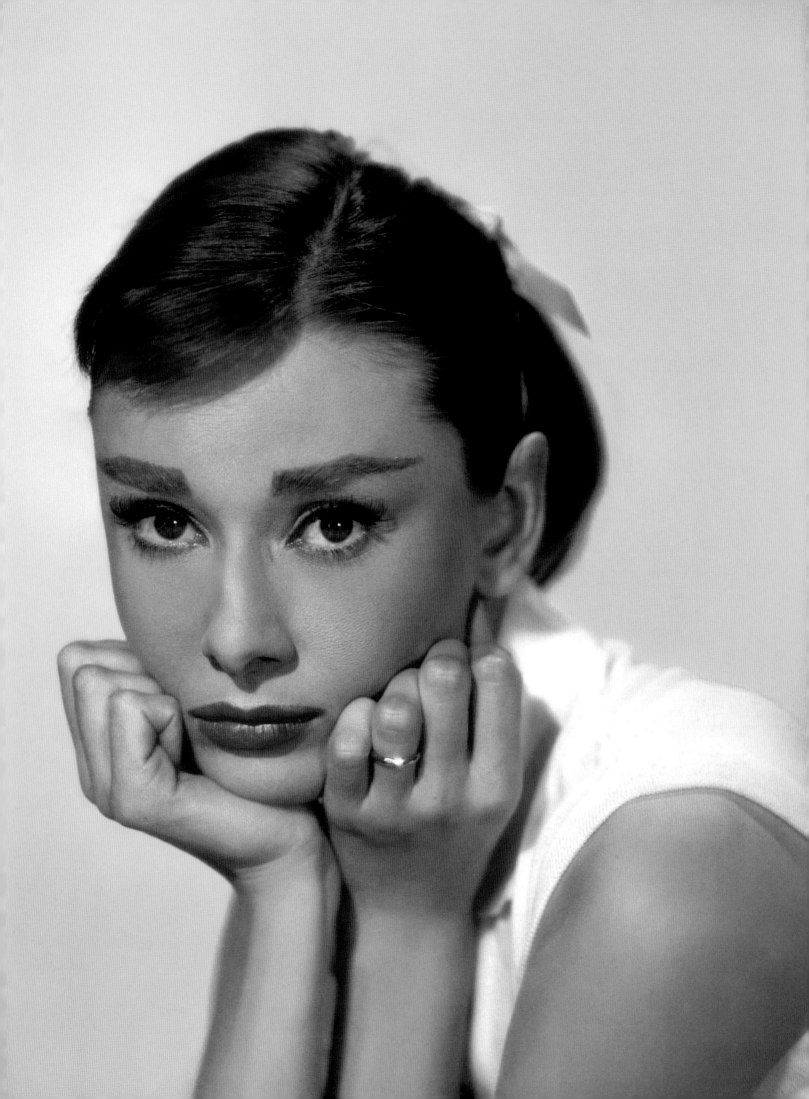

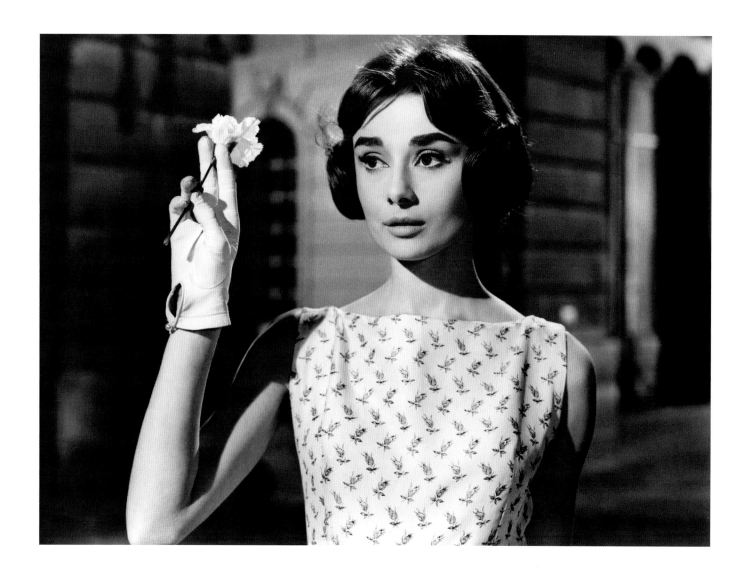

"You looked around and suddenly there was this dazzling creature looking like a wide-eyed doe prancing in the forest. Everybody on the set was in love with her within five minutes. She's a wispy little thing, but you're really in the presence of somebody when you see that girl."

BILLY WILDER (Director, *Love in the Afternoon*)

OPPOSITE AND ABOVE *Love in the Afternoon*. (Photos courtesy Independent Visions/MPTV.)

"In the movie, there's this running gag about Flannagan's private gypsy band that follows him on all his escapades playing 'Fascination' every time he meets a new woman. Well, Wilder told me he chose that song because it was playing the first time he ever made love. That made me so embarrassed, even though I later found out he made up the whole thing, that I couldn't look at him if he was giving me some advice when that song was playing. And it seemed 'Fascination' never stopped playing. I think Wilder wanted me to gain some self-confidence, learn to rely more on my own instincts than his."

AUDREY HEPBURN

OPPOSITE Audrey with director Billy Wilder on the set of *Love in the Afternoon*. The screenplay by Wilder and I. A. L. Diamond is based on the Claude Anet novel *Ariane, jeune fille russe* (translation: *Ariane, Young Russian Girl*), which was previously filmed as *Scampolo* in 1928 and *Scampolo, ein Kind der Strasse* (translation: *Scampolo, a Child of the Street*) in 1932, the latter with a script cowritten by Wilder. In Vladimir Nabokov's 1930 short novel, *The Eye*, two of the female characters are reading *Ariane, jeune fille russe*.

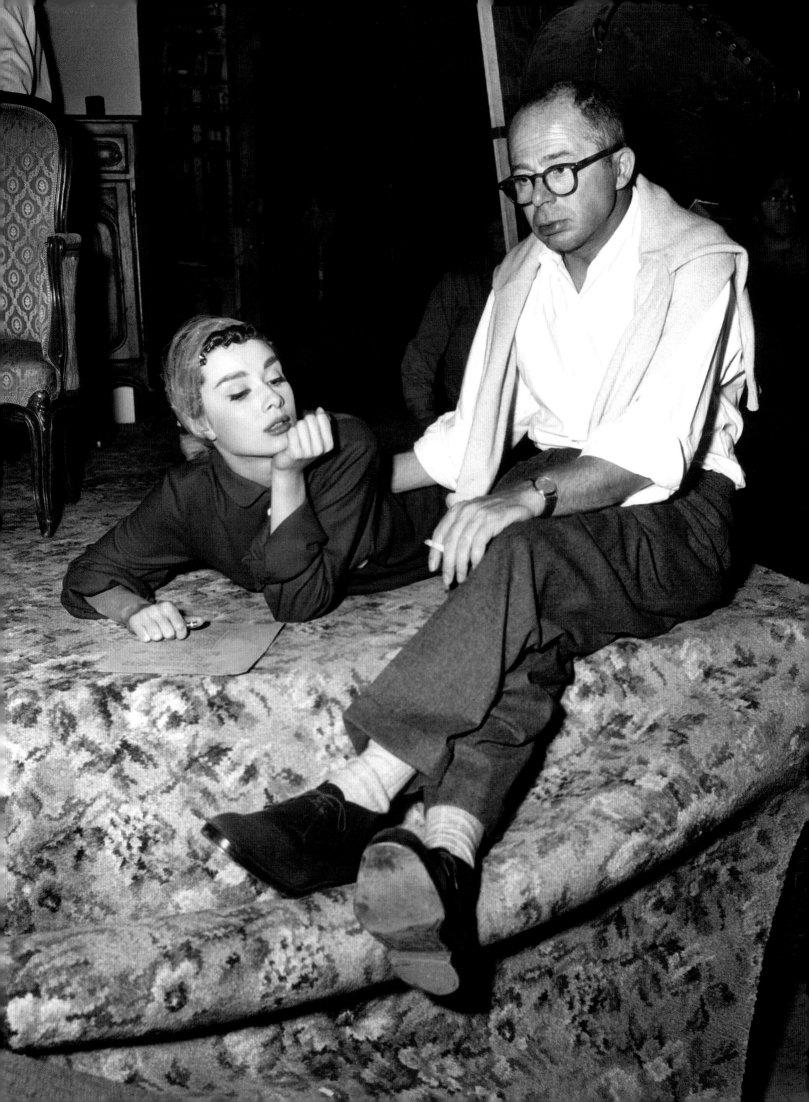

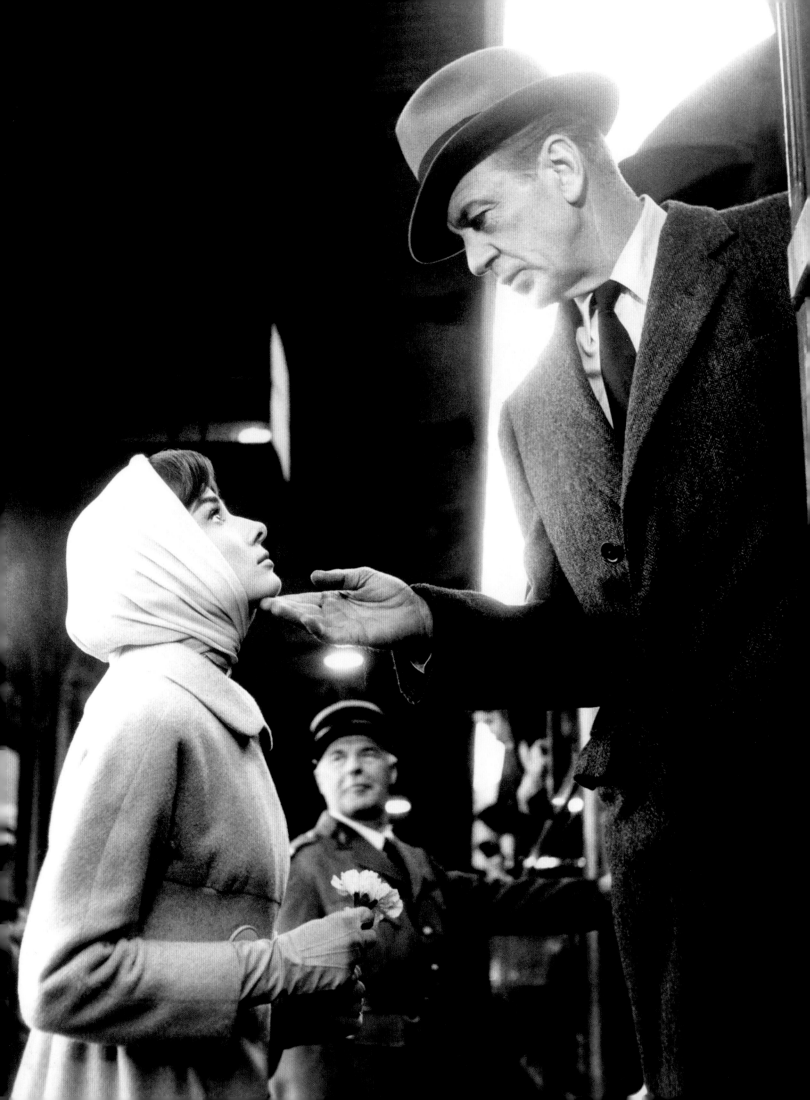

FRANK FLANNAGAN: Everything about you is perfect.

ARIANE CHAVASSE: I'm too thin! And my ears stick out, and my teeth are crooked and my neck's much too long.

FRANK FLANNAGAN: Maybe so, but I love the way it all hangs together.

[They kiss.]

Dialogue between Audrey as Ariane and Gary Cooper as Frank, from the screenplay for *Love in the Afternoon*

OPPOSITE With Gary Cooper in a scene filmed on location at Gare de Lyon, Paris. The ending of *Love in the Afternoon* shows the two lovers departing together on a train, which threatened to put the film on the Catholic Legion of Decency's "Condemned List." Maurice Chevalier was called back to do the voice-over heard at the close of the film, in which he reports that the couple are "now married, and serving a life sentence in New York, state of New York, USA."

"I lavished attention on that puppy. I am a frugal person, but I bought Famous the most expensive collars, the best cuts of meat, the most gentle shampoos. I was out of my mind with love for that little dog. I guess it took my mind off my fears about meeting the great Gary Cooper."

AUDREY HEPBURN (On Mr. Famous, the Yorkshire terrier husband Mel Ferrer gave her just before *Love in the Afternoon* began filming)

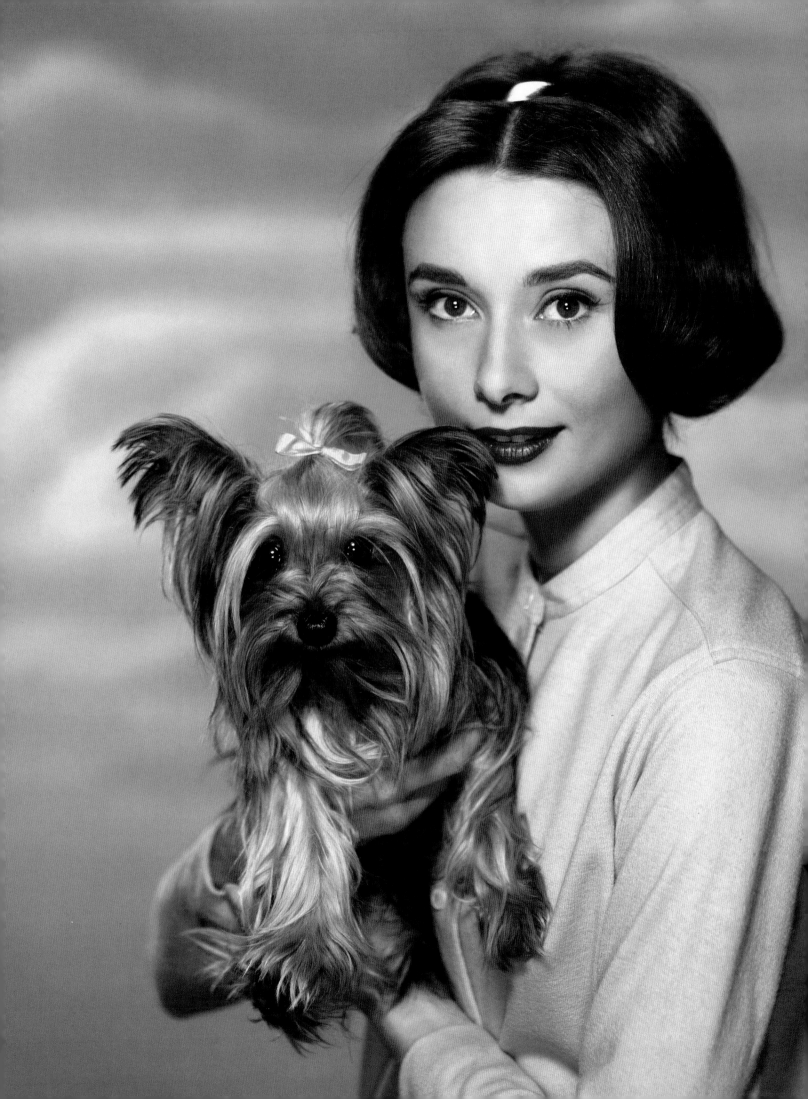

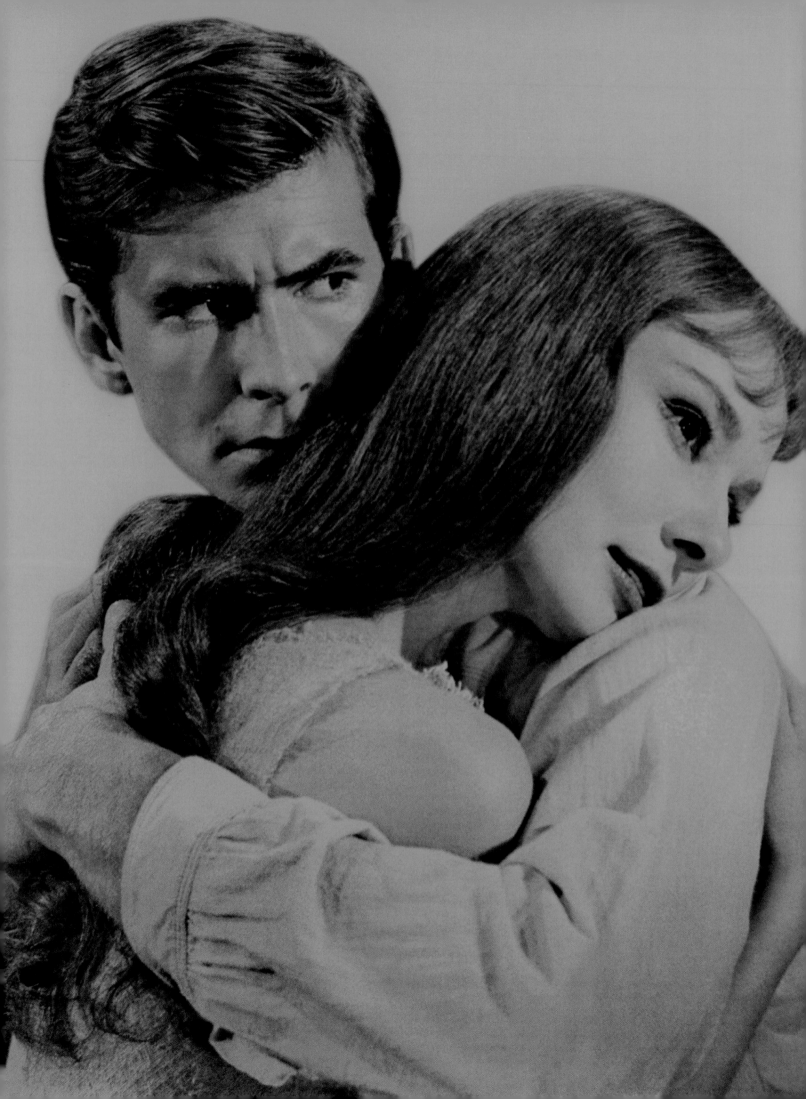

Green Mansions

1959

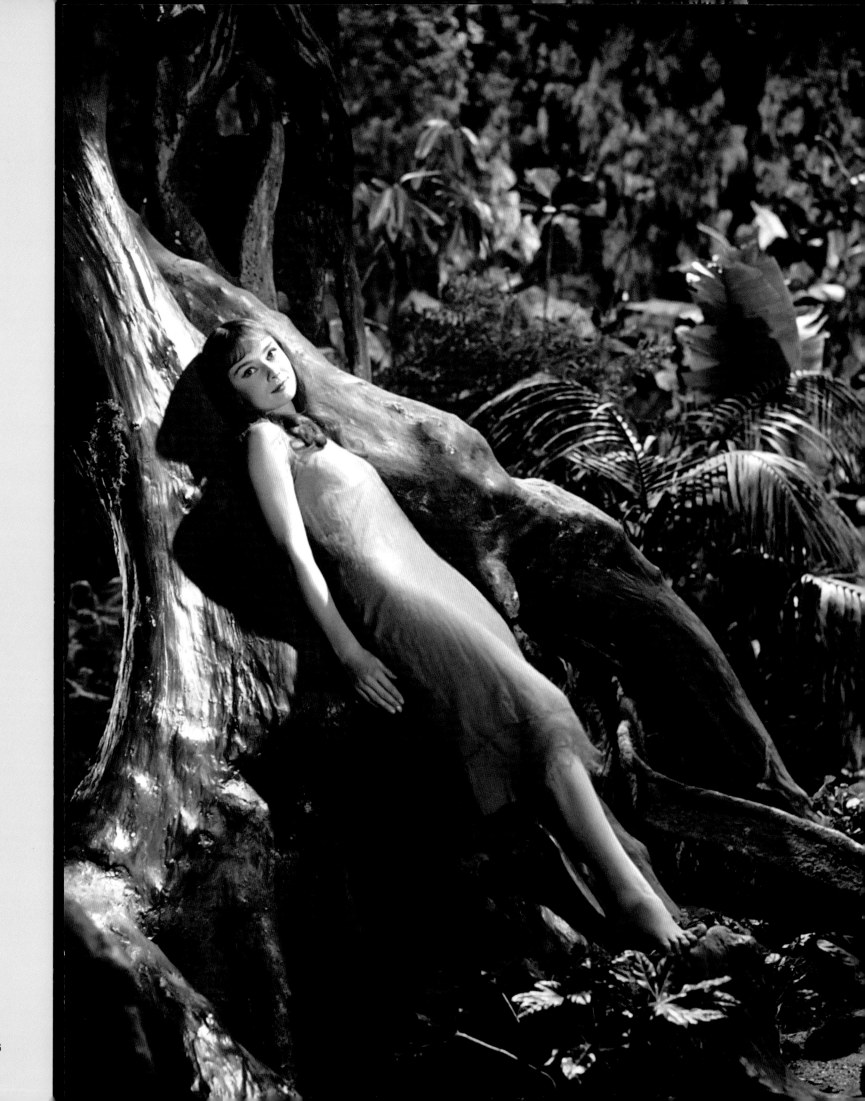

Green Mansions

1959

Audrey Hepburn as Rima and Anthony
Perkins as Abel in *Green Mansions*.
Directed by Mel Ferrer, MGM, 1959.

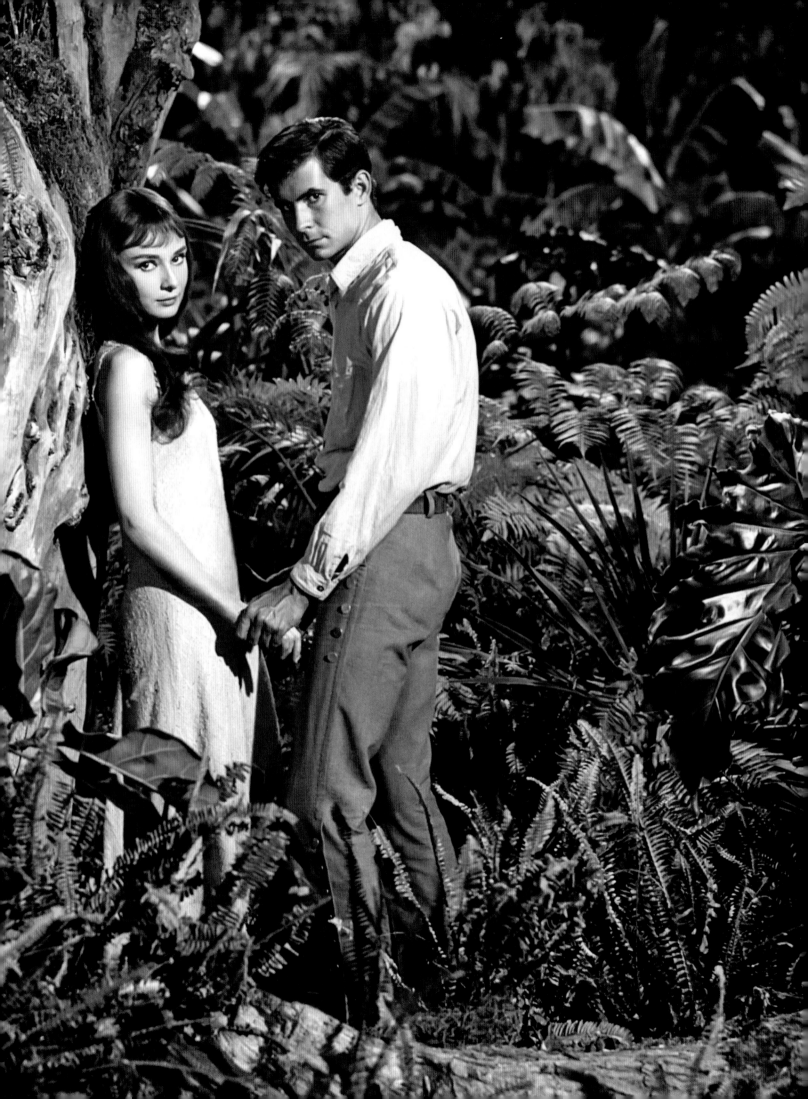

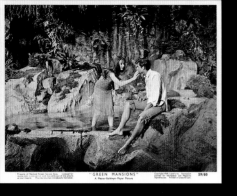

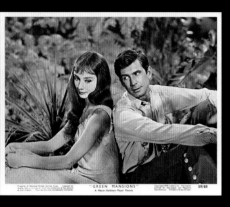

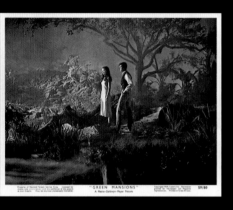

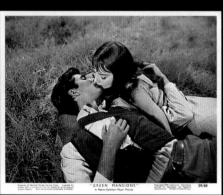

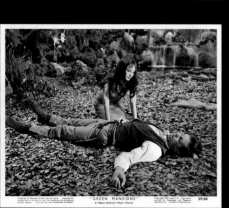

"Her figure and features were singularly delicate, but it was her color that struck me most, which indeed made her differ from all other human beings. The color of the skin would be almost impossible to describe, so greatly did it vary with every change of mood—and the moods were many and transient—and with the angle on which the sunlight touched it, and the degree of light."

WILLIAM HENRY HUDSON (Author, *Green Mansions: A Romance of the Tropical Forest*)

LEFT AND OPPOSITE Lobby cards and film poster for *Green Mansions*. The film was based on William Henry Hudson's 1904 novel of the same name.

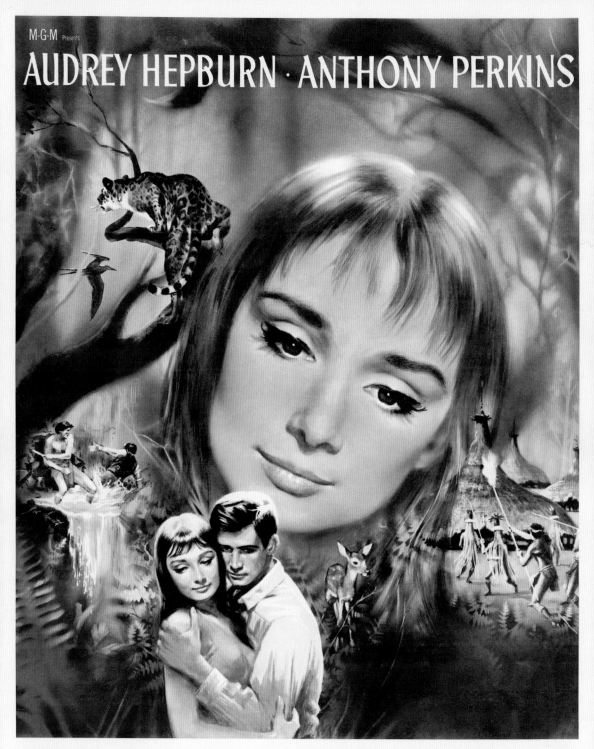

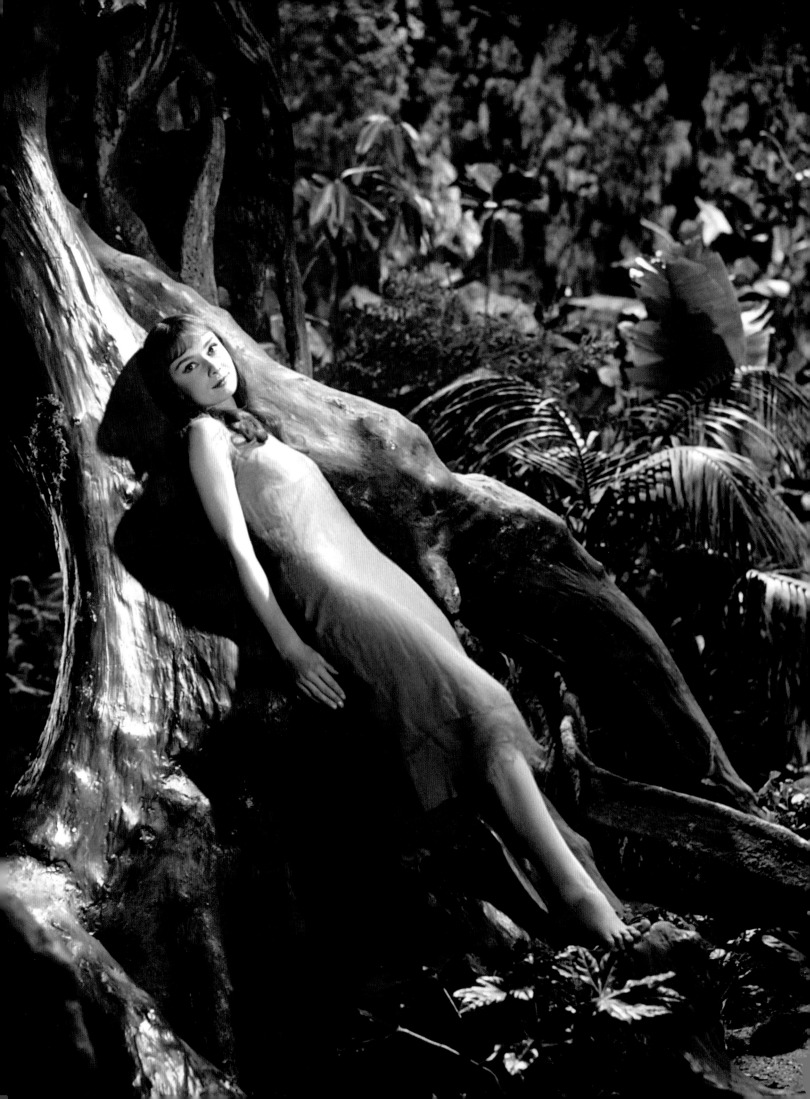

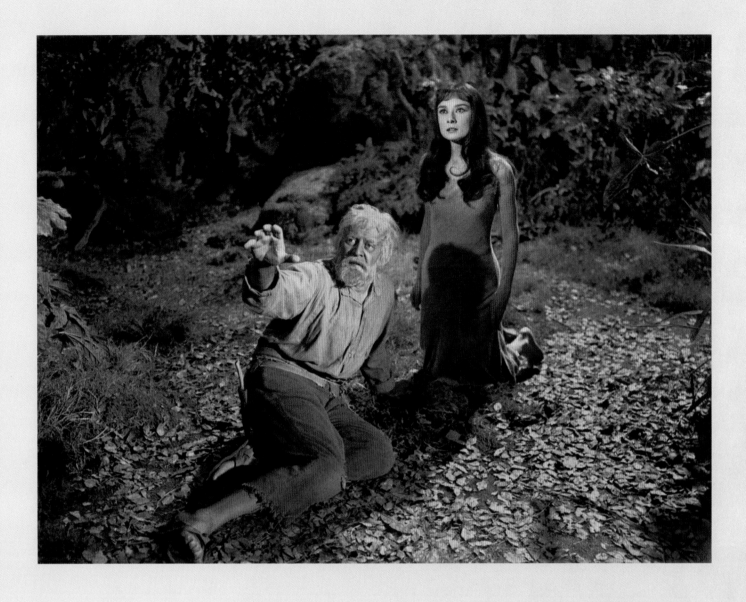

"[Rima is first seen] reclining against the massive roots of a huge tree. So perfect is her camouflage against the ferns and herbage, the greenish-grey of her brief chemise blending with the moss and the roots, the dark mass of her hair so much like the rich brown of the tree trunks that she is invisible to Abel and becomes visible to us gradually as the camera moves slowly closer."

From MEL FERRER'S rewrite of the Dorothy Kingsley screenplay adaptation of *Green Mansions* by William Henry Hudson

OPPOSITE Audrey as Rima, the Bird Girl, an orphan living her life in the forests of the Amazon. **ABOVE** Audrey with Lee J. Cobb as Nuflo, *Green Mansions*.

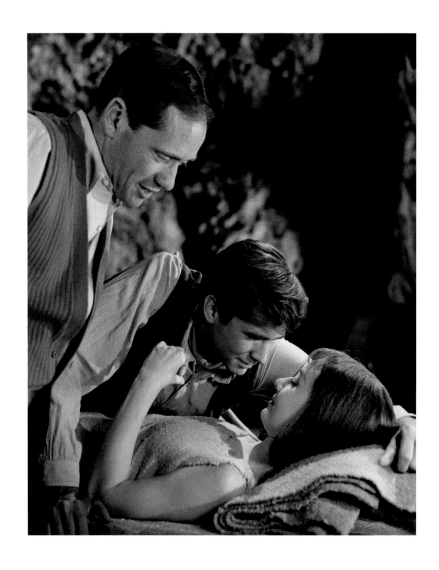

"I thought she was the most exquisite creature I'd ever seen, and I was very nervous to be directed by her husband! I mean there was a lot of kissing and touching. It was a charged atmosphere, with the jungle and the animals, and the sense of heat and color, and the last thing I wanted was for somebody's husband to ruin it."

ANTHONY PERKINS (Costar, *Green Mansions*)

ABOVE Original news caption: "Three-Cornered Kiss…. Audrey Hepburn and Anthony Perkins, the young lovers of MGM's *Green Mansions* have their romantic scenes supervised by director Mel Ferrer—Miss Hepburn's off-screen 'romance'—her husband! When asked how she felt having her husband direct her love scenes with another man, Miss Hepburn shrugged: 'Uninhibited!' Edmund Grainger produced." **OPPOSITE** Audrey with Anthony Perkins. *Green Mansions* was originally to be produced by RKO in 1932 with Dolores del Río and Joel McCrea as the stars, following their success in the film *Bird of Paradise*.

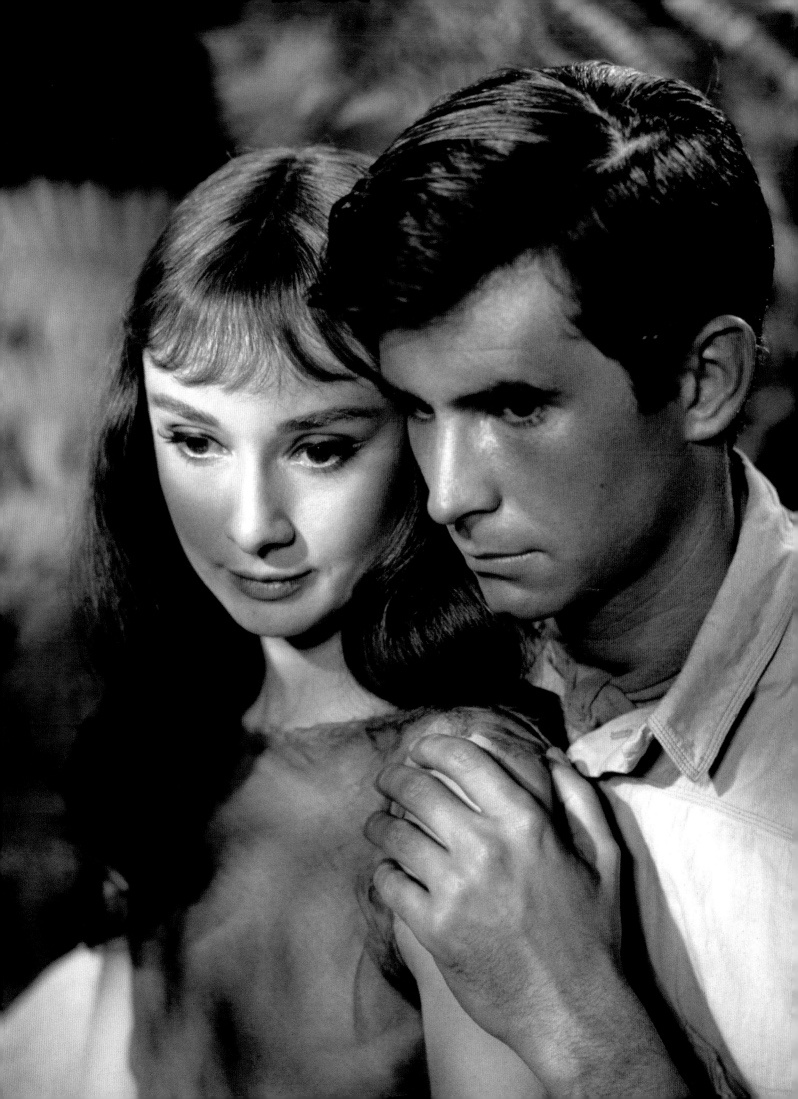

Green Mansions. Pier Angeli was originally considered for the part of Rima, with Vincente Minnelli as director, before Audrey and Mel Ferrer expressed interest in developing the project. To appear in the film, Audrey turned down the title role in *The Diary of Anne Frank*.

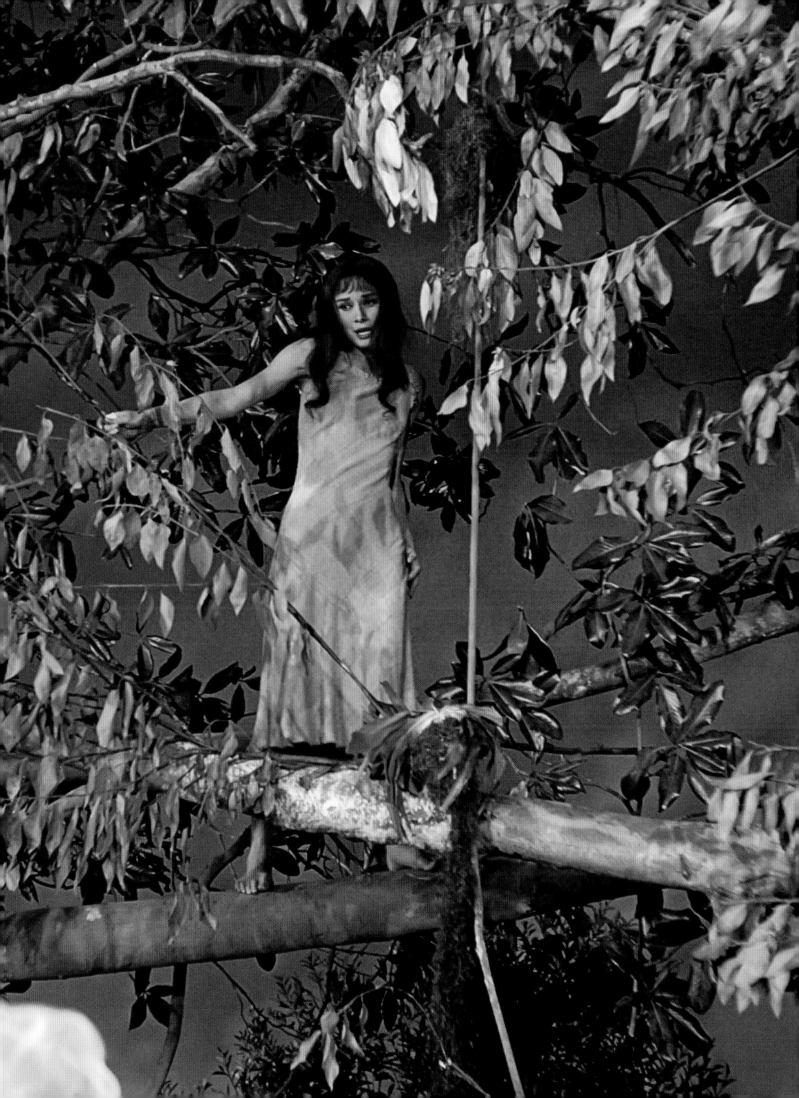

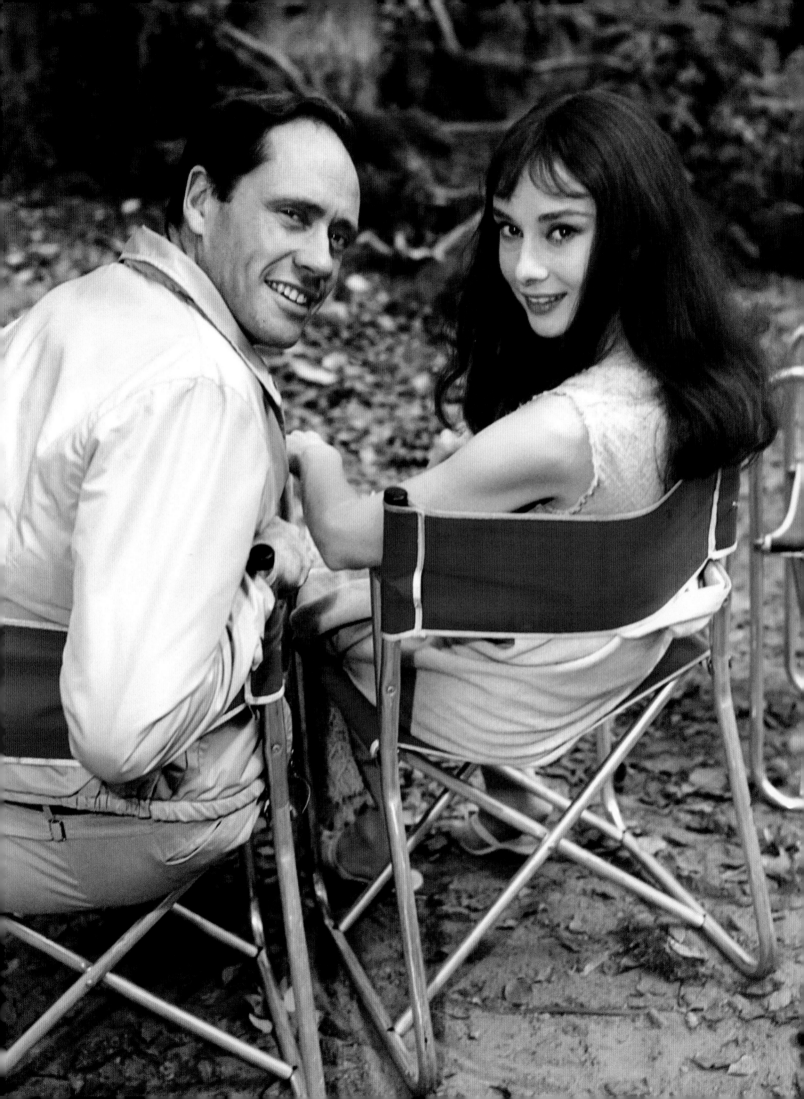

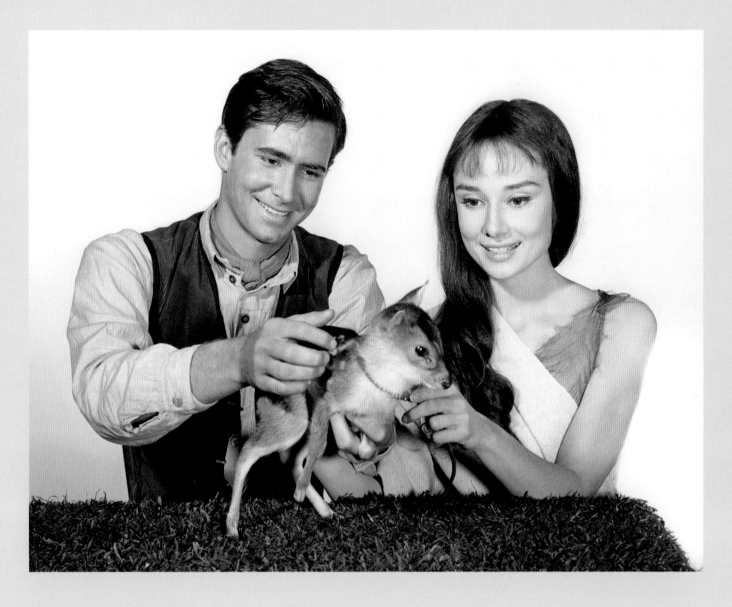

"Ip is a European deer. When she is fully grown she will stand only four feet high, and she'll be pure white. Fortunately Ip is a wonderful actress. In all our scenes she behaves beautifully—never more than two takes and most of the time she comes through on the first take."

AUDREY HEPBURN (Speaking of the young deer she brought into her home during the filming of *Green Mansions*)

OPPOSITE Audrey with director (and husband) Mel Ferrer on the set of *Green Mansions*. Ferrer traveled to South America to select possible filming locations, but most of the action sequences were shot on indoor stages in Lone Pine, California. Ferrer also had several snakes and birds native to the Venezuelan jungle captured and shipped to Hollywood for use in filming. **ABOVE** Audrey with costars Anthony Perkins and "Pippin," *Green Mansions*.

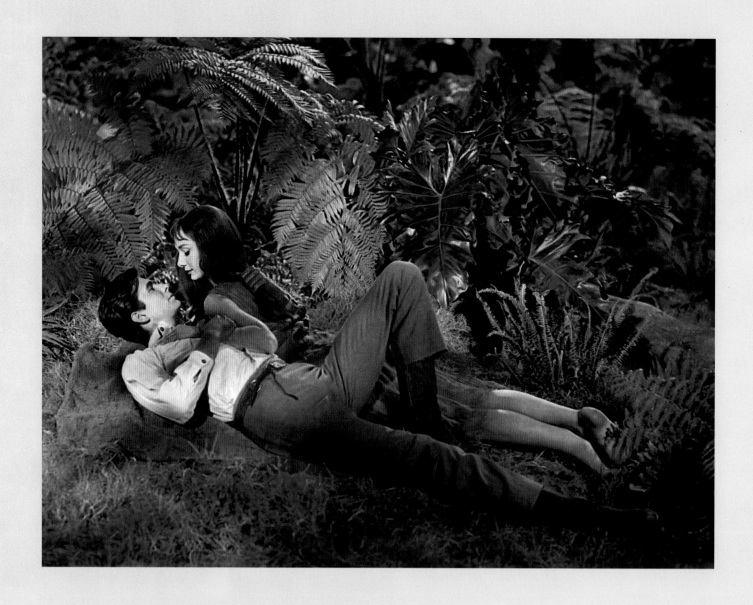

"For the first time in my career, I lost my shyness. . . . Love scenes have always been difficult for me. But with my husband directing and leading Tony and me through the emotional passages, things fell into place."

AUDREY HEPBURN

ABOVE Audrey with Anthony Perkins, *Green Mansions*. **OPPOSITE** Audrey as Rima. Legendary Brazilian composer Heitor Villa-Lobos created a score for the picture, most of which was unfortunately rejected by the studio. Villa-Lobos reworked this score as a concert suite, *Floresta do Amazonas* (*Forest of the Amazon*), which was premiered in 1959 by the Symphony of the Air orchestra in New York. It was also later recorded as a cantata with soprano Renée Fleming.

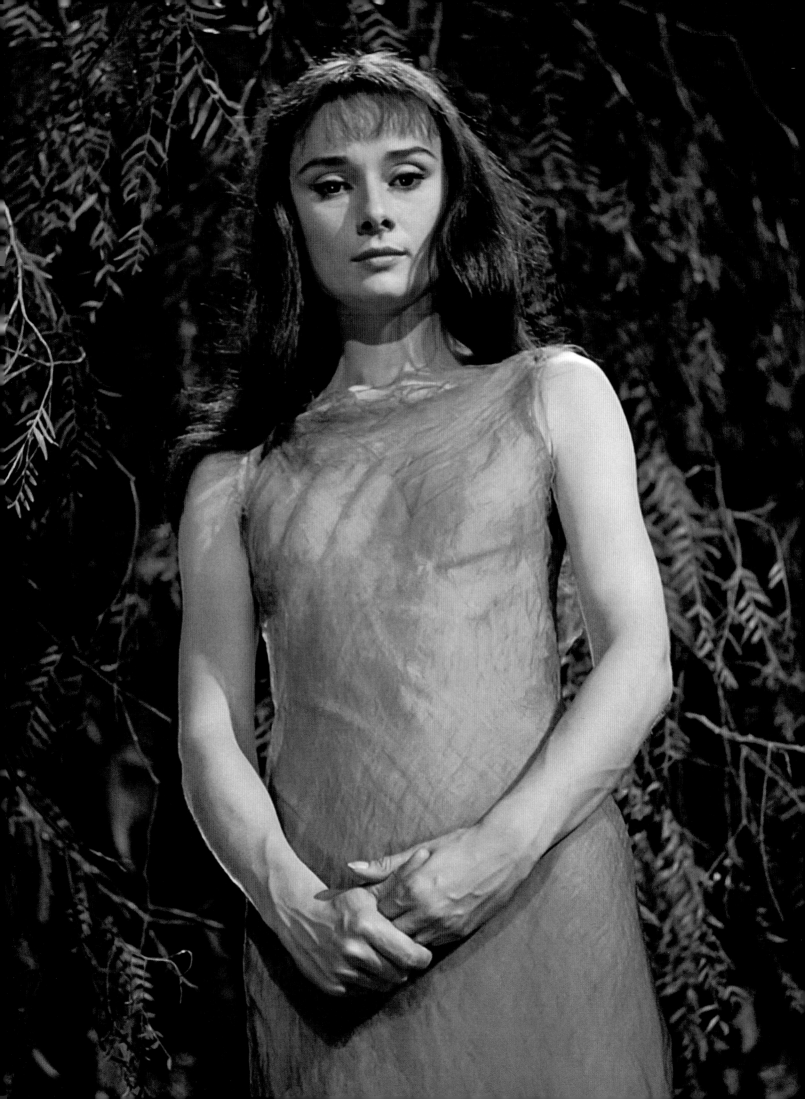

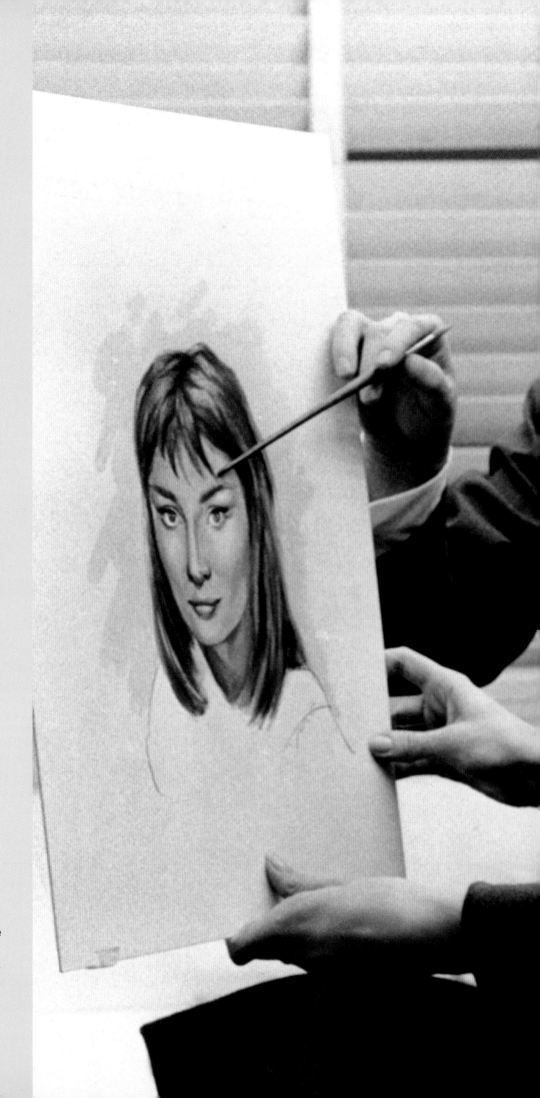

MGM makeup artist William Tuttle, whose previous credits included *The Wizard of Oz* and *Singin' in the Rain*, shows Audrey one of his sketches for her tree-nymph look in *Green Mansions*. In 1965 Tuttle became the first makeup artist ever to receive an Academy Award.

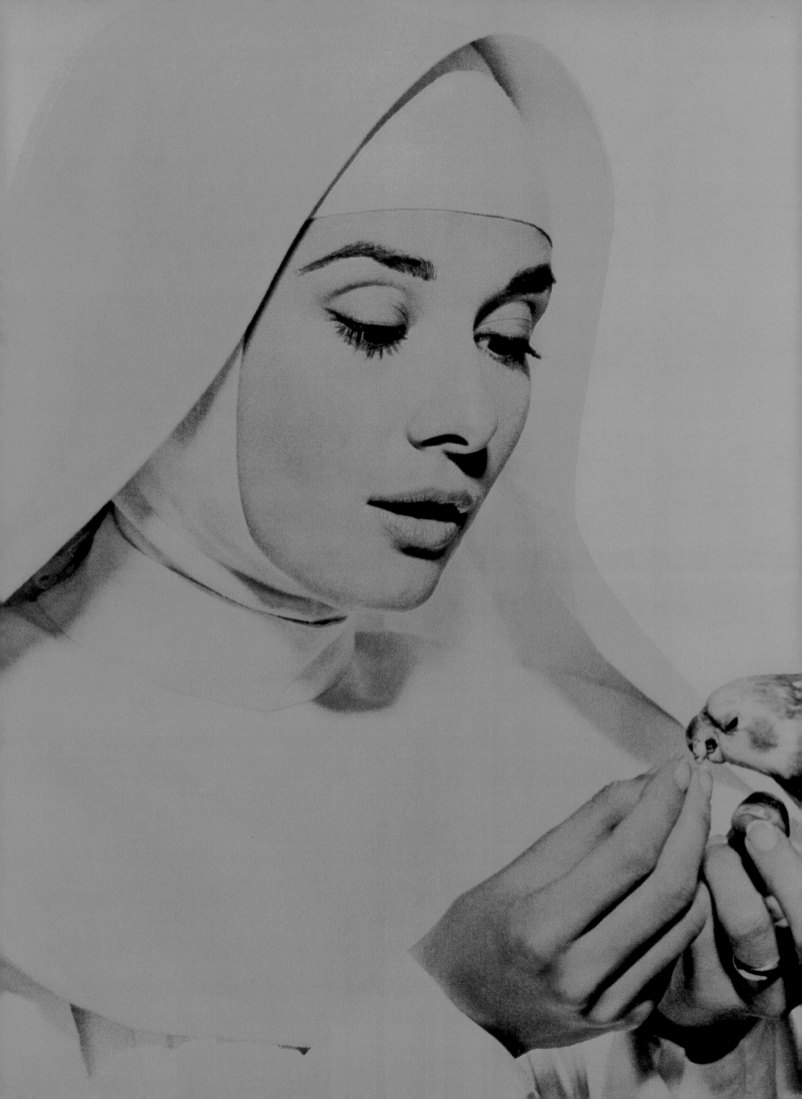

The Nun's Story

1959

Audrey Hepburn as Sister Luke (Gabrielle "Gaby" van der Mal) in *The Nun's Story*. Directed by Fred Zinnemann, Warner Bros., 1959. The character was based on the life of Marie Louise Habets, a Belgian nurse and nun.

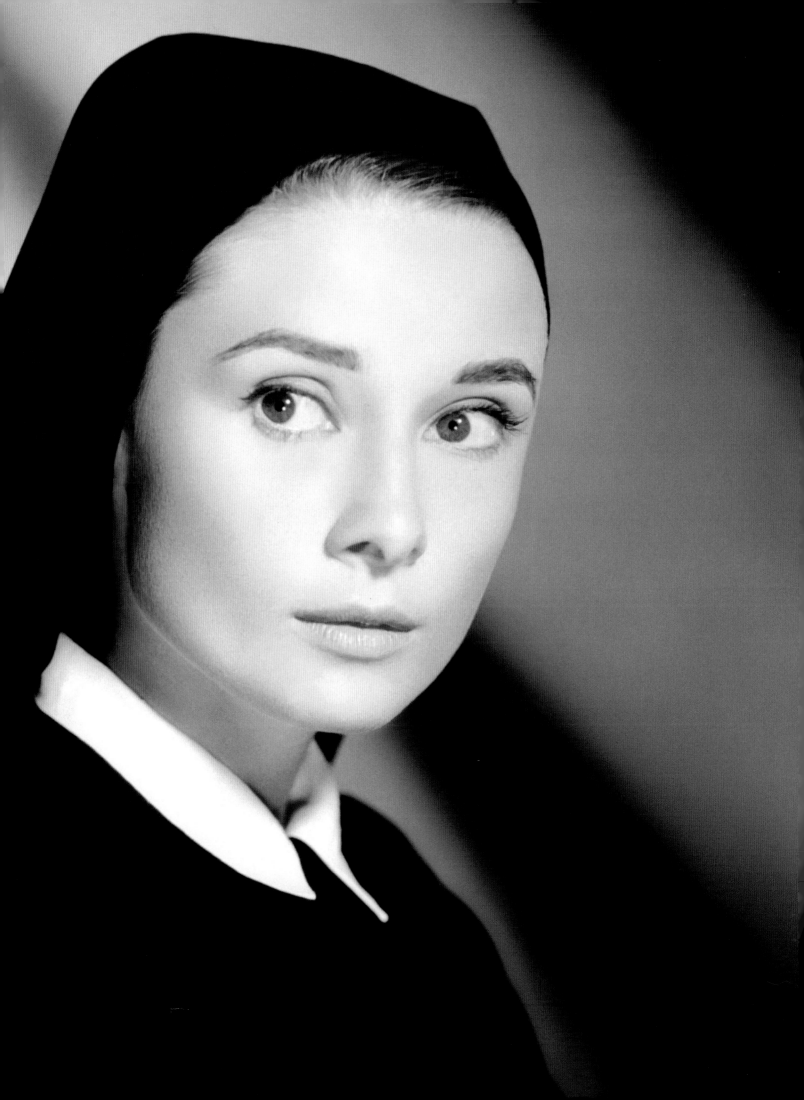

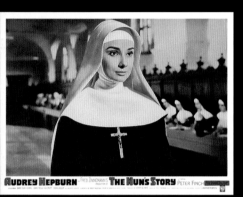

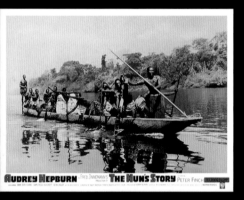

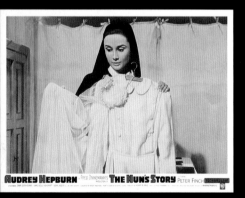

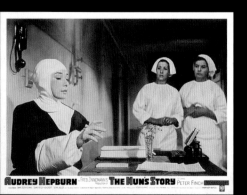

"I was attracted to this property more than any other film script I'd ever read. I was really moved by the story, completely swept up in Gabrielle's wrenching decision. I loved that we shared a birthplace, and that one of the more dramatic episodes of the story took place during World War II when the Nazis terrorized Europe."

AUDREY HEPBURN

LEFT AND OPPOSITE Lobby cards and French film poster for *The Nun's Story*. The film is an adaptation of Kathryn Hulme's 1956 novel of the same name.

Warner Bros.
présente

AUDREY HEPBURN

DANS UN FILM DE
FRED ZINNEMANN

AU RISQUE DE SE PERDRE

PETER FINCH · DAME EDITH EVANS · DAME PEGGY ASHCROFT · DEAN JAGGER

et MILDRED DUNNOCK · NIALL MAC GINNIS · PATRICIA COLLINGE

TECHNICOLOR ®

Scénario de
ROBERT ANDERSON · D'après le roman de KATHRYN HULME · Musique composée et dirigée par FRANZ WAXMAN · PRODUIT PAR HENRY BLANKE · Mise en scène de FRED ZINNEMANN

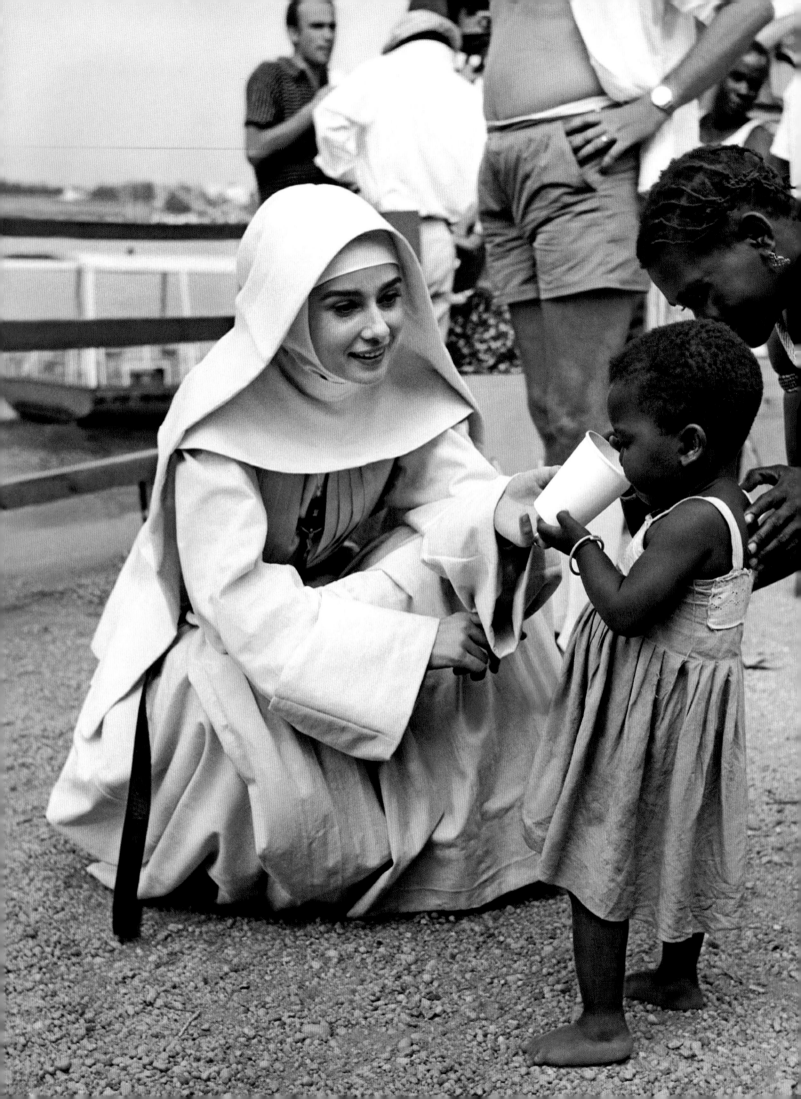

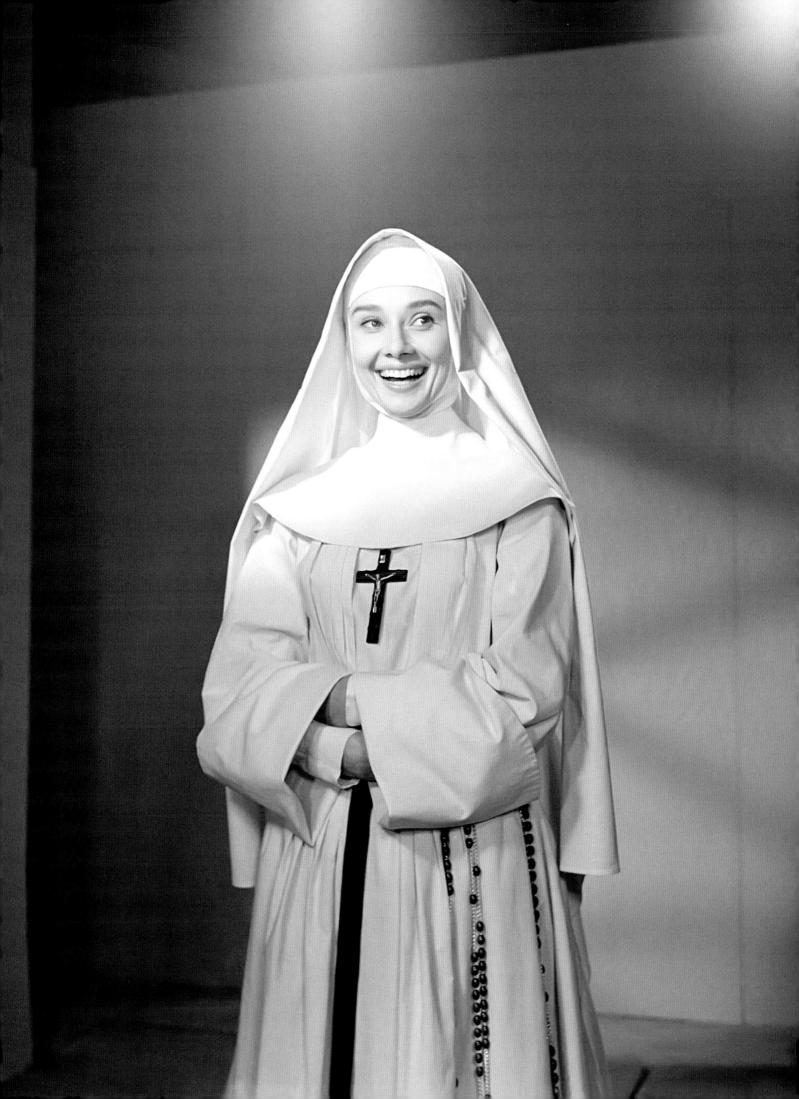

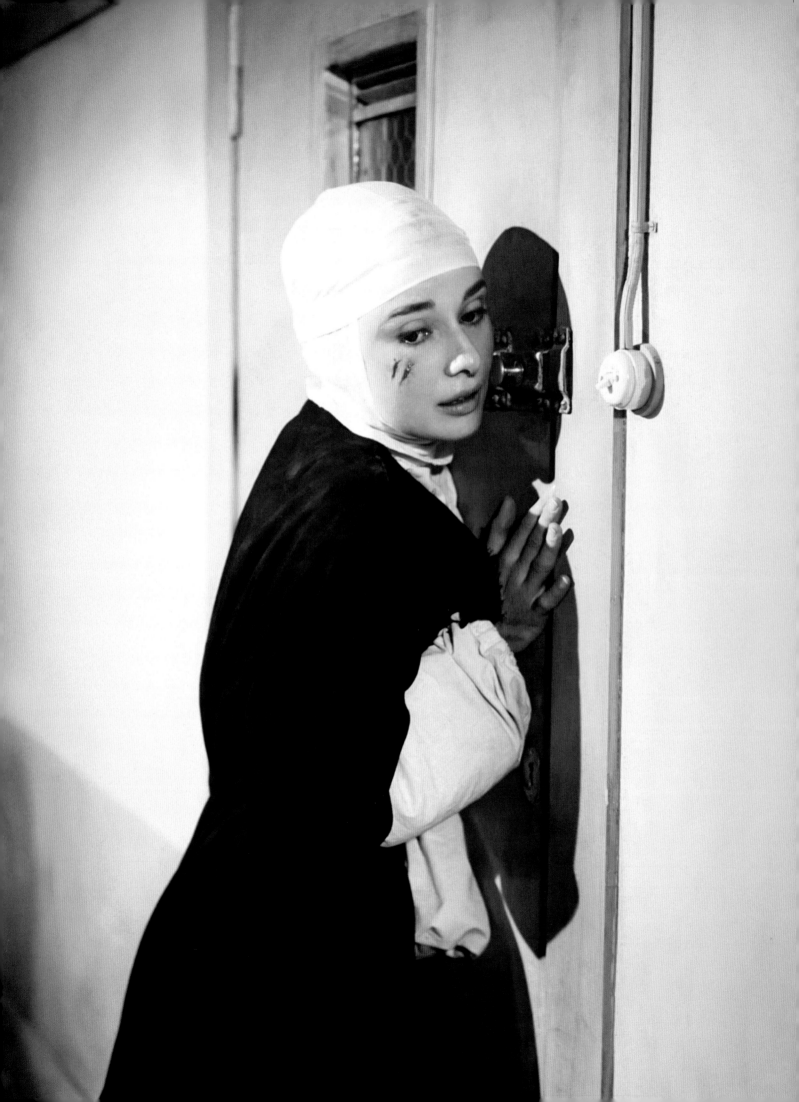

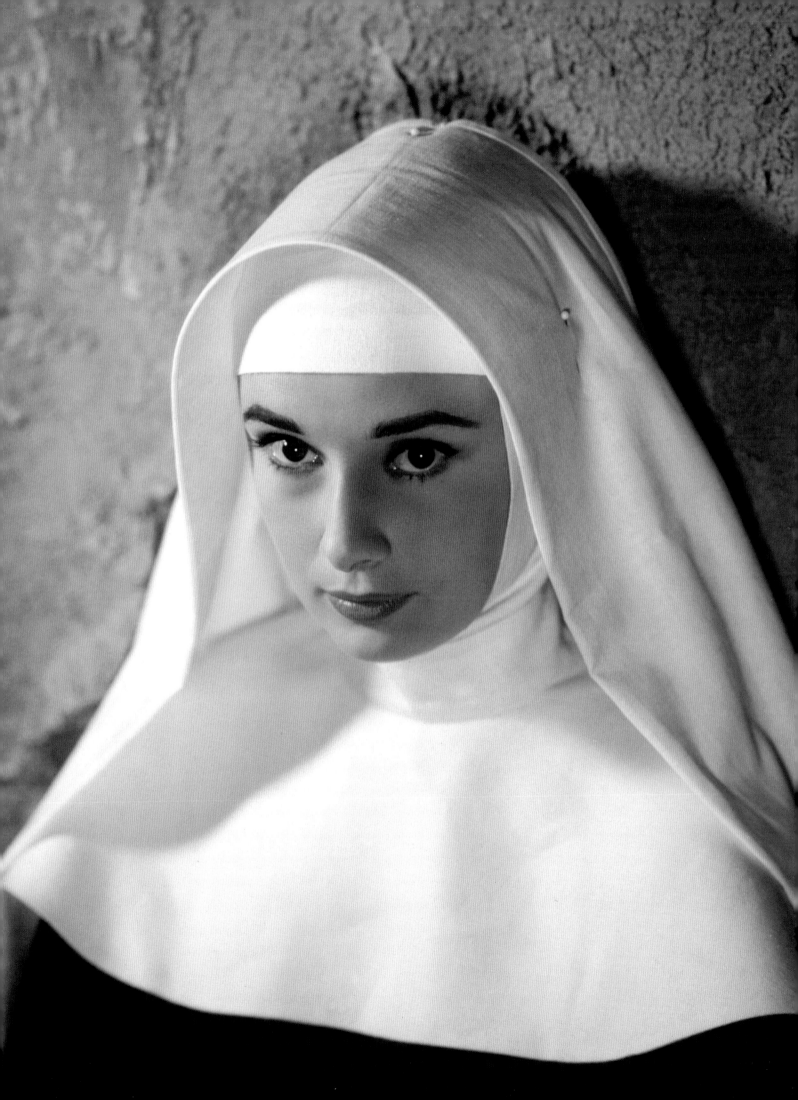

This book is dedicated to Jamie Vuignier.

PHOTO CREDITS

All photographs, magazine covers, advertisements, movie posters, and lobby cards are from the author's collection, with the exception of the following:

Courtesy Independent Visions / MPTV (mptvimages.com): Pages 12, 14, 18–19, 39, 40, 41, 42–43, 45, 50–51, 53, 58, 59, 60, 64–65, 66, 68, 69, 70, 71, 73, 79, 84, 85, 86, 95, 96, 97, 108–109, 110, 111, 112, 113, 114–115, 117, 118–119, 120, 121, 122–123, 126–127, 130–131, 133, 136, 140, 142, 143, 144, 146–147, 148, 149, 150, 152, 155, 160, 165, 181, 185, 186, 187, 202.

Courtesy Photofest (photofestnyc.com): Pages VI, 3, 4, 6, 7, 9, 13, 15, 23, 28–29, 30, 31, 34, 35, 44, 54, 55, 72, 74, 76, 80, 81, 82, 83, 90–91, 94, 98, 99, 129, 134, 139, 168–169, 172–173, 174, 175, 178, 182–183, 184, 189, 190, 193, 200, 206, 207, 210–211, 218, 220, 221, 225, 227, 229.

Margaret Herrick Library / The Academy of Motion Picture Arts and Sciences: Pages 46, 132, 180, 219, 223.

Sam Shaw / Reproduced with kind permission of Shaw Family Archives (shawfamilyarchives.com): Pages 176–177, 179.

The Kobal Collection / Art Resource (picture-desk.com): Front cover, pages 25, 32, 36, 38, 100, 101, 102, 105, 196–197, 204–205, 209.

The Lou Valentino Collection: Pages 135, 137, 159.

The Walter Albrecht Collection: Pages 27, 78.

REFERENCES

Astaire: The Man, the Dancer, Bob Thomas. St. Martin's Press, New York, 1984.

Audrey and Bill: A Romantic Biography of Audrey Hepburn and William Holden, Bob Thomas. Running Press, Philadelphia, 2015.

Audrey at Home: Memories of My Mother's Kitchen, Luca Dotti. HarperDesign, New York, 2015.

Audrey Hepburn, Barry Paris. Putnam, New York, 1996.

Audrey Hepburn: A Biography, Warren G. Harris. Wheeler Publishing, Accord, Massachusetts, 1994.

Audrey Hepburn: An Intimate Portrait, Diana Maychick. Birch Lane Press, New York, 1993.

Audrey: Her Real Life, Alexander Walker. St. Martin's Press, New York, 1994.

Audrey: A Life in Pictures, Carol Krenz. Metro Books, New York, 1997.

Bogart: A Life in Hollywood, Jeffrey Meyers. Houghton Mifflin, Boston, 1997.

Burt Lancaster: An American Life, Kate Buford. Alfred A. Knopf, New York, 2000.

Dancing on the Ceiling: Stanley Donen and His Movies, Stephan M. Silverman. Alfred A. Knopf, New York, 1996.

Edith Head's Hollywood, Edith Head and Paddy Calistro. E. P. Dutton, New York, 1983.

Enchantment: The Life of Audrey Hepburn, Donald Spoto. Harmony Books, New York, 2006.

Fred Astaire, Joseph Epstein. Yale University Press, New Haven, 2008.

Gary Cooper: An Intimate Biography, Hector Arce. William Morrow & Co. Inc., New York, 1978.

Gregory Peck: A Biography, Gary Fishgall. Scribner, New York, 1996.

Gregory Peck: A Charmed Life, Lynn Haney. Carroll & Graf, New York, 2004.

Growing Up with Audrey Hepburn: Text, Audience, Resonance, Rachel Moseley. Manchester University Press, Manchester, UK, 2009.

Hollywood Goes Shopping, David Desser and Garth Jowett, eds. University of Minnesota Press, Minneapolis, 2000.

Inside Oscar: An Unofficial History of the Academy Awards, Mason Wiley and Damien Bona. Ballantine Books, New York, 1986.

John Huston: Courage and Art, Jeffrey Meyers. Crown Archetype, New York, 2011.

A Life in the Movies: An Autobiography, Fred Zinnemann. Scribner, New York, 1992.

Lives of the Great Photographers, Juliet Hacking. Thames & Hudson, London, 2015.

Maurice Chevalier, Michael Freedland. Wiilliam Morrow, New York, 1981.

Model Woman: Eileen Ford and the Business of Beauty, Robert Lacey. Harper, New York, 2015.

The Musical Films of Fred Astaire, John Mueller. Alfred A. Knopf, New York, 1985.

Nobody's Perfect: Billy Wilder, A Personal Biogaphy, Charlotte Chandler. Simon & Schuster, New York, 2002.

An Open Book, John Huston. Alfred A. Knopf, New York, 1980.

Steps in Time: An Autobiography, Fred Astaire. Harper & Brothers, New York, 1959.

Wilder Times: The Life of Billy Wilder, Kevin Lally. Henry Holt, New York, 1996.

Yesterday, Today, Tomorrow: My Life, Sophia Loren. Atria Books, New York, 2014.

adweek.com
agnautacouture.com
calivintage.com
celebrity.yahoo.com
devodot.com
flicker.com
f-picture.net
ids.barbie.com

imdb.com
latimes.com
marieclaire.co.uk
nytimes.com
opulencedecay.com
philippehalsman.com
pinterest.com
princessmonkey.com

rareaudreyhepburn.com
rottentomatoes.com
tcm.com
telegraph.co.uk
theclotheshorse.com
usmagazine.com
vanityfair.com
viamargutta51.com

vintag.es
vintagemoviestarphotos.com
vogue.com
vogue.it
wikipedia.org
youtube.com

ACKNOWLEDGMENTS

Special thanks to:

Stan Corwin

Calvert Morgan, Sean Newcott, Lynn Grady, Laura Brown, Susan Kosko, and the team at HarperCollins Publishers

Evan Macdonald and Sloan De Forest

Manoah Bowman, Andrew Howick, Jay Jorgensen, Howard Mandelbaum, Matt Severson, and Lou Valentino

Russell Adams, Susan Bernard, Mark Bishop, Charles Casillo, Lauretta Dives, Amanda Erlinger, Michael Epstein, Laura Ex, Joshua Greene, Todd Ifft, Glenn Kawahara, Dave Kent, Linda Kerridge, Veronique Lau, Jeffrey McCall, Geri McNeil, Alan Mercer, Phil Moad, Paul Morrissey, Pat Newcomb, Mauricio Padilha, Roger Padilha, Loretta Schmidt, Reynold Schmidt, Scott Schwimer, Edie Shaw Marcus, Meta Shaw Stevens, Ramona Sliva, Melissa Stevens, Debra Tate, Darren Thomas, Faye Thompson, Isabel Torres, Jamie Vuignier, Fay Wills, and Ralph Wills

DEY ST.
AN IMPRINT OF WILLIAM MORROW *PUBLISHERS*

HarperCollins books may be purchased for educational, business, or sales promotional use. For information please e-mail the Special Markets Department at SPsales@harpercollins.com.

FIRST EDITION

Designed by Stephen Schmidt and David Wills

Library of Congress Cataloging-in-Publication Data has been applied for.

ISBN 978-0-06-247206-9

16 17 18 19 20 SCP 10 9 8 7 6 5 4 3 2 1